DESIGNERS & JEWELLERY

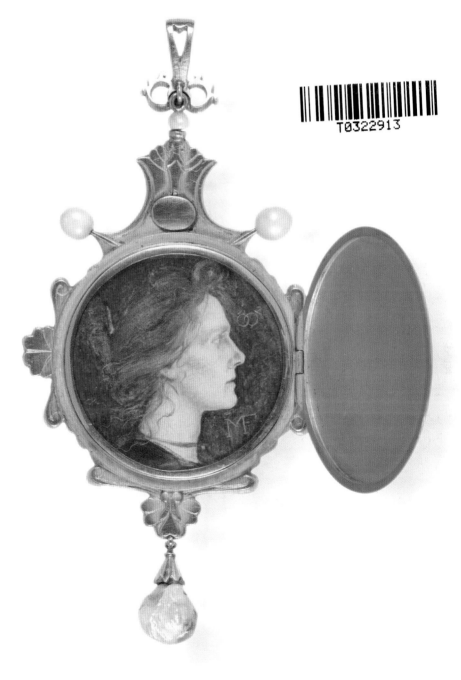

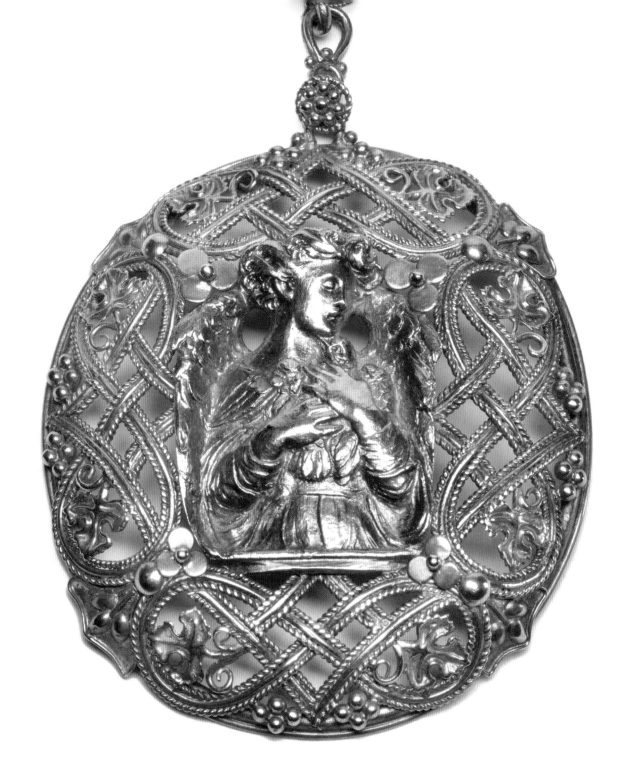

HELEN RITCHIE
&DESIGNERS
JEWELLERY AND METALWORK FROM THE FITZWILLIAM MUSEUM
JEWELLERY
1850–1940

PWP

The
Fitzwilliam
Museum
CAMBRIDGE

Sponsored by

Published on occasion of the exhibition

Designers and Jewellery 1850–1940:
Jewellery and Metalwork from the Fitzwilliam Museum

31 July–11 November 2018
at The Fitzwilliam Museum, Cambridge

Philip Wilson Publishers
Bloomsbury Publishing Plc
50 Bedford Square, London, WC1B 3DP, UK
29 Earlsfort Terrace, Dublin 2, Ireland

Bloomsbury, Philip Wilson Publishers and the Philip Wilson logo
are trademarks of Bloomsbury Publishing Plc

First published in Great Britain in 2018

FRONT & BACK COVER cat. no. 51 (*front and back*)
IMAGES WITHOUT CAPTIONS: p. i, cat no. 51 (*interior*); p. ii, cat. no. 44;
pp. iv & v, cat. no. 63; p. x, cat. no. 47; pp. 8–9, cat. no. 25; p.10, cat.
no. 1; p. 52, cat. no. 22; p. 60, cat. no. 24 (*reverse*); pp. 79 & 81, cat.
no. 31 (*details*); p. 87, cat. no. 42; p. 99, cat. no. 53; p. 144, cat. no. 8;
p. 155, cat. no. 66; p. 156, cat. no. 67 (*reverse*); p. 164, cat. no. 20.

Every attempt has been made to gain permission for the use of the images
in this book. Any omissions will be rectified in future editions.

A catalogue record for this book is available from the British Library
Library of Congress Cataloguing-in-Publication data has been applied for

ISBN 978 1 78130 067 1

10 9 8 7 6 5 4 3 2

Cover design: Lucy Morton at illuminati
Designed and typeset in Perpetua by illuminati, Grosmont
Printed and bound in India by Replika Press

To find out more about our authors and books
visit www.bloomsbury.com and sign up for our newsletters

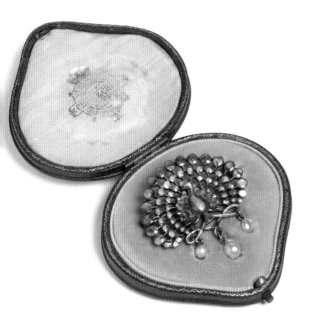

CONTENTS

DIRECTOR'S FOREWORD

The Fitzwilliam Museum is filled with treasures, but not all of these wonderful objects can be on display constantly in the permanent galleries. We simply don't have room to have everything out on show at any one time. It is therefore a particular pleasure to reveal these objects to the public through publications such as this, which presents an opportunity to showcase the wide and varied holdings of the Museum and the extraordinary examples of craftsmanship cared for by the Department of Applied Arts.

This book highlights 70 exquisite pieces of jewellery and metalwork dating from between 1850 and 1940, both in the permanent collection and on long-term loan to the Museum from benevolent collectors. This publication would not have been possible without the generous sponsorship of Nicholas Snowman, Chairman of Wartski, to whom we are particularly grateful. Sincere thanks are also due to Museum staff, especially those who cleaned, conserved and photographed objects, and those responsible for the display that will accompany this book, held in the Museum's Octagon Gallery between 31 July and 11 November 2018. Thanks also to Helen Ritchie, whose new research into this previously overlooked part of the collection forms the backbone of this splendid publication.

Tim Knox
Director and Marlay Curator,
The Fitzwilliam Museum

FOREWORD

Wartski is delighted to sponsor the publication of this book, the first dedicated to the collection of jewellery and metalwork dating between 1850 and 1940 at the Fitzwilliam Museum. It represents an intensely productive period of design and includes pieces made by some of the most notable craftsmen to work in precious metals during this time, as well as objects by famous architects and artists whose work in silver and gold is less well known.

It is a project that has happy associations for Wartski. In 1984, Geoffrey Munn published the first book dedicated to the work of Castellani and Giuliano, both of whom are represented in the pages to follow. The Fitzwilliam Museum has been generous in its support of past exhibitions at Wartski, lending a group of jewels designed by Charles Ricketts to *Artists' Jewellery: Pre-Raphaelite to Arts & Crafts*, in 1989. We are also delighted that as part of the bequest of Mrs Hull Grundy, several pieces originally purchased from Wartski now form part of the Museum's collection.

We relish this opportunity to discover more about these remarkable treasures and would like to congratulate Helen Ritchie on her substantial contribution to the history of the goldsmith and jeweller.

Nicholas Snowman OBE
Chairman, Wartski

ACKNOWLEDGEMENTS

This book would not exist without the generous sponsorship of Wartski. Its directors have advanced the scholarship of jewellery in numerous directions and I am grateful to Geoffrey Munn, Katherine Purcell, Kieran McCarthy and Thomas Holman for sharing their considerable expertise.

Many thanks to John Keatley and the Frua-Valsecchi family for allowing me to include some of their wonderful objects currently on loan to the Fitzwilliam Museum, and to the Cooper family for allowing me to reproduce images from its family archive.

Thanks also to others who have shared their research and knowledge, to Anthony Bernbaum, Alan Crawford, Richard Dennis, Michael Krier, Martin Levy, St John Simpson, and to Charlotte Gere and Judy Rudoe, who also kindly read the manuscript in its early stages. Their research on nineteenth-century jewellery has transformed the field.

I have received generous assistance from staff at numerous archives and institutions. Thank you to Eleni Bide, Katie Holyoak and Stephanie Souroujon at the Goldsmiths' Company; Max Donnelly, Olivia Horsfall-Turner, Whitney Kerr-Lewis and Clare Phillips at the Victoria and Albert Museum; Matthew Winterbottom at the Ashmolean Museum; Vicky Wilson at RIBA; Neil Parkinson at RCA Special Collections; Carol Jackson at Chipping Campden Archive; the Hart family; Patricia McGuire and Peter Monteith at King's College Archive, Cambridge; and the staff of the National Art Library, London, and University Library, Cambridge.

I am also grateful to the staff at Philip Wilson publishers: Anne Jackson (commissioning editor), Clare Martelli (production editor), Robin Gable (copy-editor) and Lucy Morton (designer).

I am lucky to work with numerous talented colleagues. I would like to thank former Director and Marlay Curator Tim Knox and Assistant Director Kate Carreno, as well as Michael Jones (Head of Photography) and his wonderful team, especially Amy Jugg, for the spectacular new images reproduced in this book, Lynda Clark (Image Library Manager), Jacqueline Hayes, Kerry Wallis and Liz Irvine (Finance Manager, Financial Coordinator and Purchasing/Accounts Clerk, respectively), Diana Caulfield (Librarian), Paola Ricciardi (Research Scientist) and Trevor Emmet. I would also like to thank colleagues in the curatorial division: Suzanne Reynolds (Assistant Keeper, Manuscripts and Printed Books), Richard Kelleher (Assistant Keeper, Coins and Medals), Matthew Ball (Documentation Assistant, Coins and Medals), Hettie Ward (Assistant Keeper, Paintings, Drawings and Prints) and Nicholas Robinson (Archivist).

The staff and volunteers of the Applied Arts Department deserve particular thanks for their incredible and sustained help: Nik Zolman, Andrew Maloney and Tim Matthews (Senior Chief Technician, Senior Technician and Technician, respectively), Jo Dillon (Senior Conservator of Objects), Flavia Ravaioli (Conservator of Objects), Anna Lloyd-Griffiths (Secretary to Keepers) and Julia Poole (Honorary Keeper of Western Ceramics).

Finally, heartfelt thanks to Victoria Avery (Keeper, Applied Arts) and Emma Jones (Marlay Sculpture Researcher) for their continued encouragement and daily words of wisdom, and to my family and Alun Graves for their unstinting support.

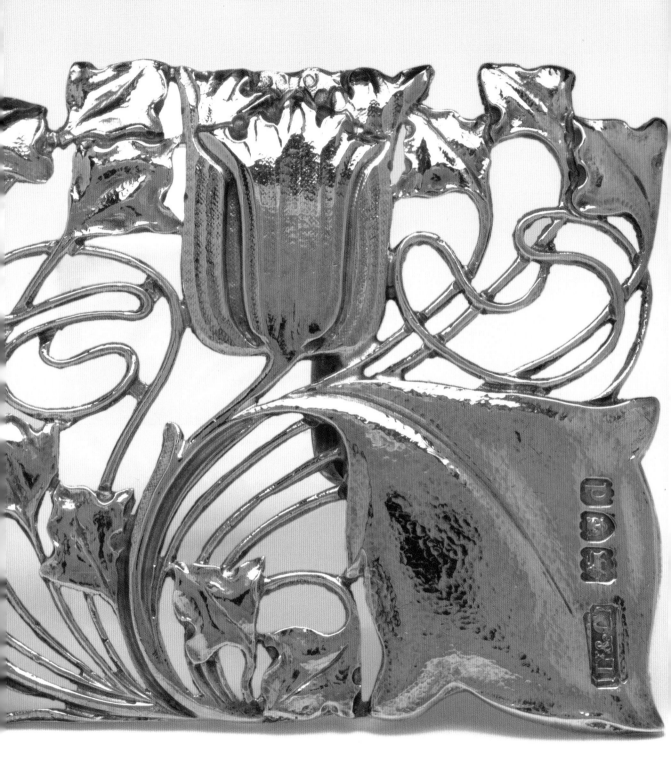

INTRODUCTION

Like many other of Britain's oldest art institutions, the Fitzwilliam Museum has been described as a 'collection of collections'. The Museum was founded in 1816 by Richard Fitzwilliam, 7th Viscount Fitzwilliam of Merrion (1745–1816), who bequeathed his art collection and library, with funds to house them, to the University of Cambridge in order to further 'the Increase of Learning and other great Objects of that Noble Foundation'. Since then, the Fitzwilliam has benefited from hundreds of generous gifts and bequest, amassing one of the finest collections of art and antiquities in the UK, and indeed in Europe.

One of five curatorial departments, the Department of Applied Arts cares for around 40,000 objects, including Chinese, Japanese and Korean art, Islamic art, European arms and armour, clocks and watches, fans, furniture, textiles, glass, ceramics, sculpture and jewellery and metalwork. With such

a breadth of material, and with only a limited amount of space, it is difficult to display all of the collections at once, which is why publications such as this, generously sponsored by Wartski, are so important in allowing the Museum to share less-well-known aspects of its important holdings. The Museum's collection of modern metalwork and jewellery is broad and represents the popular and fruitful period of design from the mid-nineteenth century to the beginning of the Second World War.

This book also provides an opportunity to highlight some of the Museum's most generous benefactors. The large majority of the objects included in this catalogue were given to the Museum by Mrs Anne Hull Grundy née Ullmann (1926–1984), who between 1982 and 1984 gave over 150 pieces of jewellery, and some metalwork, to the Museum (*fig.* 1). An eccentric figure, Mrs Hull Grundy was born in Germany to

FIG. 1 Mrs Hull Grundy (1926–84). *London, British Museum*

bespoke bed, surrounded by cabinets of jewellery, she corresponded with dealers via the post in order to continue collecting European jewellery, metalwork, Japanese netsuke and ivories, and ceramics made by the Martin Brothers.

Mrs Hull Grundy was a demanding customer but a good one. Describing herself as a 'large spider sitting at the centre of a web of dealers, salerooms and museums', she liked to 'outwit them all' and sent letters, postcards and jewellery back and forth constantly from her home in Chilbolton.¹ Unlike most other jewellery collectors, who were interested in either archaeological pieces, very niche category objects (e.g. mourning rings, a vast collection of which were given to the Museum by Spencer George Perceval) or gemstones (described by her as for 'call girls and rich dumb wives'), Mrs Hull Grundy was interested in pieces made from unusual materials such as cut steel, coral, jet and paste (she quipped 'I prefer my paste to other people's diamonds') and those that were signed or marked, or in their original cases and therefore told her something about the history of the piece, or its place in the history of jewellery design. In many ways, Mrs Hull Grundy was the first collector to take jewellery seriously as another avenue of art history, and to study what it could tell us about the lives of those who made and wore it.

But her caustic wit and fearsome manner meant that she was as difficult to deal with

a wealthy Jewish industrialist family, and emigrated to England in 1933. A precocious child, she collected objects from the age of 11, driven around the fashionable antiques shops of the West End by her chauffeur. She married artist and entomologist John Hull Grundy (1907–1984). After being disabled by a respiratory condition at the age of 21, she was confined to her bed for the rest of her life. However, this did not dim her passion for collecting, and from her enormous

as she was generous. Towards the end of her life, her sight and health failing, Mrs Hull Grundy began to portion out her collection and send pieces to different museums around the UK, something she claimed to have had in mind since her childhood in Hampstead, visiting Kenwood House. A committed atheist – 'I do not expect any reward in the hereafter, for when I die I will be as dead as every chicken I eat' – her and her husband's gifts to museums were to act as monuments to their memory. She preferred 'virgin' museums, those that did not already have substantial collections of jewellery, and tried to suit the gift to the museum; for example, sending the best Scottish pieces to Glasgow, jet to Harrogate, seaside jewellery to Weston-super-Mare, and the best and largest gift to the British Museum, which she presented in 1978. But as former Keeper of the Applied Arts department of the Fitzwilliam Museum, Dr Julia Poole, recalls, receiving these gifts could be something of a trial:

> Enormously generous on the one hand, she was equally unpredictable on the other. While museum curators welcomed her gifts, they also dreaded her telephone calls. Indeed, if enthusiasm was seen to lack or a thank you note too slow, she would invariably attack. No number of telegrams she considered too much, threatening with legal proceedings if not mutilation.[2]

Items would arrive in biscuit tins, and if Mrs Hull Grundy changed her mind would

be followed by an open postcard declaring that a piece should be sent to the curator at another museum, Birmingham perhaps, or Cheltenham, or sent back to the dealer. But Mrs Hull Grundy's gift formed the basis of the Museum's varied collection of jewellery, and although she claimed to 'hate art and crafts' the large number of high-quality pieces designed by Arts and Crafts designers in the gift prove that this may have been a theatrical overstatement on her part. Her maxim 'If you don't love it, don't buy it' remains excellent advice for would-be collectors.

Since its foundation, collectors have often lent objects from their collection to the Museum in order to allow the public to see them, albeit temporarily. In 2016, the year of the Museum's bicentenary, this tradition continued with the temporary loan of more than 100 superb works of art from the Frua-Valsecchi Collection. This belongs to Massimo and Francesca Valsecchi, and until recently was on private display in their home in Cadogan Square, Chelsea. The couple have been collecting privately for over 50 years. Massimo, a former economist and lecturer at the University of Milan, and Francesca, granddaughter of one of Italy's most famous twentieth-century collectors, the industrialist Carlo Frua de Angeli, met in London but moved to Milan to open a branch of the Genoa and Turin Gallery La Bertesca, which staged the first show of Pop Art in Italy. They began to collect contemporary art

and opened their own space in 1973. It was not particularly commercial, often buying 'against' the market, and the pair ended up keeping many of the things they had purchased for themselves. This culminated in an astonishingly eclectic collection of art, ranging from paintings by Stanley Spencer and Giovanni Cariani, furniture by William Burges and Giuseppe Maggiolini, and works of art including early European porcelain (including a Meissen vulture made for Augustus the Strong's Japanese Palace), Christopher Dresser ceramics, Fabergé, an enormous collection of glass by Tiffany, Daum, Loetz and Cappellin & Co., and of course a rare aluminium clock designed by C.F.A. Voysey (*cat. no.* 24).

A long-term lender and friend of the Museum is John Keatley, chairman of the Keatley Trust. The Trust was founded on 29 January 1968 for the 'advancement of education by acquiring by purchase, gift, loan or otherwise objects … of artistic, literary or historic interest or importance for the purposes of their public exhibition in Great Britain' and celebrates its fiftieth anniversary in 2018. Comprising over 1,500 beautiful objects, including furniture, ceramics, glass, metalwork and book bindings, made mostly in the twentieth century, the Keatley Trust lends to museums all over Britain. Although works of art from the twentieth century have always appealed visually to John Keatley, it is not the beauty of a piece that compels him to acquire it, but

its role in illustrating the century that proved to be the most transformative for all British people; that which saw the greatest improvement in the lives of everyone. It is their role as signifiers of this twentieth-century shift that so interests this generous collector.

This book brings together 70 pieces in the collection of, or on loan to, the Fitzwilliam Museum, designed by almost 30 named designers/workshops. The objects are grouped according to designer and are ordered chronologically using the year of birth of designers, or year of foundation of companies. They span a range of styles, encompassing the complex and intricate historicist and neo-Gothic, the naturalistic Arts and Crafts, the sinuous curves influenced by the European art nouveau movement and the structural modernity of the 1920s and 1930s.

The mid-nineteenth century witnessed a great plurality of historicist styles. The discovery of ancient jewellery provided a wealth of designs not seen previously, satisfying the curiously nineteenth-century affection for objects that were both novel and also based on that which had come before. This duality is highlighted in a tongue-in-cheek fictitious letter published in *Punch* on 16 July 1859, accompanying a cartoon (*fig.* 2), in which, after visiting Castellani's shop in Rome (pp. 11–13), a young woman writes to her friend, saying, 'Everything there is taken exactly from the antique, so that you are quite safe in choosing whatever you like and cannot go

wrong.' More generally, historicist designs were based on a multitude of sources: Anglo-Saxon jewellery discovered in Britain; jewels seen in Hans Holbein's drawings; surviving European Renaissance jewels and Gothic architecture; the jewellery of contemporary India and ancient Scandinavia; and, most famously, the jewellery of Ancient Greece and Italy.

The careful replication of exquisite ancient jewellery and the departure from the more naturalistic and gem-set jewellery of the earlier part of the nineteenth century were viewed favourably by most, including William Burges, who in 1863 declared that 'it is only since our workmen have taken to imitating the beautiful articles found in the tombs of Etruria and Magna Græcia that an artist can pass a jeweller's shop without shutting his eyes'.[3] Although historicist jewellery had initially been made in Italy, partly with political motives in mind (p. 12), it was soon favoured by those who travelled to Italy and saw it in the workshops of Castellani (pp. 11–13), and eventually by the intellectual and artistic circles of Britain, who were interested in its historical connotations and fashionable novelty.

This fashion was widely disseminated not only via print sources but via the many International Exhibitions held throughout the latter half of the nineteenth century, beginning with the Great Exhibition in London in 1851, followed by other International Exhibitions and Fairs in London

(1862, 1871, 1885, 1886), Dublin (1865), Paris (1855, 1867, 1878, 1889), Vienna (1873) and Philadelphia (1876), among many others. These exhibitions were intended to display the wealth of manufactured goods produced by different countries, and to encourage trade, showcasing 'the exquisite combination of the noble material with the nobler artistic handicraft'.[4] The competition provided by these international displays, at which medals were given to the best examples of objects within categories, spurred on new developments in materials and techniques across all categories of goods, including jewellery and metalwork. The exhibitions were also widely illustrated and commented upon, and provided much discussion for those interested in the booming industry and trade of the era.

However, not everyone was in agreement with the ever-increasing productivity and consumerism showcased by these events. Although many of the most expensive examples of manufactured goods were produced, at least in part, by hand, many of the cheaper copies produced as 'trickle-down' fashions relied on cheap labour and increasing mechanisation. As one jewellery firm put it, 'on the die stamp entering the door of a goldsmiths' workshop, Art flies out by the window.'[5]

For individuals such as critic and writer John Ruskin (1819–1900) and artist, poet and activist William Morris (1834–1896), this disconnect between craftsman and

object resulted in a mean, dispirited object, and unhappiness on the part of the maker. Morris especially believed that art and society could be improved by a change in labour conditions, if craftspeople returned to a state in which they had the time and inclination to put something of themselves into the objects and play a part in the design, making by hand and paying attention to natural materials. Instead of looking back to Ancient Greece and Italy, Morris looked back to British medievalism, especially the guild system, in which craftspeople worked together on particular crafts in small workshops. By the 1880s, Morris had become an internationally famous figure and commercially successful designer. His views gained more supporters, and in 1887 the Arts and Crafts Exhibition Society was formed in order to provide artists and craftspeople with an opportunity to display their work to the public. The first exhibition was held in the New Gallery in 1888. The first president of the Society, artist Walter Crane (1845–1915), wrote in the introduction to the catalogue of the first exhibition:

> The true root and basis of all Art lies in the handicrafts. If there is no room or chance of recognition for really artistic power and feeling in design and craftsmanship – if Art is not recognised in the humblest object and material, and felt to be as valuable in its own way as the more highly rewarded pictorial skill – the arts cannot be in a sound condition…[6]

The Arts and Crafts Movement took its name from this society, but in reality it was a loose band of like-minded societies (including the Art Workers' Guild, founded in 1884), workshops, manufacturers and designers, many of whom (like William Morris) had socialist views. More generally the term 'Arts and Crafts' referred to a way of working and a loose aesthetic. Craftspeople who adhered to Arts and Crafts thinking usually worked in smaller workshops, making objects predominantly by hand (although some machinery was often used – a bone of contention among different craftspeople). The Arts and Crafts Movement championed the beauty of the raw material and therefore few attempts were made to 'hide' its natural appearance. In metalwork this meant that silver was not gilt or highly polished and other, less expensive metals such as copper and pewter were often used instead. Gold was used by some designers but was not as common. Enamel was popular and stones were prized for their natural colour and appearance, not their relative value. Instead of using sparkling, faceted gemstones, Arts and Crafts designers favoured less expensive hardstones, cut smoothly to show off their colour. Objects were expected to be functional as well as beautiful, and a belief that surface ornamentation was supposed to reflect the functionality of the object resulted in a simpler style than that of the 1860s and 1870s. Instead of always looking backward to

previous styles, designers often looked to the natural world, favouring animal and plant motifs.

But the Arts and Crafts Movement suffered some setbacks. Although many Arts and Crafts designers were socialist in their outlook, their refusal to use industrial machinery and reliance on skilled labour meant that their works of art were expensive and out of the reach of members of the working and even lower middle classes, appealing instead to the artistically engaged upper middle and upper classes, who did not necessarily share the political perspective of the designers. Also, as the Arts and Crafts aesthetic grew in popularity other less scrupulous manufacturers, such as Arthur Lasenby Liberty (pp. 94–8), produced objects in the same style which looked handmade but had actually been made at least partly mechanically, in huge metal shops in Birmingham. However, this pioneering reform movement inspired similar movements in Europe, America and Japan, and remained popular in Britain for decades.

This popularity perhaps partly accounts for Britain's more muted adoption of other design trends of the early twentieth century, including French art nouveau, art deco, and the modernist movement that started at Bauhaus in Germany. Some British designers, notably C.F.A. Voysey (pp. 57–61) and H.G. Murphy (pp. 132–7), did break away and were influenced by external design movements, but more generally British designers were no longer at the forefront of design innovation. Britain began to follow, instead of leading the way.

However, as illustrated in the following pages, the jewellery and metalwork created between 1850 and 1940 not only demonstrates the various trends of this exuberant period of design, but is also representative of the numerous ideologies and political positions of those who designed and made these pieces. They tell a story of industrialisation and trade; of travel and exploration and the effect of other cultures on British life and design; of the striving to discover or invent a national 'style' and identity; of religious beliefs, social mores and etiquette; and, as jewellery has always done, they reveal the personal and emotional artistic lives of designers, makers and wearers. Like all art forms, jewellery and metalwork provide a means of self-expression. In the words of artist Charles Ricketts (pp. 99–115), spoken at the close of the nineteenth century,

It seems such a pity to seek visions when you can make them…[7]

DESIGNERS

CASTELLANI *1814–1930*

A dynasty of ambitious and creative Italian jewellers, the Castellani family produced a vast array of jewellery inspired by the archaeological pieces discovered in Italy during the early part of the nineteenth century, and galvanised the production and popularity of historicist jewellery more widely.

The firm was founded by Fortunato Pio Castellani (1794–1865) in Rome in 1814, selling not only contemporary jewellery, but also paintings and works of art, aimed at the increasing number of tourists who visited Rome. From 1828 Castellani was patronised by Michelangelo Caetani, Duke of Sermoneta, who provided access to archaeological digs undertaken by the state. He encouraged Fortunato to narrow his focus and concentrate on producing jewellery that imitated the ancient jewellery that was at that time being discovered in Italy. Castellani's sons Alessandro (1823–1883) and Augusto (1829–1914) took over the business, although neither physically made jewellery himself. Alessandro had lost a hand in a hunting accident at the age of 13, but was a visionary designer. In 1858 he was sent into exile for his political activities but used this as an opportunity to promote the firm and to establish new premises at 85 Avenue des Champs-Elysées, Paris. Assisted by friend and fellow jeweller Carlo Giuliano (*see* pp. 24–7) he subsequently established a business at 13 Frith Street, Soho, London, as well as another workshop and a school for

goldsmiths in Naples, which by 1865 was run by jeweller Giacinto Melillo (1846–1915). Melillo continued to run the business after 1870, when Alessandro returned to Rome to set up his own art and antiquities gallery. Alessandro was also instrumental in assisting the French government to purchase part of the Campana collection in 1861 (an unsurpassed private Italian collection of ancient works of art, including Roman and Hellenistic jewellery, which the firm had restored and catalogued and took much inspiration from). He died in 1883 and is remembered as an immensely successful collector of artefacts from the ancient world. The British Museum acquired large groups of objects from him in both 1865 and 1872 and a posthumous sale of the remainder of his collection was held at Palazzo Rosso, Rome, in 1884.

The original establishment in Rome (which moved premises twice) became a key 'stop-off' for visitors touring the city. It gave wealthy tourists the chance to see a variety of original objects from eight different periods of history displayed in showcases around the walls, and then to

purchase jewellery inspired by or copied from that which they had just seen, directly from the Castellani workshop. Arguably this presentation of the history of Italy as one long progressive narrative, leading to the present, had a political undertone. The Castellani family were in favour of a unified Italy and this specially arranged display of Italian history used art ingeniously, subtly, to encourage this political idea.[8] After Fortunato's retirement, his son Augusto became the manager of the business in Rome. His son Alfredo (1850–1930) subsequently took on the business, but it declined as tastes began to change and jewellery in the new art nouveau style became more popular. Without children himself, Alfredo planned for the future. He gifted various pieces to museums, but most notably gave 526 pieces of jewellery made by Castellani and over 5,000 ancient objects, including ceramics, glass and bronze collected by the family, to the Museo Nazionale Etrusco di Villa Giulia, in Rome.

It is difficult to overstate the popularity of Castellani's jewellery. Although many other companies designed jewellery inspired by that belonging to ancient civilisations, Castellani had both invented a market for it and remained the most successful at producing it, partly because of its painstaking experiments in reproducing techniques such as filigree and granulation, and experiments with electrotyping and gilding. Whereas other jewellers more often copied designs found in printed sources, which disseminated recent archaeological discoveries, the Castellani were able to handle original historic pieces, such as those in the Campana collection and those that the family collected themselves, allowing them to examine the objects more closely and replicate more intricate details. They were the originators of jewellery made in the 'Etruscan' or 'archaeological' style, and their work was seen by hundreds of thousands of people at the International Exhibitions in London in 1862, Paris in 1867 and Vienna in 1873.

This brooch (*cat. no.* 1) is a very modest example of their output, which usually consisted of pieces of fine and intricate gold work, often set with carved hardstones or tiny glass mosaics, including motifs such as vases and animal heads, as seen here. Some pieces were in the medieval style, but the majority of their work favoured older styles of jewellery discovered in Italy by 'its Etruscan, Greek, Roman, or other inhabitants'.[9] In his slim paper printed for private circulation, *Antique Jewellery and Its Revival* (1862), produced to correspond with the Castellani display at the International Exhibition of 1862,

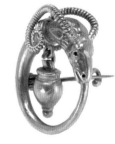

CAT.NO.1 Gold brooch, made by Castellani in Rome, *c.*1860-70

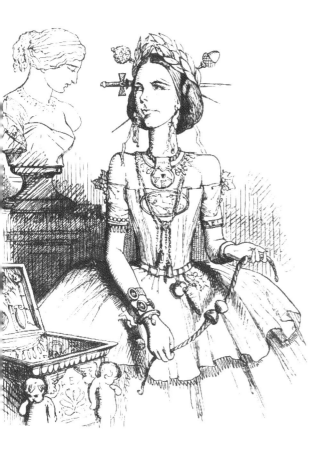

FIG. 2 Cartoon from *Punch*, 16 July 1859

London, Alessandro Castellani acknowledged the influence of other civilisations, such as ancient India and Egypt, on the art of European countries such as Italy, but still confessed that, 'among all their ancient ornaments that have reached us, the most conspicuous for beauty of form and admirable workmanship are those which the Italian soil has yielded.'[10] He readily admitted that there were still many aspects of production of ancient jewellery that remained a mystery to them, but that they had been able to 'revive, both in design and workmanship, the best types of jewels according to the successive phases of the goldsmith's art in our country', from the 'archaic Etruscan …, the Italo-Greek, the pure Greek, the Roman of the best period, … the Lower Empire … works of Christian and Byzantine origin … and the Italian revival'.[11]

Castellani received numerous high-profile commissions, including a 'Roman lady's jewel casket' for Maria Pia of Portugal in 1862; a casket and parure (set) consisting of a crown, brooch and earrings in the medieval style given to Victoria, Crown Princess of Prussia, on the birth of her daughter in 1872; a 'Carolingian' parure sold to the King of Italy, Umberto I, in June 1891 as a gift for the German Empress; and a gold cup presented by the city of Rome to Pope Pius IX. Even before their tremendous showing at the International Exhibition of 1862, word of the popularity of Castellani's workshop and showrooms with tourists in Rome had made its way back to Britain, where it was mocked in a cartoon in *Punch* (16 July 1859; see *fig.* 2). It depicts a diminutive lady weighed down by an entire casket's worth of Castellani's jewels, all worn at the same time, who has written to her friend:

> *My* great object in Rome is to go, the very first thing, to that dear, delightful, interesting shop, CASTELLANI's in the Via Poli, where Imogen says you have nothing to do but to lay down scudi enough, in order to be made perfectly classical in appearance. Only think of that!

WILLIAM WHITE *1825–1900*

A talented Gothic Revivalist architect based in the south-west of England, White built a successful career around his concept of 'domestic gothic' and the importance of colour, occasionally designing metalwork to harmonise with his polychromatic interiors.

Born to the Rev. Francis White and his wife, Elizabeth Master, White was apprenticed to Daniel Goodman Squirhill, architect and surveyor of Leamington Spa, and to the architect Sir George Gilbert Scott in London, before establishing his own practice in Truro in the late 1840s. His modest but solid and sensitive work in the neo-Gothic style was greatly in demand, and he built numerous churches, rectories, houses and schools throughout Britain, as well as designing cathedrals for Madagascar (1889) and Pretoria (c. 1890). White became a fellow of the Institute of British Architects in 1859, a fellow of the Society of Antiquaries in 1864, and was elected president of the Architectural Association in 1868–69.

White published widely on his thoughts regarding design, especially polychromy, in journals such as *The British Architect, The Builder* and *Building News*, and through the Ecclesiological Society, of which he became a member in 1849. This Society, which aimed to promote the study of Gothic architecture, spawned many others, such as the Exeter Diocesan Architectural Society, through which White met John Garratt.[12]

John Garratt Jnr had inherited Bishop's Court, Clyst St Mary, Devon, a medieval residence of the Bishops of Exeter, from his father John Garratt Snr, a wealthy tea merchant and Lord Mayor of London, who had purchased it in 1833. Garratt Jnr had long held an interest in Gothic architecture, having become a follower of the Oxford Movement whilst studying at Christ Church. On the death of his father in 1859, Garratt Jnr commissioned White to remodel Bishop's Court, a project White completed in 1864.

The emphasis of the remodelling was the chapel, dedicated to St Gabriel. With its triple lancet windows, bell turret, medieval-style encaustic floor tiles and polychromatic decorative scheme, the interior has been described as 'a serious mid-c19 architect's conception of domestic gothic'.[13] Like many nineteenth-century architects, White designed some furniture and fittings for the interior, including a great table in the style of Pugin, a hall sideboard, and candelabra and candlesticks for the chapel, designed to harmonise with the altar, painted with flowers and a cross, in red, blue and gold, under a triptych

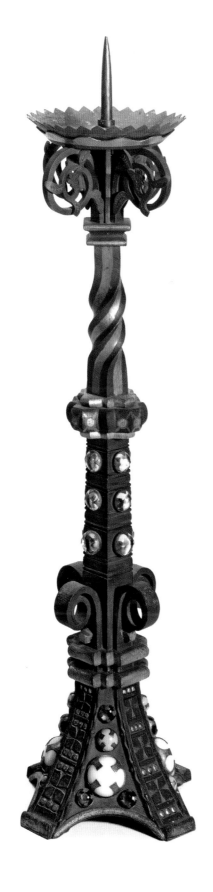

depicting the Annunciation, Crucifixion and Nativity, in turn below stained glass windows.[14]

The colours used on this large pair of bronze altar candlesticks (*cat. no.* 2) not only match the chapel's decorative scheme, but also have another purpose. According to White's thoughts on colour as expounded in his lecture 'A Plea for Polychromy', given at the Architectural Museum in London, in which he argued that different colours could affect the human body and mind in different ways, the colours used in the chapel have particular resonance. White stated that the nerves are 'excited by the presence of red … and deadened or benumbed by the presence of blue', and that the optic nerves could be excited in gloomy surroundings by small applications of yellow, or of gold.[15] Therefore, according to White's theory, in the dark space of the chapel, lit only by candlelight, these candlesticks would have caught the eye of the viewer and alerted their senses, but also encouraged a calm sense of contemplation.

These candlesticks remained in Bishop's Court until 1994, when the contents of the house were sold on the premises by Bearne's of Torquay. This pair of candlesticks was purchased by Blairman & Sons Ltd, and sold to the Fitzwilliam Museum. More recently, a pair of the matching candelabra was acquired by the Art Institute of Chicago.

CAT. NO. 2 Pair of bronze altar candlesticks, designed by William White, c. 1860–64

WILLIAM BURGES ARA *1827–1881*

An inventive and ingenious architect working mainly in the neo-Gothic style, Burges built on the revival of medievalism of the earlier part of the nineteenth century, taking inspiration from myriad places, cultures and sources, which resulted in an eclectic and fantastic style that he applied to everything from buildings to cutlery.

Burges was born in 1827 and educated at King's College School, London. His interest in engineering and design, especially the neo-Gothic, flourished at a young age, after he received a copy of A.W.N. Pugin's *Contrasts* for his fourteenth birthday. Burges later went on to train in architecture under Edward Blore, surveyor to Westminster Abbey, followed by a spell under architect Matthew Digby Wyatt, whom he helped with plans for the Great Exhibition of 1851. He travelled extensively throughout Europe and studied the arts of other countries and eras vicariously (Pompeian, Assyrian, Japanese, etc.), resulting in a uniquely eclectic style that contemporaries named 'Burgesian Gothic'. Although much of his inspiration is derived from ecclesiastical sources, Burges was of 'no church' himself, preferring the aesthetics of religion to any actual theology.

He secured his first architectural commission (St Fin Barre's Cathedral, Cork) in 1863. Although he was rewarded with regular commissions from that time, many of his most ambitious schemes were never completed, including: the Crimea memorial church, in polychrome Italian Gothic, designed for Constantinople in 1865 (the funds from which, according to the engraved description around the neck of this decanter, allowed him to pay for its production); a design for the new law courts in London (1866–7); and a controversial plan to decorate the interior of St Paul's Cathedral with polychrome marble and Byzantine mosaics (1870–77). However, the time saved by not focusing on these many unbuilt schemes enabled Burges to focus on those that were completed, including Cardiff Castle (1866 onwards), Castell Coch, Glamorgan (1872 onwards) – both for the 3rd Marquess of Bute – and his own home, 9 Melbury Road, Kensington (1875–81). He not only designed the structure and form of his home, but also created complete decorative schemes, commissioning murals and painted furniture from many leaders of the Pre-Raphaelite movement, including Dante Gabriel Rossetti, Edward Burne-Jones, Simeon Solomon, Frederick Smallfield and Edward J. Poynter. However, unlike other

CAT.NO.3 Glass and silver decanter, designed by William Burges, made 1865-66

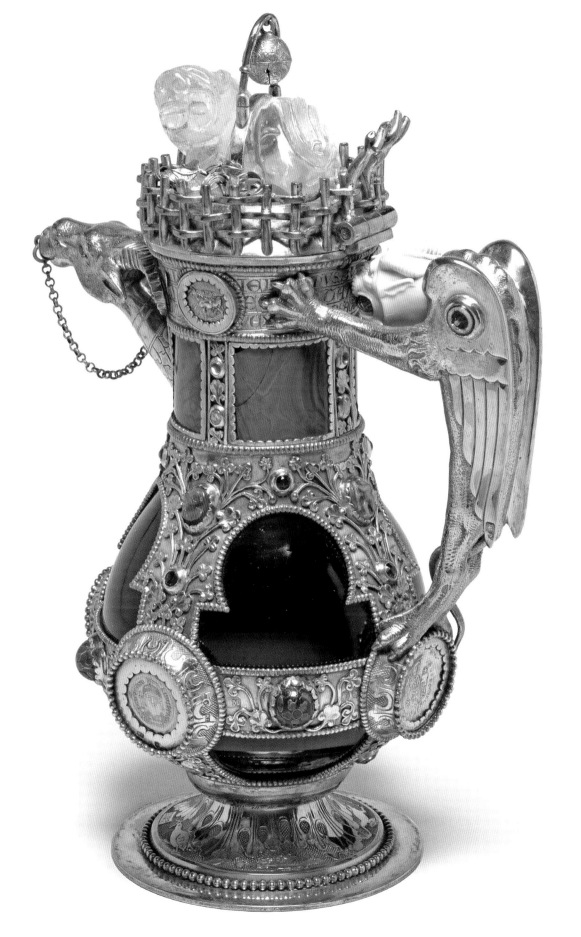

architect-designers who had gone before him, including Pugin and William Morris, Burges never intended these pieces of furniture to be put into commercial production. Occasionally his metalwork designs, which were produced in collaboration with numerous silversmiths, were intended for patrons. These included the chalices made for St Michael's Church, Brighton, and a small number of jewels made for the Marchioness of Bute, the wife of his greatest patron.[16] But most metalwork was made for his own use and displays a dazzling originality that surpasses any silver designed earlier in the century.

Beyond his main career, Burges participated in the bohemian and cultural life of London. He lectured and published widely, was a member of numerous artistic and professional societies, including the Hogarth Club, the Medieval Society, the Royal Institute of British Architects and the Ecclesiological Society, for whom he organised the medieval court of the International Exhibition of 1862. He was elected to the Royal Academy just one year before his death. He collected widely, bequeathing much of his collection to the British Museum (see below). Eccentric, but well liked by all of his peers, Burges became more unusual in appearance and was nicknamed 'Ugly Burges' towards the end of his life. His tastes, however, did not waver. He refused to follow the changing fashion in design throughout the 1870s, instead remaining steadfast to the Gothic until the end, declaring 'I have been brought up in the 13th century belief, and in that belief I intend to die.'[17]

In all of Burges's work, whether architectural or smaller scale, inspiration came from various sources. Burges travelled widely and his sketchbooks, now in the Victoria and Albert Museum, are filled with cut-and-pasted pencil and ink designs and rubbings from churches and cathedrals from all over Europe. Burges noted anything that interested him, including brass and ironwork, mosaics and stained glass, architectural features, design plans, interiors and funerary effigies, providing a confection of Gothic patterns, people and animals who inhabited these spaces. To these, Burges added his own designs. In this one decanter (*cat. no.* 3), he brings together elements from a range of ancient and medieval cultures, made from a variety of materials, incorporating

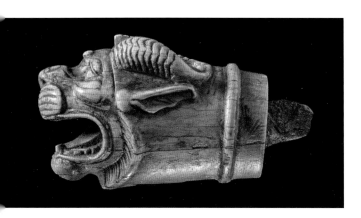

FIG. 3 Ivory Achaemenid fitting, carved in the shape of a horned lion's head, 4th–6th century BC. London, British Museum

ancient coins, seventeenth-century cameos, a Chinese rock crystal lion, enamels and a whole host of animals and creatures.

In some ways, this decanter can be read architecturally, with archways and uprights, fretwork and roundels or rose windows, providing the main structure for the design. Unsurprisingly, given his love of early Gothic French architecture over English, the three- and five-leafed repetitive foliate motifs that cover the silver mounts are probably based on the detail of a stonework arch of the 'Portal of Clincy', in the thirteenth-century Collegiate Church of Our Lady of Les Andelys, Normandy, of which Burges made an ink drawing in his sketchbook.[18] Whilst on his travels Burges undoubtedly searched out earlier silver- and metalwork, and he may have been inspired by early Italian silver, such as the fourteenth-century reliquary casket in Sulmona Cathedral, Abruzzo, which is topped by a large rock crystal lion, very similar to that seen here.[19]

Other sources of inspiration came from the many objects that Burges collected, including a large collection of armour, which he gave to the British Museum. This collection includes an Achaemenid fitting, perhaps for some sort of weapon (*fig.* 3), in the form of a horned lion or chimaera's head, carved in ivory. Burges believed it to be Assyrian and may have purchased it from the archaeologist, collector and politician Sir Henry Layard. As Burges gave the fitting, along with other weaponry, to the British

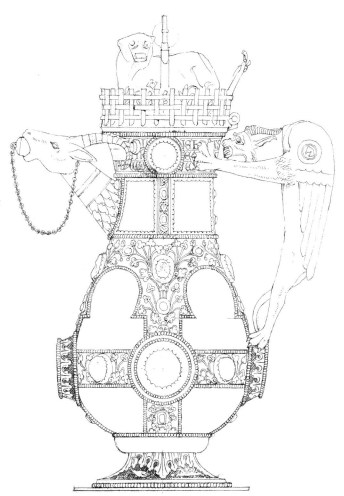

FIG. 4 Design for decanter by William Burges, in *Orfèvrerie Domestique*. London, RIBA Collections

Museum in 1864, at the same time that he was designing this decanter, he must have made close notes, or had the ivory head copied in advance, ready to be set into the handle of the decanter.

The jewelled silver strips adorning this decanter, filled with cabochon jewels (not cut or faceted) were in Burges's opinion 'the great key to the decorations of jewellery of the Middle Ages'.[20] But these decanters show an enormous breadth of

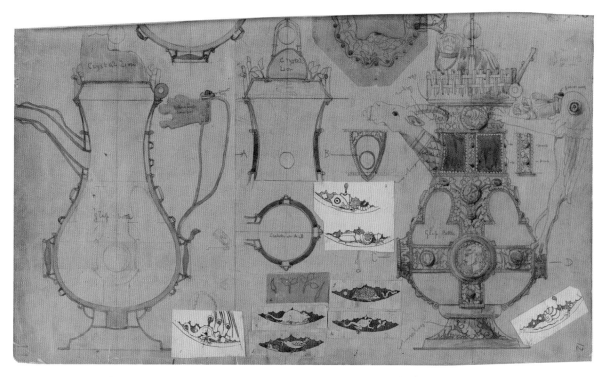

FIG. 5 Coloured design for decanter by William Burges, in *Orfèvrerie Domestique*. London, RIBA Collections

FIG. 6 Photograph of two decanters by Francis Bedford published in *The Designs of William Burges, A.R.A. (c.1885)*. London, National Art Library

inspiration in the materials and motifs used, from not only medieval Europe but also the ancient Assyrian world, as well as Byzantine and Romanesque decoration and influences from as far afield as China and Japan. As J. Mordaunt Crook has argued, Burges mourned the state of jewellery and metalwork made in the earlier part of the nineteenth century, and instead looked to the ancient world and the antique jewellery replicated by firms such as Castellani, to Renaissance jewellery, which was just beginning to be re-examined by designers during the 1850s, and to medieval jewellery, inspiration for which Burges found in manuscript sources in the British Museum.[21]

Designs for Burges's decanter survive in his album of designs and sketches for metalwork, entitled *Orfèvrerie Domestique*, now in the collection of the Royal Institute of British Architects (RIBA).[22] The designs comprise a detailed line sketch depicting all of the elements (*fig. 4*) and a larger coloured sketch which shows the structural and decorative elements (*fig. 5*), including notes such as 'crystal lion' and 'glass bottle', although interestingly the lion's head is described as 'mother of pearl', not ivory. The mother-of-pearl lion's head was eventually used on a second, similar decanter (see below).

This decanter must have greatly pleased Burges. Unlike most of his other metalwork designs, which usually resulted in only a single piece, Burges had three very similar decanters made to this design, all in 1865.

This decanter, and one now in The Higgins Bedford, were intended for his own use.[23] The designs date to 1864, but the three decanters were made the following year. The numerous hallmarks on the silver mounts of this decanter indicate two different silversmiths: Josiah Mendelson and George Angell. Both of the decanters made for his own use were on display in Burges's final home, The Tower House, Kensington, London, which he designed and built from 1875, and lived in from 1878. The Tower House formed the culmination of Burges's long career in neo-Gothic design and he continued to design the interior and unique pieces of furniture for it until his death in 1881. Filled with thousands of painted architectural details and fittings, and a multitude of painted furniture, some of which had been decorated by Rossetti and Burne-Jones, the house remains intact and in private hands, while key pieces of furniture can now be found in various institutions, having been given away and sold at various auctions.[24]

Mrs Mary Haweis (1848–1898), an art critic for various ladies' magazines and wife of one of Burges's clients, the Rev. H.R. Haweis, wrote a gushing and detailed account of The Tower House for the magazine *The Queen* (1880–1881), which was reprinted as *Beautiful Houses* (1882). In it, she gives a vivid picture of this home as one

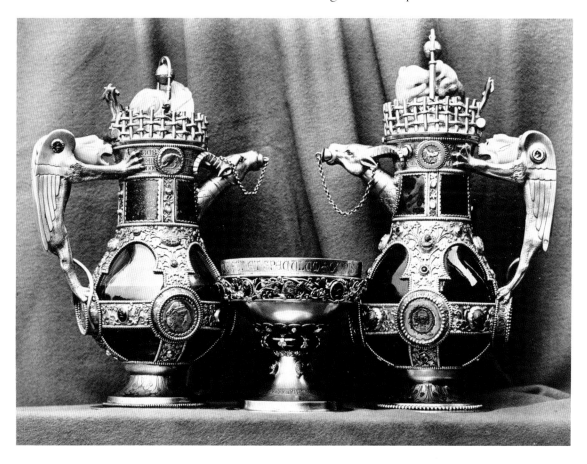

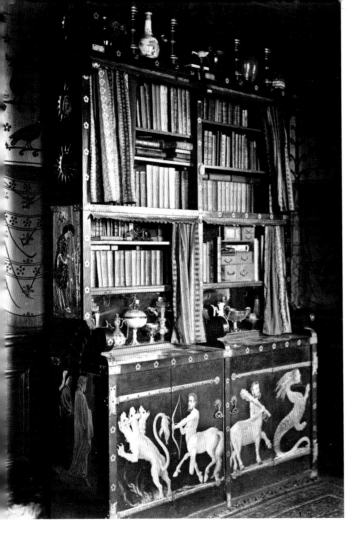

FIG. 7 Burges's painted library book case in a photograph from *The House of William Burges, A.R.A.* (1886). London, National Art Library

Both decanters can be seen on Burges's painted library book case (*fig. 7*) in a photograph in *The House of William Burges, A.R.A.* (1886), published by Richard Popplewell Pullan. Pullan (1825–1888), Burges's brother-in-law, was an architect and archaeologist. He had moved into The Tower House after Burges's death. Pullan also published *The Designs of William Burges*, in which he included a photograph by Francis Bedford of these two decanters (*fig.* 6) along with one of three jewelled goblets designed by Burges,[27] eulogising 'It is impossible to praise too highly these splendid vessels which are triumphs in the way of mediaeval design.'[28]

The decanter in the Fitzwilliam Museum holds another great distinction, having formerly been part of the collection of respected connoisseurs of nineteenth-century art Charles and Lavinia Handley-Read. Charles Handley-Read (1916–1971) trained as an architect at St Catharine's College, Cambridge, before working as a school-master at Bryanston, his former school. His initial passion lay with modernism, including the work of Wyndham Lewis, whose monograph he completed in 1951. However, after visiting the seminal exhibition *Victorian and Edwardian Decorative Arts*, held at the Victoria and Albert Museum in 1952, Handley-Read turned his attention to the designers of the late nineteenth century, and to William Burges in particular. His marriage to Victorian sculpture

of 'brightness, joyousness and strength', a veritable 'Aladdin's palace',[25] filled not only with furniture but with 'cups of jade, knife-handles, goblets of silver and rock crystal set with gems … precious drinking vessels which those who have had the privilege of dining with Mr Burges know the pleasure (and pain) of handling',[26] referencing Burges's penchant for using the fantastic creations that he had designed for himself.

expert Lavinia Stainton the following year also encouraged his new interest in a period of design that was then incredibly unpopular, associated with stuffiness, over-ornamentation and a lack of 'good' design. This lack of popularity meant that fine works of art were available at relatively low prices, allowing the Handley-Reads to form an astonishingly large and varied collection of decorative arts dating from the mid- to late nineteenth century. The Handley-Reads purchased this decanter and that now in The Higgins Bedford, from dealer Richard Dennis. Dennis had purchased them at an auction held by Phillips, Son & Neale in November 1968, paying £1,800 for the pair.[29] He gives an illuminating account of both the art world of the time, and Charles's enthusiasm for more 'academic' decorative arts of this sort:

> Ben Nyman and Duncan Smith [dealers of a different generation] were the underbidders. They were the old school of dealers, not very interested in research but very keen on anything that glittered or looked expensive. We were of the next generation, challenging their position. You needed courage – they ruled the rooms, as leaders of the 'ring'. It was a good price for the time but not special, still I was a bit nervous and arriving back at the shop I was pleased when CHR [Charles Handley-Read] dropped in on his daily preamble. His eyes were on stalks as he tried to be nonchalant – I was in fact relieved as he bought them, having no other obvious customer.[30]

As the collection grew, Charles also began to work on a large publication on the life and work of Burges, but over time he struggled to complete the gargantuan task and lost confidence in his abilities. As he was described in one of his many obituaries:

> Towards the end of his life a growing delusion of self-doubt caused by over-work destroyed his confidence in his own academic abilities and made him unwillingly regard himself as an aesthete rather than a scholar; yet what was immediately apparent to those who knew him was the subtle balance of both elements.[31]

In recognition of the importance of the Handley-Read collection and the effect that Charles and Lavinia's careful connoisseurship had wrought on the rehabilitation of this previously written-off period of design, a large exhibition of the collection was planned, to be held at the Royal Academy in 1972. However, just a few months before the display was due to open, events were tragically overshadowed by Charles's unexpected suicide on 15 October 1971, followed closely by Lavinia's on 9 December. The exhibition, although subdued, went ahead as planned, and included this decanter (Royal Academy cat. no. B88). The collection was subsequently broken up and gifted or sold to various private individuals and institutions, with over 200 pieces making their way to The Higgins Bedford. The Fitzwilliam purchased 14 pieces from the Handley-Read estate, including this decanter.

GIULIANO *c. 1860–1914*

Founded by Carlo Giuliano, this successful family firm was praised for the spirited and various nature of its historicist jewellery, but also for its enamelling, which was widely judged to be the best in late-nineteenth-century Britain.

Carlo Giuliano (1826–1895) was born in Naples and had worked in Castellani's Rome workshop, before travelling to England, probably with Alessandro Castellani (*see* pp. 11–13) in around 1860, to assist him in setting up a manufactory at 13 Frith Street, Soho, London. For seventeen years he created pieces for the West End trade and for other retailing jewellers, including C.F. Hancock of Bond Street, Hunt & Roskell (*see* pp. 50–52) and Phillips (*see* pp. 36–43), before eventually opening his own retail premises at 115 Piccadilly, where he was listed as art jeweller, goldsmith, silversmith and diamond merchant. He was joined by another Italian jeweller, Pasquale Novissimo (1844–1914). Giuliano died in 1895, and in his will he kindly bequeathed to all his devoted retail customers a small gift from his stock of a value up to £50, and also over £200-worth of pieces to the then South Kensington Museum (now the Victoria and Albert Museum). Seventeen pieces, some of which were made by Novissimo, made their way to the V&A and were displayed in a case by the tea rooms, until it was smashed and the jewellery stolen, in 1899. His sons Carlo Joseph (born *c.* 1860) and Arthur Alphonse (*c.* 1864–1914), who had taken over the business, gave the Museum seven more items in 1900, presumably to make up for those lost. The pair traded under the name of Carlo & Arthur Giuliano and remained in the Piccadilly premises until 1912, when the business moved to 48 Knightsbridge, before finally closing for good in 1914 after the death of chief designer Novissimo and the tragic suicide of Arthur.

After Castellani, Carlo Giuliano, alongside John Brogden (*see* pp. 44–9) and Robert Phillips (*see* pp. 36–43) was thought to be the best at creating archaeologically inspired jewellery, although he rarely copied it exactly as Castellani did, instead taking inspiration from it and replicating the technique, as described by commentator Mrs Haweis:

> [M]odern technical work actually excels the old, as I convinced myself one day at Mr Giuliano's, in a necklace of his own design and workmanship, worthy, for its beauty, of a place in a museum of art. The grain work (each grain being made in gold, and laid on separately, not imitated by frosting) was finer than any I ever saw.[32]

The 'grain work' or granulation that she refers to was a Castellani speciality, and

Giuliano may have learnt how to produce this exceptionally fine work when he trained in their Rome workshop. What separated Giuliano from his competitors, however, was his interest in creating pieces that echoed the fine, intricate and heavily enamelled jewellery that had been produced throughout the Renaissance period. This emphasis on coloured enamel, which appears only rarely and in small amounts in classical jewellery, gave the work created by the Giuliano workshop a distinctive quality. For example, when the artist Charles Ricketts turned to designing jewellery, he could have approached any jeweller in London, but entrusted the workshop of Carlo and Arthur with the creation of his fantastical and delicate jewels (*see* pp. 99–115).

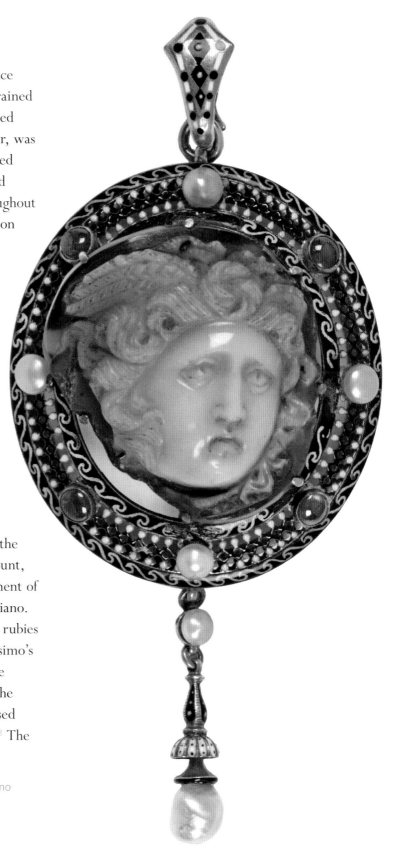

This large pendant (*cat. no.* 4) combines a genuinely ancient Roman cameo depicting Medusa, dating from the second century AD, with an ornate mount, made some time between the employment of Novissimo and the death of Carlo Giuliano. The ornate enamelled mount, set with rubies and pearls, is typical of many of Novissimo's designs, which in turn are based on the black-and-white enamelled designs in the French neo-Renaissance style popularised by the French firm Froment-Meurice.[33] The

CAT. NO. 4 Enamelled gold and cameo pendant (*enlarged*), probably made by Pasquale Novissimo for Carlo Giuliano, c.1874–95

black-and-white pattern is similar to that found in a design by Novissimo, now in the Victoria and Albert Museum, although that design is set with a large cabochon instead of a cameo.[34] There is a possibility that this mount may have originally held a similar cabochon. The quality of the soldering on the seven gold claws that hold this cameo in place is not as fine as the rest of the piece, and this cameo may have been added later, replacing an earlier cabochon or cameo perhaps due to a breakage, or to suit the taste of a new owner. This black-and-white enamelling, coupled with rubies, can also be seen in one of the firm's most high-profile commissions, a pendant incorporating a medallion of Queen Victoria, commissioned by the Queen as a wedding gift for one of her god-daughters, Victoria Alexandrina Elizabeth Grey (d. 1922).[35]

The two silver bracelets (cat. nos 5 & 6), one with floral decoration and one with lions' heads, are inspired by a type produced by many jewellers working in the historicist style, including Castellani and Giacinto Melillo in Naples. Usually made in gold and formed of square plaques (not rectangular as seen here), these bracelets were based on three ancient Etruscan examples in the Campana collection (see p. 11). However, those three 'bracelets' were actually formed

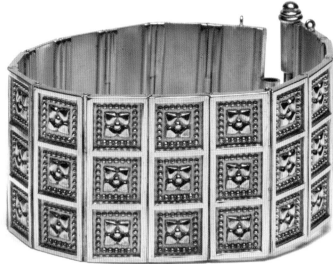

from flattened earrings, the front and back of each one showing alternately. Whether intentionally or not, Castellani perpetuated this invented form.[36] Although the design became more fluid over time, the structure of these bracelets certainly harks back to those produced slightly earlier by Castellani.

CAT. NO. 5 Silver bracelet, made by Carlo Giuliano, c. 1874–95

CAT. NO. 6 Silver bracelet, made by Carlo Giuliano, c. 1863–95

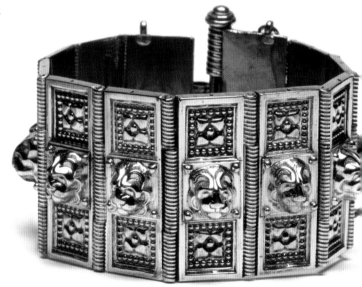

Carlo and his two sons were not the only members of the Giuliano family working in London. Although less is known about this side of the family, Carlo Snr's brother Federico came to London some time later and worked for him before setting up his own business, registering a mark at Goldsmiths' Hall on 24 February 1876 from 4 South Crescent, Store Street. In 1883 this business moved to 24 Howland Street, at which time it became a partnership between Federico and another relative, Ferdinand (sometimes Ferdinando) Giuliano. By 1903 the business had shut down and Federico returned to Naples, where he died in 1913. After the dissolution of the company, Ferdinand sold his jewellery through Beatrice Cameron's retail premises in Mount Street, as can be seen from the interior of the case of cat. no. 8.

Federico and Ferdinand Giuliano's work is rarely signed or marked, although this gold and pearl acorn brooch (*cat. no. 7*) is marked 'F.G' and is close in style to other pieces by them. This brooch is a good example of a piece of jewellery designed around a single element, in this case a pearl shaped like an acorn. The enamelled and gem-set caduceus brooch (*cat. no.* 8) is unmarked, but retains its original case, stating that it was retailed through Beatrice Cameron. The caduceus (in mythology, the symbol of Hermes, two snakes wound around a winged staff) seems to have been especially popular among the Giuliano family. A plain gold and chased version is in the British Museum,[37] and a gold and enamelled caduceus brooch topped with a pearl, by Carlo Jnr and Arthur Alphonse, is in the Victoria and Albert Museum.[38]

CAT. NO. 7 (*right*) Gold and pearl acorn brooch, attributed to Federico Giuliano, c.1876-1903

CAT. NO. 8 (*above*) Enamelled gold caduceus brooch, made by Ferdinand Giuliano, c.1903-10

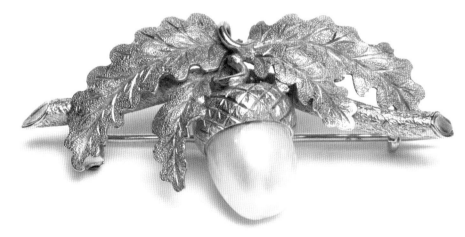

CHRISTOPHER DRESSER *1834–1904*

Talented and versatile, Dresser designed with mass production in mind, believing that beautiful, functional objects should be within reach of most people. His trips to Japan inspired a subsequent clean-cut, linear style that he applied to a range of media, creating objects that proved to be some of the most radical and influential of the final decades of the nineteenth century.

Dresser was born in Glasgow, but moved with his family to Sussex at the age of 13, and subsequently studied at the Government School of Design (now the Royal College of Art), at Somerset House, London, from 1847 to 1854. Here he was influenced by Henry Cole, the first director of the South Kensington Museum (now the V&A), and the designer Owen Jones (*see* p. 39). In 1854 he married Thirza Perry and together they had 13 children. The need to support his ever-expanding family may at least partly account for Dresser's wide-ranging and hectic career.

Dresser designed a multitude of different objects for numerous manufacturers, including wallpaper, textiles, ceramics and metalwork, which was particularly admired. His design theory was based on 'the belief that natural forms should be abstracted and made geometric for use in ornamentation'.[39] This was articulated in various papers and lectures he gave, including 'On the Relation of Science to Ornamental Art' (1857) and 'The Rudiments of Botany' and 'Unity and Variety' (both 1859), which contributed towards him being awarded a doctorate by

Jena University in 1860. He was appointed the Chair of Botany applied to the Fine Arts at the Department of Science and Art, South Kensington (1860), and the Chair of Ornamental Art and Botany at the Crystal Palace (1862).

However, Dresser spent less and less time on natural sciences, spending more time instead designing. In 1862 he published *The Art of Decorative Design*, which encouraged readers to create their own designs. However, in hindsight, one of Dresser's most significant contributions to the applied arts was his first visit to Japan in 1876–77 and the subsequent publication of *Japan: Its Architecture, Art, and Art Manufactures* (1882). Japan had been closed to most foreign visitors between the mid-seventeenth century and the late 1850s, when it gradually began to open its borders. Dresser's travels to Japan inspired his book and a number of other designs that he produced during the 1880s. These proved incredibly popular among fashionable aesthetic circles. Dresser died suddenly in Germany whilst on a business trip, in 1904. His work went largely

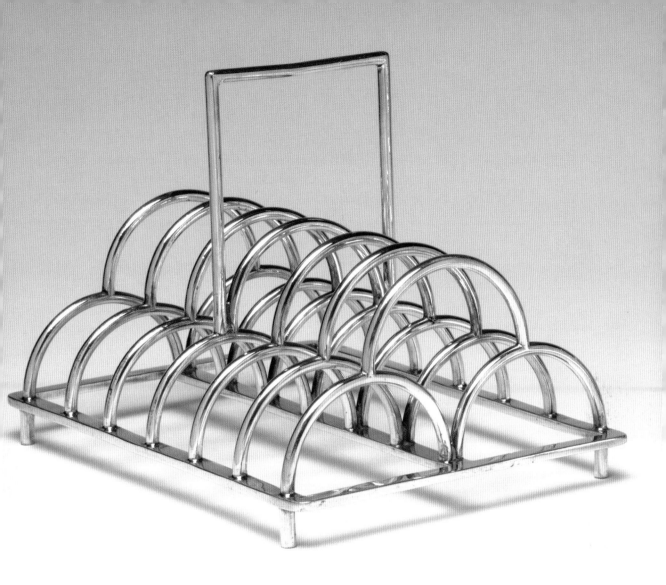

CAT. NO. 9 Electroplated nickel silver toast rack, designed by Christopher Dresser, made by James Dixon & Sons, c.1880

unnoticed for 30 years, until it was 're-discovered' by the art and architecture critic Sir Nikolaus Pevsner in 1936.

In some respects it is not surprising that Dresser's work was rediscovered in the 1930s. His sleek and geometric metalwork anticipates modernism and looks as though it could have been designed in the years after the First World War, not 40 years previously. Although Dresser's personal motto, 'truth, beauty, power', seems to sum up ideas shared by William Morris and later members of the Arts and Crafts movement, Dresser felt very differently about the nature of craftsmanship and believed that in order for good design to be egalitarian, and reach as many people as possible, it was necessary

to work with industrial manufacturers and use machines, as well as modern materials such as cast iron and linoleum. He was also a firm believer in crediting design, opposing the 'anonymity' favoured by some Arts and Crafts craftspeople, and his facsimile signature can be found on many of the objects he designed.

Dresser has often been called the first independent industrial designer because of his emphasis on designing functional but beautiful objects in a range of media with mass production in mind, and because of the nature of his relationship with the tens of manufacturers with whom he worked. His wholly original designs for metalwork, most of which date from after his first trip to Japan, combine a stark and attractive functionality for users that could also be more easily made by manufacturers with an emphasis on form and silhouette rather than surface decoration.

Dresser designed metalwork for numerous firms, including Benham & Fround (from 1873), Elkington & Co. (from 1875), Hukin & Heath (from 1878), James Dixon & Sons (from 1879) and Richard Perry, Son & Co. (from 1883). James Dixon & Sons were long-established manufacturing silversmiths, platers and metal workers, based in Sheffield. They supplied silver to Elkington & Co. and to Tiffany in New York, among others, and had a London showroom. Exhibiting at most of the international trade fairs of the mid-nineteenth century, they were especially well regarded as makers of Sheffield plate (a 'sandwich' of silver and copper, used widely from 1820 to make household goods) and, after having purchased a licence from originators Elkington & Co. in 1848, electroplated wares (a process of coating base metals with more expensive metals, usually silver, using electricity). Dresser sold 37 designs to the firm between 1879 and 1882, not all of which were put into production.[40] The firm registered the designs it did use between 1880 and 1885.[41] This toast rack (*cat. no. 9*), model no. 67, dates from *c.* 1880 and is stamped with Dresser's facsimile signature (*below*).

The letter rack (*cat. no. 10*), unusually in sterling silver (not plated), was made by Hukin & Heath. Founded by Jonathan Wilson Hukin and John Thomas Heath in Birmingham in 1855, the firm was best known for its novelty products and seems to have been the first to employ Dresser on his return from Japan in 1877, where he had been hugely influenced by the efficacy and beauty of the clean-cut lines of much Japanese design. The firm registered designs by Dresser from 1878 until at least 1881,[42] and an exhibition of his radical new designs

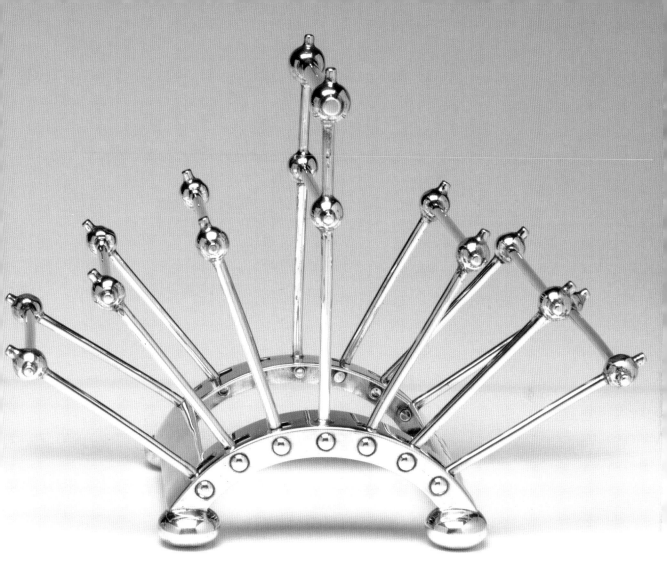

was held in August 1879 at the firm's new London premises at 19 Charterhouse Street, to great acclaim, with particular emphasis being placed on Dresser's involvement and good taste. A writer for the *Art Journal* commented that art works had been produced at no higher cost than usual, but exhibited 'grace combined with the useful – simplicity and purity of form with readiness of application to the purposes to which they are to be applied'.[43]

Hukin retired in 1881 and was replaced by John Hartshorne Middleton. This letter rack, made in 1892–93, dates from this period and shows that like many other companies Hukin & Heath kept producing Dresser's designs long after his association with them was at an end, which may explain why his facsimile signature does not appear on this piece. This rack is articulated (the struts

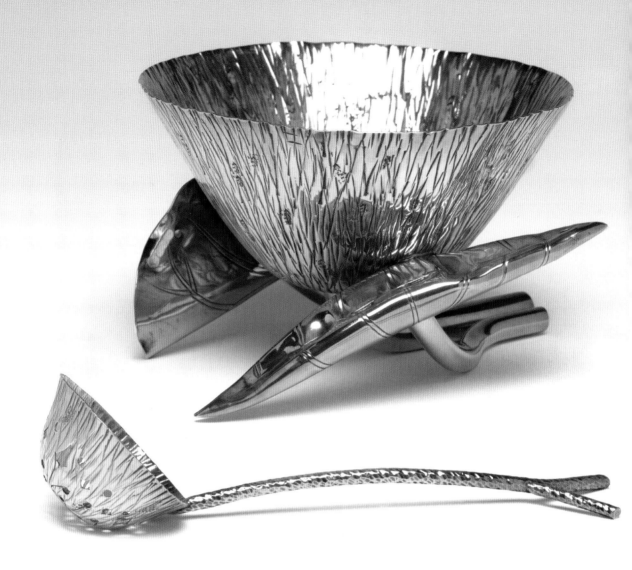

move) and is one of at least three slightly
differing versions. This version, with an open
base, is model no. 2655, whereas the fixed
version is model no. 2556. Another version is
of a slightly different shape and could act as a
book end and letter rack.[44]

The unusual sugar bowl and sifter spoon
(*cat. no.* 11) was also made by Hukin & Heath,
in 1884–85, when the company was still
working with Dresser. Although the design

was not registered as Dresser's and therefore
can only be attributed to him, his Japanese-
inspired influence is clear in the attention to
detail paid to the unfurling lotus leaf, which
cleverly acts as a support for the bowl, and
the tiny hollow tubular cross-sections visible
in the cut stalk.

ERNESTO RINZI *1836–1909*

An Italian jeweller brought to London by Alessandro Castellani, Rinzi worked on a smaller scale than other manufacturers of historicist jewellery, and made many fine pieces in the Renaissance Revival style. He was especially skilled at enamelling and later in his career painted many enamel portrait miniatures.

Rinzi originated from Milan, and was probably encouraged to travel to London by the well-known jeweller Alessandro Castellani (*see* pp. 11–13). He appears to have worked first from 25 Osnaburgh Street, before moving to 32 Argyll Street in 1862, where he remained until 1883. His naturalisation papers held at the National Archives, Kew, dated 15 February 1867,[45] reveal that he came to Britain eight years earlier, in 1859. By 1867 he was married with one child and working as a jeweller, presumably under his own name, from 32 Argyll Street, London, and wanted to remain permanently in Britain. The four men who testified to him being a 'person of respectability and loyalty' are William Lambeth, of the same address as Rinzi; Mark Brown, a dairyman residing at 28 Great Marlborough Street; and two men working from 65 Poland Street, Richard Quin, a 'jewel-case maker' and George Woodall, an engraver.

This nugget of information provides an insight into the working practices of smaller 'manufacturing' jewellers working at this time, who relied on an intricate network of assistants and tradesmen to assist them in the production of jewels, which they then sold through upmarket shops in the West End. These three addresses are all nearby, part of the warren of streets that made up Soho, home to thousands of tradesmen, including many jewellers, who worked sandwiched between the City and the increasingly wealthy West End. William Lambeth may have been Rinzi's assistant and Woodall may have provided the engraving expertise that Rinzi and Lambeth lacked. Or perhaps Rinzi knew Woodall well because he shared an address with Richard Quin, of Quin & Romer, case makers, who may have supplied Rinzi with his leather cases.

Rinzi worked in a similar style to Robert Phillips (see the following entry), and with his prior connections to the Castellani family was very much part of that circle. Many of his pieces are in the Renaissance Revival style and are intricately enamelled – a technique at which he was especially successful. His work included pendants and necklaces, but also caskets. One of these, now in Royal Museums Greenwich, was made in 1875 to contain the freedom scroll of the City of London. Rinzi was

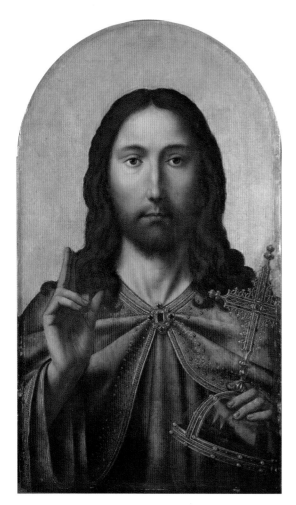

FIG. 8 Christ from *Diptych: Christ and the Virgin,* workshop of Quinten Massys, c.1510–25. London, National Gallery

commissioned to make the casket for Sir George Biddell Airy, Astronomer Royal, which explains the appropriate enamelled plaques, depicting the universe, with models of globes and telescopes.[46] Rinzi later used his enamelling expertise to paint portrait miniatures, and became a member of the Society of Miniatures, exhibiting at the Royal Academy, working from 1886 to 1899 from 107 High Holborn (1886–90) and from The Hollies, 426 Fulham Road (1890–99). Two enamel portraits by him of Queen

Victoria, both dated 1897, are now in the Royal Collection.[47]

More may in the future be discovered about Rinzi's later life if his diary, dating from between 1898 and 1903, can be decoded. Currently in the Rare Book & Manuscript Library at the University of Illinois at Urbana-Champaign, this beautifully illustrated journal was written by Rinzi in code, and is yet to give up its secrets.[48]

This cross (*cat. no.* 12) is similar to many others made throughout the 1860s and 1870s, based on a detail of a cross in a diptych of Christ and the Virgin, which entered the collection of the National Gallery, London, in 1857. Painted in *c.* 1510–25 in the workshop of Quinten Massys, then the leading painter in Antwerp, this ornate cross (*fig.* 8) surmounts a rock crystal orb, and provided the perfect inspiration for jewellers seeking to create neo-Renaissance works. John Brogden made more than one version of this cross, exhibiting one in the Paris Exposition Universelle of 1878, and so did Robert Phillips, as spied by Mrs Haweis when she visited his shop, writing 'I there observed an elegant cross copied from a picture by Quentin Matsys [*sic*] in the National Gallery.'[49] A very similar, though unmarked, cross is in the Hull Grundy collection at the British Museum, attributed to Brogden or Phillips.[50]

CAT. NO. 12 Gold pendant cross (*enlarged*), made by Ernesto Rinzi, c.1860–65

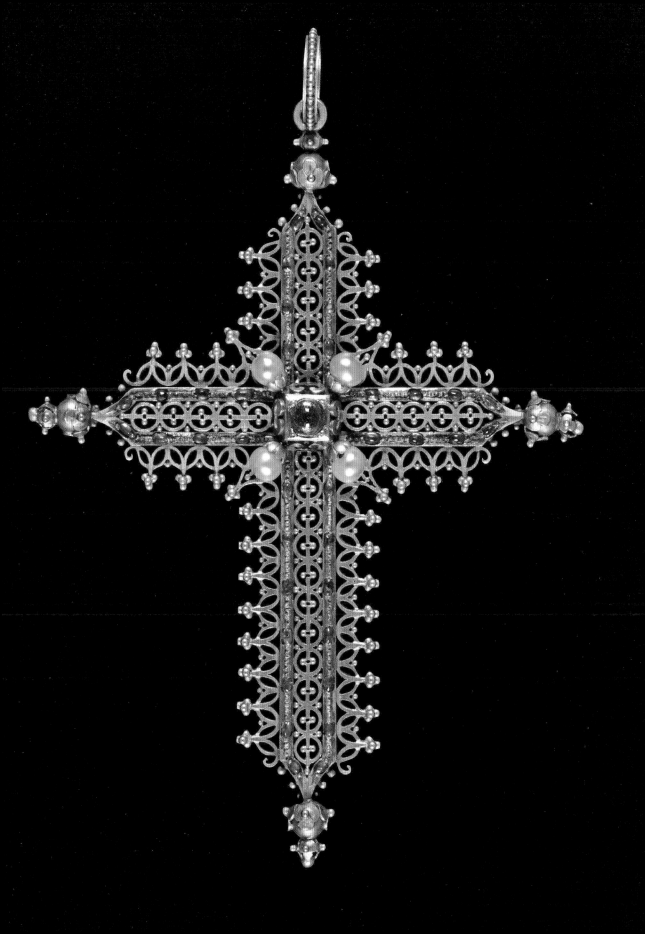

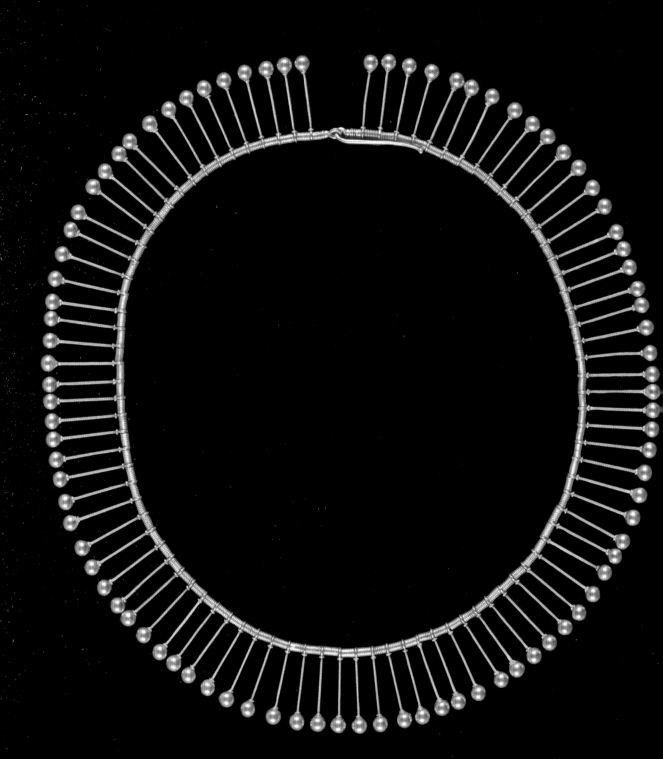

PHILLIPS BROTHERS *c. 1839–69*
PHILLIPS BROTHERS & SON *1869–1902*

The firm of Phillips Brothers was in business almost exactly concurrently with Queen Victoria's reign, and was one of the most productive and successful London jewellers of the nineteenth century, specialising in Italian archaeological jewellery, as well as pieces inspired by jewellery of India and Scandinavia.

Established before 1839 by Robert Adam Phillips and his brother Magnus, the company traded from 31 Cockspur Street, London, although by 1851 Robert Phillips seems to have been solely in charge, entering his first mark at Goldsmiths' Hall in June 1851, and his second in 1853. The firm moved to 23 Cockspur Street in 1855, and changed its name to Phillips Brothers & Son in 1869. Three years after the death of Robert Phillips in 1881, his two sons Alfred and Claude inherited the business, although Claude took no part in it, instead training as a lawyer. After becoming an art scholar, Claude became the first Keeper of the Wallace Collection. He was knighted in 1911. His trajectory shows the rise in status of wealthy professional manufacturing and jeweller families. Two years after the death of Alfred Philips in 1900, the firm ceased trading and the remaining stock was sold to jewellers D. & J. Welby Ltd of 18 and 20 Garrick Street.

Robert Phillips was an acquaintance of other leading revivalist jewellers working in London, Fortunato Pio Castellani (pp. 11–13) and Carlo Giuliano (pp. 24–7), whose earlier work he retailed, and with whom he occasionally collaborated. He was the only English jeweller to be awarded a gold medal at the Paris Exposition Universelle in 1867, for his range of jewels inspired by archaeological finds, set with coral imported from Southern Italy. Three years later he was rewarded by the King of Naples and received a decoration for service to the coral trade in light of his role in popularising coral jewellery in England. By the early 1860s Phillips held the royal warrant as jewellers to Albert Edward, Prince of Wales, later Edward VII (1841–1910), and indeed received many commissions from the royal family. In 1878 he was invited to join the jury of the Paris Exposition Universelle.

Phillips was known not only for quality, but also for variety. The chronicler of fashion Mrs Haweis recalls a visit to Phillips in Cockspur Street in her book *The Art of Beauty* (1878), and gives a vivid impression of the range and variety of jewellery on offer, pressed up alongside one another in the showroom:

CAT. NO. 13 Gold fringed necklace, made by Phillips Brothers, c.1855–69

Under the direction of Messrs Phillips, the most perfect models are sought for the ornaments they furnish. Museums and picture galleries are ransacked for devices of necklaces, earrings and pendants. I there observed an elegant cross copied from a picture by Quentin Matsys in the National Gallery [*see cat. no. 12*]; a bracelet of enamel and gold whose delicate traceries with Tudor roses and fleur-de-lis, are adapted from a fine frieze beneath the tomb of Henry VII in Westminster Abbey, bonbon boxes of Louis XVI shapes, grafted on an Indian pattern in which much of the Indian feeling for colour is retained … I saw facsimiles of exquisite Etruscan and Greek collars in gold, every detail being carefully studied, and reproduced after the manner of the ancients.[51]

Although she describes Phillips as aiming less 'at originating than Mr Giuliano' (*see* pp. 24–7) she deems that 'real artistic feeling is carried into the work'.[52] His praises had been sung even more highly by G.A. Sala in 1868, who declared:

> In the production of Etruscan jewellery I have already said that he [Phillips] ranks with Castellani … Mr Phillips' specimens of 'classic' jewellery might have been newly exhumed from the sepulchral jewel box of an Etruscan prince; and in addition to his sumptuous imitations of ancient Italian jewellery, he may be congratulated on the production of some very curious and beautiful examples copied from the goldsmiths' work of ancient Scandinavians.[53]

CAT. NO. 14 Gold and glass necklace and brooch, made by Phillips Brothers, c.1855–69

Phillips was wide-ranging in his sources of inspiration, looking further afield than many jewellers at the time, and also looking back to the 'Holbeinesque' jewels shown in paintings of Queen Elizabeth I. He traded in cameos and worked in the Egyptian and Assyrian styles, heavily influenced by the objects discovered by Sir Henry Layard during his excavations at Nimrud, an ancient Assyrian city of Upper Mesopotamia (near modern-day Mosul, Iraq). Occasionally, genuine antique engraved gems were mounted in modern pieces, designed to look historic. The most famous example of this is the striking parure (or set, comprising necklace, earrings and bracelet) made for Sir Henry Layard's bride, Enid Guest, which comprises ancient Assyrian and Babylonian cylinder and stamp seals, said to have been found by Layard at Nimrud.[54]

Phillips was also one of the first to popularise Indian jewellery. Although there had been some trade with India and interest in its art prior to 1851, the magnificent display of Indian craftsmanship at the Great Exhibition spurred on interest in this exotic 'Oriental' style of ornament. Queen Victoria became Empress of India in 1876, and the 1886 Colonial and Indian Exhibition, visited by over 5.5 million people, maintained this heightened level of curiosity. The publication of Owen Jones's masterpiece *Grammar of Ornament* (1856), which explored and replicated designs from 19 diverse geographical areas, including India, also encouraged and

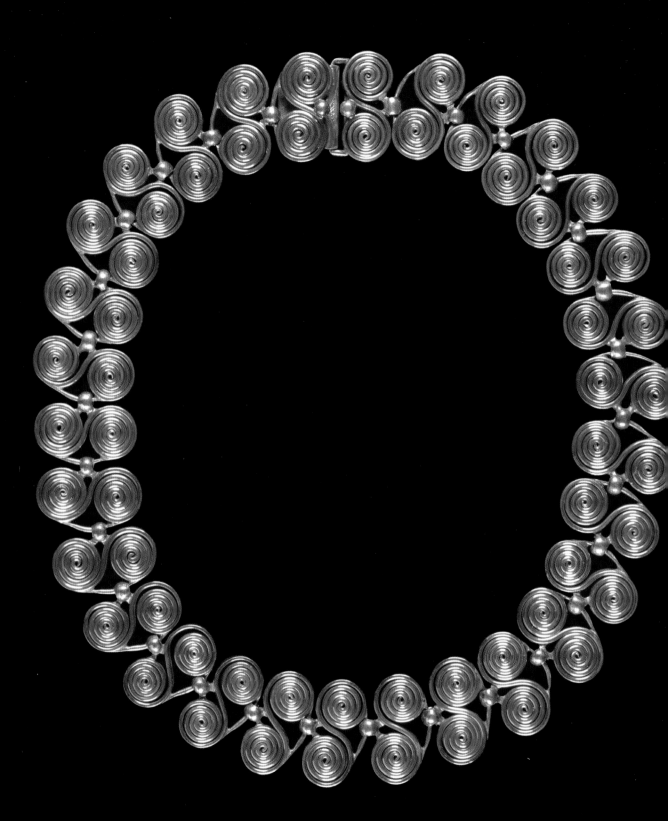

aided jewellers and other craftspeople in their designs. Phillips imported some elements from India and mounted them into specially made settings, which suited Western styles of dress and fashions. The most commonly imported elements were small plaques of Indian glass and gold work, known as *theva* work, first made predominantly in the region of Pratapgarh, Rajasthan (formerly known as Partabgarh), before spreading to Indore and Rutlam in Madhya Pradesh. This art involves embossing very thin sheets of gold leaf on a piece of molten glass. George Watt, writing in the catalogue of the 1902–03 Delhi exhibition, describes it as 'quasi-enamelling'. He writes that after taking a piece of red or green glass,

> a frame or silver wire, of the exact size and shape of the glass is next made, and across this is attached a sheet of fairly thick gold leaf. This is then embedded on lac and the pattern punched out and chased on the gold. The glass is then semi-fused, and whilst still hot the rim of silver and film of gold are slipped over the edge and pressed onto the surface of the glass. The article is again heated, until a sort of fusion takes place and the gold and glass become securely united.[55]

This gold necklace and corresponding brooch (*cat. no.* 14) demonstrate exactly this, and may be similar to the 'plaques, slabs for bracelets; gold, inlaid in glass. Indore work' that Phillips sent to the 1872 International Exhibition in London.[56] In the case of this necklace, the clasp is in the more traditional octagonal shape, often seen in Indian jewellery, whilst the four pendants and brooch are in the European form of a shamrock. This shows the extent to which pieces were made by Indian craftspeople specifically for export, to appeal to the European market. Alternatively, perhaps this piece was a commission from an Irish governor or official working in India to take back for his family, the shamrock combined with the green making a particularly Hibernian combination.[57]

CAT. NO.15 (*left*) Silver necklace made by Phillips Brothers & Son, c.1870

FIG. 9 (*above*) Silver wire double-spiral brooch by Castellani. Rome, Museo Nazionale Etrusco di Villa Giulia

FIG. 10 (*right*) Iron Age double-spiral brooch in bronze wire. Italian, 10th–9th century BC. Rome, Museo Nazionale Etrusco di Villa Giulia

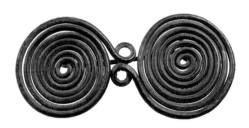

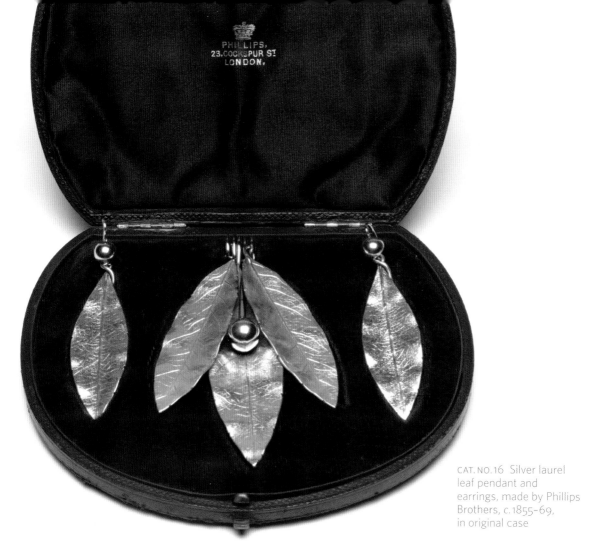

PHILLIPS,
23, COCKSPUR ST
LONDON.

CAT. NO. 16 Silver laurel
leaf pendant and
earrings, made by Phillips
Brothers, c. 1855–69,
in original case

The relationships between the band of revivalist jewellers working in London at this time are striking, as similar motifs can be seen to flow through all of their work, usually, but not always, starting with Castellani. This necklace made of silver spirals (*cat. no.* 15) is based closely on a design of silver wirework created by Castellani (*fig.* 9). This in turn is a more wearable version of a bronze spiral ornament, dating from the ninth century BC (*fig.* 10), which the Castellani family in Rome included in the first and earliest room of their eight-room display, detailing the history of civilisation in Italy through jewellery. Phillips may have been inspired by other similar spiral ornaments from Scandinavia or Central Europe, but it is most likely that he saw Castellani's silver versions. The necklace is not cast, but each pair of spirals has been worked by hand and is therefore slightly irregular. The linear design, lack of ornament and simplicity of the material do not seem out of place to a modern viewer, and indeed are reminiscent of much mid-twentieth-century jewellery, but to a viewer

42 DESIGNERS & JEWELLERY

in 1870 would have seemed unusually stark and exotic.[58] This strikingly linear form is echoed by the gold fringed necklace (*cat. no.* 13), a simplified version of more ancient forms. Each drop has been cast and threaded separately, so that they move independently, each piece moving with the wearer.

The existence and usefulness of original cases has long been overlooked. The Museum was fortunate that many pieces, mainly from the Hull Grundy gift, came in original cases, including three pieces by Phillips Brothers. The company name and address provided in the interior silk of each case can be useful, especially if the jewellery is not marked, in this instance proving that each piece was made after the firm had moved to 23 Cockspur Street (in 1855), but before it changed its name to Phillips Brothers & Son (in 1869). The case containing a beautiful cast silver laurel leaf pendant and pair of earrings in the neoclassical style (*cat. no.* 16) gives a clue to the set's former history; the label on the underside of the case reveals that the set had previously passed through the hands of S.G. Fenton, an antiques and antiquities dealer who operated from 33 Cranbourn Street from *c.* 1880 until the early decades of the twentieth century.

Inscriptions and other details can often be helpful in dating a piece or tracing its history, such as this gold brooch (*cat. no.* 17), covered with the granulation and filigree that Phillips and Castellani tried so hard to replicate

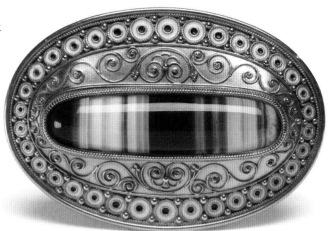

CAT.NO.17 Gold and agate brooch, made by Phillips Brothers, *c.*1865

correctly, and set with a thin, curved slice of banded agate. The inscription on the reverse, 'M.P.K/Christmas, 1865/K.J.K.' provides a rough date, but even without it the soldered 'RP' mark indicates that it was made prior to the formation of Phillips Brothers & Son, in 1869. On inspecting the pin fastening on the reverse, the hook that holds the pin in place appears to have once been a suspension loop, which has been bent backwards. This is not a recent alteration, and was almost certainly done not long after it was first made. Brooches that sat 'horizontally' did become popular during the 1860s. Did this piece originally start life as a pendant, hanging vertically, before it was altered and turned into a brooch? Such changes were not uncommon and give us a glimpse into how jewellery was adapted by maker, retailer or owner to suit current fashions.

WATHERSTON & BROGDEN *1841–64*
JOHN BROGDEN *1864–84*
WATHERSTON & SON *1864–1910/11*

John Brogden, the most successful member of two intertwined jeweller families, was one of the best-known jewellers in London, working in almost every style, greatly aided by the talented and pre-eminent female jewellery designer of the mid-nineteenth century, Charlotte Newman.

Like other jewellers of the mid-nineteenth century, the careers of these two families of jewellers are complicated and intertwined. John Brogden the elder founded a jewellers and goldsmiths in *c.* 1796, before going into partnership with James William Garland forming Brogden & Garland (*c.* 1824–31). The partnership was dissolved in 1831 but Garland remained at the same address, and went into partnership with a former apprentice, James Henderson Watherston (Garland & Watherston, *c.* 1831–41). Brogden, however, was clearly still on good terms with the pair, as he sent his young relative, also called John Brogden (1820–84), to apprentice for seven years with the firm, from 1834. Garland & Watherston dissolved their partnership in 1841, just as Brogden finished his apprenticeship. Watherston moved the business to 16 Henrietta Street, Covent Garden, and went into business with the young John Brogden (officially 1848), where they are recorded as wholesale jewellers.

Watherston retired from the business, leaving John Brogden to continue trading on his own account (as 'John Brogden') until his death in 1884. Meanwhile, James Watherston went into business with his son Edward James, trading as Watherston & Son, at 12 Pall Mall East, until they were forced to relocate in 1902, after their building was purchased compulsorily, in a bid to reduce the risk of fire to the National Gallery next door. They moved to 6 Vigo Street, and operated from there until the business closed in 1910/11.[59]

Watherston & Brogden showed 'gold brooches, bracelets, necklaces, chains, seals and rings' as well as a large enamelled vase at the Great Exhibition of 1851, where they were described as producing 'the finest articles in the jewellery department',[60] as well as showing in exhibitions in Paris in 1855 and London in 1862. This cameo (*cat. no.* 18) carved in horned helmet shell is typical of the cameos that remained popular

CAT. NO.18 Cameo brooch, made by Watherston & Brogden, 1862–64, in original case

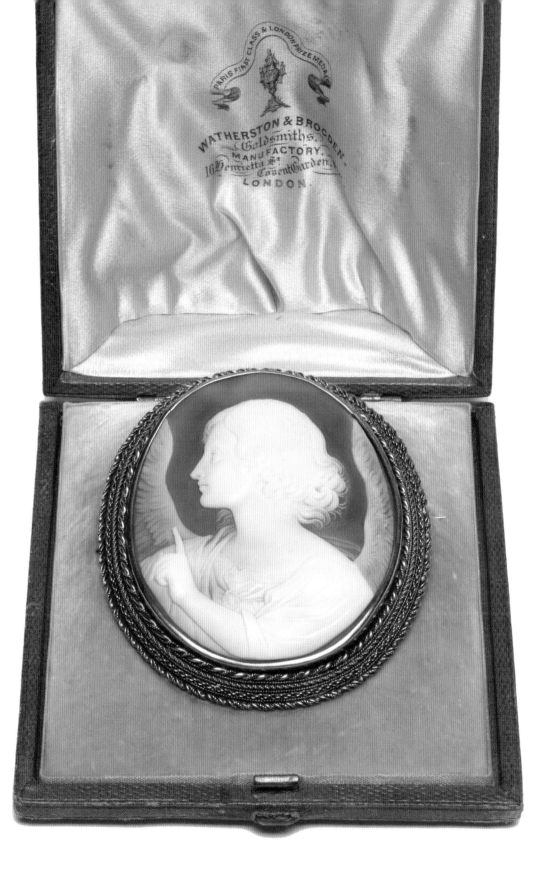

throughout the nineteenth century. The subject, an angel raising her finger, mounted in gold with a rope twist border, is similar to the mount seen around a cameo on a sheet of Brogden cameo designs now in the collection of the Victoria and Albert Museum,[61] which probably date from around 1860, when Brogden was still in business with Watherston. The sketch is annotated, each cameo having been given a number, and two different prices. No. 368 (with a mount most similar to this brooch) is priced at 45 shillings (or £2 5s), written in pencil, and £5 written in ink (*fig. 11*). These may refer to

the cost of production and the recommended retail price, showing the healthy margin of large cameos such as this. The inscription in the case of this cameo allows us to date it precisely from between 1862, when the firm exhibited at Paris, and 1864, when the partnership was dissolved.

It was (and remains) common for jewellers to have their cases made by an external craftsman. However, the nature of this work – creating a case for a prominent jeweller, who requires their own name to be visible inside the case – has meant that these workers have remained partly anonymous. This aspect of the jewellery trade merits much more research, but

FIG. 11 Sheet of cameo and mount designs by John Brogden, c.1860. London, Victoria and Albert Museum

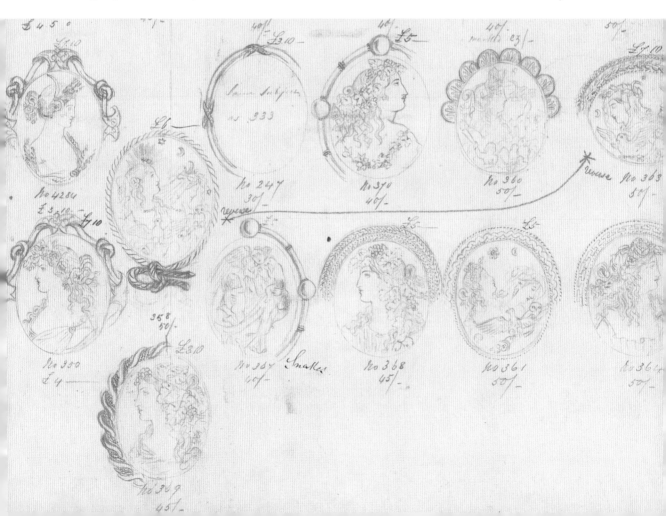

occasionally jewellery historians are helped by the survival of a case maker's mark. These small initials, usually stamped 'blind' (i.e. without colour) on the exterior and underside of the case are easy to miss and difficult to decipher. However, painstaking research carried out by jewellery historian Charlotte Gere has resulted in the matching up of some initials with names of makers, and their addresses. The Watherston & Brogden case containing the cameo is stamped 'MO', a maker who is yet to be identified. However, the case containing the earlier brooch by Watherston & Son (*cat. no.* 20) is stamped 'WB', for William Betteridge. According to Gere's unpublished research, Betteridge was in business with Frederick Harker at 80 Wardour Street, Soho, from 1869 until 1880, making cases and stamping them 'H & B'. This partnership was dissolved, but Betteridge carried on with other partners under his own name, using the mark 'WB', until 1916. This means that this brooch dates from slightly later than previously thought, from at least 1881.[62]

John Brogden's success grew greater still after Watherston's retirement, due mainly to his successful working relationship with Charlotte Isabella Newman. Newman had trained as a jeweller at the government art school at South Kensington before joining Brogden in the mid-1860s. She was undoubtedly the first important female artist-jeweller

CAT.NO.19 Gold brooch, made by John Brogden, *c.*1864-85

of the nineteenth century, pre-empting the success of numerous women artists during the Arts and Crafts period. Her designs were resourceful, varied and numerous; she was able to work successfully in a variety of historic styles, including Assyrian, Etruscan, Egyptian and Renaissance Revival, as well as creating pieces with more typical nineteenth-century motifs, including flowers, stars and knots, very few of them alike. This small brooch (*cat. no.* 19), which imitates granulation by having tiny cuts made in the surface of the wirework, dates from early on in Brogden's career, around the time that he employed Newman. Of the 1,593 Brogden designs held by the V&A, most of them in colour, 74 bear her signature, although, considering that most others are not signed, significantly more can be attributed to her. She helped Brogden win a silver medal at the Paris Exhibition of 1867 and unusually both

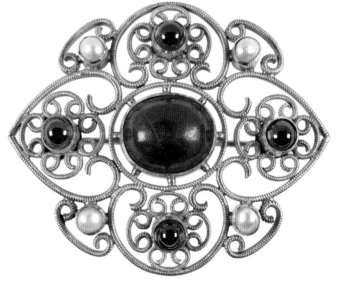

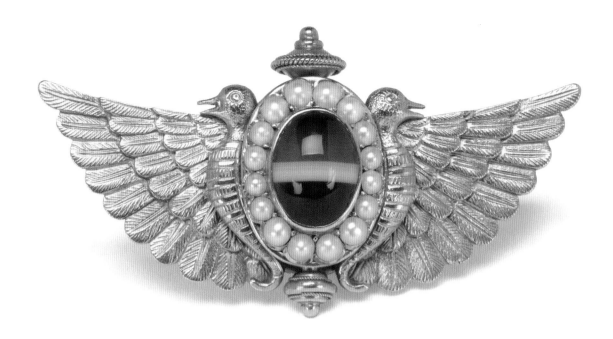

she and Brogden received gold medals in Paris in 1878, where their work was commented upon favourably by Castellani. In 1881 she moved with Brogden to larger premises at 6 Grand Hotel Building, Charing Cross, where goldsmiths could be seen working busily in the basement, from which time Brogden described himself as 'Art Goldsmith'. According to some cases from this date, he was also patronised by Prince Leopold, youngest son of Queen Victoria.

After Brogden's death in 1884, Charlotte Newman set up her own business as 'Mrs Newman. Goldsmith and Court Jeweller' at 10 Savile Row, retaining many of the craftsmen who had worked for Brogden – their respect for Newman clearly overcame any scruples they may have had about being employed and managed by a woman.

Watherston & Son were less well known, but ran a successful business as manufacturing goldsmiths, jewellers and gold chain makers, later branching out to deal in diamonds and pearls and retail silver. They also exhibited in the Paris Exhibition of 1867. A catalogue produced by the company in 1907, entitled *The Place of Jewellery in Art*, shows that the firm held the royal warrant to Edward VII, as well as the royal warrant to the German emperor, Wilhelm II.[63] The catalogue displays a breadth of jewellery, some still in the archaeological style, illustrating, for example, casts of jewellery found at Pompeii, alongside Watherston's replicas, as well as this brooch (*cat. no.* 21), described as an 'old Egyptian design' and priced at £5 15s (*fig.* 12).

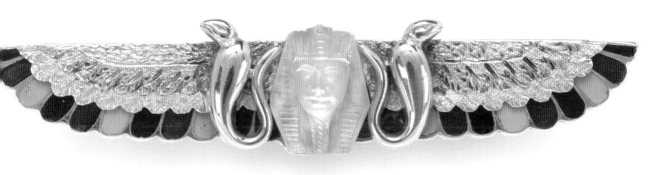

CAT. NO. 20 Gold and agate brooch, made by
Watherston & Son, after 1881–98

CAT. NO. 21 Enamelled gold brooch, made by
Watherston & Son, c. 1906

Another vaguely Egyptian-style brooch,
this time incorporating a banded agate, was
made by the firm a decade or two earlier
(*cat. no.* 20). The catalogue also includes some
jewels in the neo-Renaissance style as well
as more delicate, contemporary designs,
incorporating numerous gemstones. The
firm clearly states its purpose, however,
repeatedly explaining 'how the old world
designs govern the new and are reproduced
today in a modified form', insisting that they

can prove that 'the wearers of jewellery
today are instinctively returning to the old
Greek models, and not merely gratifying the
passing whim of an ever-changing fashion.'[64]
This may have struck a chord 40 or 50 years
earlier, but was not so popular an attitude
by the early part of the twentieth century,
by which time numerous new fashions *were*
taking hold, and may explain the closure of
the firm at the Vigo Street premises just a
few years later.

*No. W 17.—Brooch, old Egyptian design, carved moonstone, sphynx in centre,
wings enamelled. Price* **£5 15s.**

FIG. 12 Detail of Egyptian-style
brooch from Watherston & Son's
The Place of Jewellery in Art (1907).
London, National Art Library

6, Vigo Street, W. Leading from Regent Street, through
Burlington Gardens, to Bond Street.

HUNT & ROSKELL 1843–97

A large and successful firm of jewellers and silversmiths, employing almost one hundred men, Hunt & Roskell targeted the traditional market for gemstones and large pieces of silver, instead of the emerging market for historicist and revivalist jewellery.

Hunt & Roskell was a well-known firm of jewellers and silversmiths, which designed and made pieces at a manufactory at 26 Harrison Street, near Clerkenwell, before retailing them in its impressive showroom at 156 New Bond Street. Originally founded by the master silversmith Paul Storr in 1819, the company had traded under various names, Storr & Co. (1819–22), Storr & Mortimer (1822–38), Mortimer & Hunt (1838–43), before finally becoming Hunt & Roskell, in 1843. John Samuel Hunt, who had worked with Storr, continued as a partner until his death in 1865, when he was succeeded by his son, John Hunt (d. 1879). His partners were Robert Roskell, formerly a watchmaker, and Charles Frederick Hancock. Hancock retired in 1849 but Roskell remained until his death in 1888. In 1889 the firm was transferred to J.W. Benson (although still trading as Hunt & Roskell), before it was converted into a limited company in 1897, remaining in business until c. 1965.

Instead of targeting the educated elite who were interested in reproductions of ancient jewellery (the clients targeted by firms such as Giuliano and Phillips), Hunt & Roskell continued to focus on the traditional market for high-end gemstones. Although the firm retailed some of Carlo Giuliano's work before he set up his own premises at 115 Piccadilly (*see p.* 24), and its display at the 1872 International Exhibition included some pieces in the neo-Gothic style and some simulating Japanese cloisonné enamel work, its history was one founded in the British silversmithing tradition, and it was best known for its 'monumental goldsmiths' work, colossal services of plate, trophies, cups, and so forth'.[65] It also produced more traditional jewellery, often floral, often set with brilliant stones (although not in the case of *cat. no.* 22). The firm flourished during this period; the 1851 census records John Hunt living at the premises with his wife and five children, five domestic servants, a porter, two shopmen and employing 35 people in the business, with significantly between 80 and 100 more people employed at the workshop on Harrison Street.[66] For many years the firm held the royal warrant to Queen Victoria and created impressive displays at the International Exhibitions of 1851, 1862, 1867, 1872 and 1884.

CAT. NO. 22 Gold brooch/hair ornament (*enlarged*), made by Hunt & Roskell, c.1850

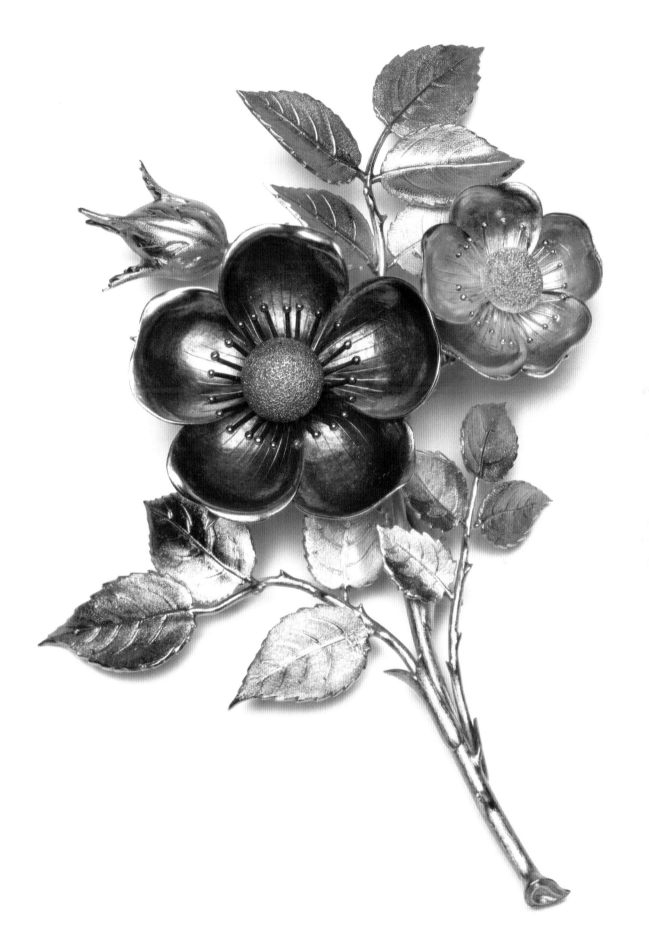

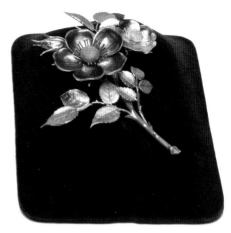

In 1865, a reporter visited the showroom and described a breathtaking display of gems:

> We must next proceed to the inspection of the valuables in the glass cases which surmount the counters and in which are contained some of the greatest treasures of the establishment. How pretty and sparkling these gems look, nestling in their soft couches of red and white velvet! Here is one charming specimen, which however is more remarkable for the dazzling brilliancy achieved in the setting than the large size of the stones... We are told that Messrs. HUNT and ROSKELL are the largest holders of precious stones in Europe.[67]

In 1881, Hunt & Roskell's workshop on Harrison Street received a visitor, 15-year-old Beatrix Potter. She wrote extensively about the visit in her encoded diary, noting (unsurprisingly) the four or five cats she spied on the tour, but also the many different workspaces, the presses, the casting room, the firing and finishing rooms, the designers and the 'six or seven thousand' designs kept onsite, the workmen sitting in an attic room, '*hung* with plaster casts ... working at a long wooden bench opposite windows from which was an extensive view of chimneys; nothing to tempt them to waste their time there', and the dust she saw everywhere – 'nothing had been dusted since the house was built I should think.'[68]

There is more to this brooch by Hunt & Roskell (*cat. no.* 22) than first appears, both literally and metaphorically. The pin fastening on the reverse screws off and can be replaced by a two-pronged hairpin attachment, allowing the spray of dog roses to be worn as either a brooch or a hair ornament. This was relatively common during the mid-nineteenth century, but few survive intact, as usually one or more parts are lost. The survival of the piece in its original case, with a compartment made specially to accommodate the pin attachment, means that we can see how it was originally intended to be worn. However, the choice of flower, a dog rose, would have spoken to a contemporary viewer in the well-known language of flowers, conveying in its thorny beauty both the pleasure and the pain of love.

PHOEBE TRAQUAIR *1852–1936*

Working in a distinctively warm and rich palette across a range of media, including paintings, textiles, manuscripts and enamels, Traquair was among the leading artists in Edinburgh at the turn of the twentieth century.

Born in Kilternan, Dublin, the sixth of seven children, to physician Dr William Moss and his wife Teresa, Phoebe Anna Traquair studied art at the School of Design at the Royal Dublin Society, before marrying the Scottish palaeontologist Ramsay Heatley Traquair in 1873, moving to Edinburgh the following year. After the birth of her three children, Traquair went on to create a diverse range of public murals, paintings, embroideries, illuminated manuscripts, enamels and jewellery.

In Edinburgh the Traquairs moved in artistic and socially progressive circles, counting pioneering sociologist Patrick Geddes and Pre-Raphaelite artist William Holman Hunt among their friends and corresponding with artists and intellectuals such as Walter Crane and John Ruskin. Throughout the 1870s Scotland experienced a dramatic upswing in interest in the visual arts, predominantly thanks to the inter-national fame of the Glasgow School – a loose group of galvanising artists including architect Charles Rennie Mackintosh, painter Margaret MacDonald and illustrator Jessie M. King, whose style combined elements of traditional Celtic design, Japanese-inspired design known as *Japonisme*, and techniques

from the Arts and Crafts movement, resulting in a distinctive style more aligned with the bold and dynamic art nouveau movement than with anything seen in England at that time.

Although not a part of this movement, Traquair benefited from this renewed interest in art. Her own inspirations came from the literary and visual works of the Romantic poet William Blake, as well as the palette and themes of the work of Pre-Raphaelite artist Dante Gabriel Rossetti, whose work was avidly collected by Traquair's older brother, William Richardson Moss. Her early works were mainly landscape watercolours and embroidered domestic textiles, but in 1885 Patrick Geddes commissioned her to decorate the new mortuary chapel of the Royal Hospital for Sick Children. Traquair completed it the following year, but was disappointed when the building was demolished just eight years later, although some of her panels were painstakingly transported to the new mortuary, where they survive today. Other large-scale decorative projects included the song school of St Mary's Episcopal Cathedral, Edinburgh (1888–92), the major

commission of the interior of the Catholic Apostolic Church, Edinburgh (1893–1901), the chancel of the church of St Peter at Clayworth, Nottinghamshire (1904–05), and the Manners chapel at Thorney Hill in the New Forest, Hampshire (1920–22).[69]

Traquair excelled in a range of studio crafts, including art embroidery, book design, book cover tooling and illuminated manuscripts. Her simply but boldly drawn forms in startling hues and a warm and vibrant palette stood apart from the work of other artists, and her 'passion for pure and beautiful colour'[70] was often commented upon by critics at the time. In 1898 'M.L.M.' wrote breathlessly in *The Studio*:

> It is not to the North that we look for art opulent with the colour and warmth of the South. … In the grey cold North it is sombre art that we are led to look for. Therefore, when in Scotland's capital, we turn a corner and find ourselves in the small chapel behind the choir-stalls of the Catholic Apostolic Church in Broughton Street, it is little wonder if we catch our breath at surroundings so rich and so little anticipated. For the whole chapel scintillates and glows like a jewelled crown.[71]

Following this commission, Traquair's reputation grew quickly. She exhibited with the Arts and Crafts Exhibition Society from 1899 onwards and with the Guild of Women-Binders at the Exposition Universelle, Paris, in 1900. She was invited to exhibit at the Chicago World Fair in 1893

and subsequently showed her quartet of silk-embroidered panels *The Progress of a Soul* (1893–1902)[72] at the fair at St Louis, in 1904. In 1920, twenty years after the Academy refused to admit her, Traquair finally became the first woman to be elected as an honorary member of the Royal Scottish Academy (a fact of which she was clearly proud – including it in the headstone she designed for herself and her husband in Colinton Churchyard, Edinburgh).

Traquair learnt the art of enamelling from the wife of Sir Thomas Gibson-Carmichael (1859–1926), governor of Victoria: Lady Gibson-Carmichael of Castle Craig, who had herself learnt it in the 1890s from the famous enameller Alexander Fisher. Enamelling, which required more expensive materials and a kiln, became popular with well-off amateur and semi-professional craftspeople, who were thrilled by its often tricky but always transformative nature. The Carmichaels also had an extensive collection of European art, including medieval Rhenish enamels, which inspired Traquair, who became attracted to the medium as much for its historic precedent as for its vibrant range of colours.[73] Traquair experimented with enamelling throughout 1901 and finessed her technique, producing most of her finest enamels (of around 150 in total made in her lifetime) between 1903 and 1908. She showed 30 of them at the Arts and Crafts

CAT. NO. 23 Enamel pendant, *The Helper* (*enlarged*), made by Phoebe Traquair, 1903

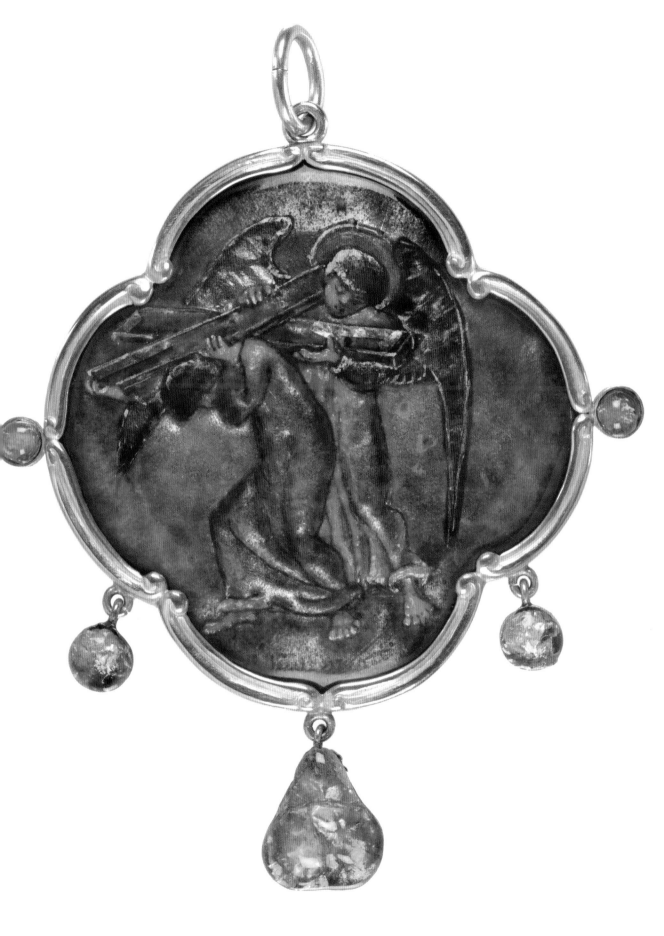

FIG. 13 Sheet of sketches and designs by Phoebe Traquair. London, Victoria and Albert Museum

Exhibition Society display in 1903, and they were mentioned in *The Times*:

> A case of enamels in the South Room, by Mrs Traquair, is noteworthy; still more so are a set of four really wonderful panels in needlework by the same lady, whose decorations and miniatures are one of the sights of Edinburgh.[74]

Many enamelled plaques were inserted into small gold triptychs or caskets, forms also inspired by medieval art, but others were turned into pieces of jewellery, mounted by the well-known Edinburgh goldsmith Brook & Son. Traquair designed her enamels first on paper. Few finished designs survive, but a sheet of sketched and coloured designs remains in the Victoria and Albert Museum (*fig.* 13). It shows sketches for two finished pendants *Sunshine and Storm* (now in a private collection) and a double-sided pendant *Morning and Evening* (whereabouts unknown, illustrated in *The Studio* 37, 1906, p. 139).[75] In each of these, the figure of a celestial angel appears to a mortal as a helpful guide, which was a motif Traquair had first adopted in manuscript illuminations in the 1890s. There are also very loose sketches of Christ crucified, visible on the lower part of the paper, intimating perhaps that this pendant, entitled 'The Helper' (*cat. no.* 23), which shows the same helpful angel helping Christ to carry the Cross, was potentially part of a series of works depicting aspects of the Crucifixion.

CHARLES FRANCIS ANNESLEY VOYSEY *1857–1941*

Breaking away from all that had come before, Voysey's revolutionary linear and 'fit for purpose' architecture was widely praised and received much attention from commentators abroad. He also applied his unique aesthetic to textiles, wallpaper, furniture and clocks.

Born in Hessle, near Hull, Voysey was the third of ten children born to the reforming minister Rev. Charles Voysey (1828–1912), the founder of the Theistic Church, and his wife, Frances Edlin. Between 1874 and 1879 Voysey studied architecture under the Gothic Revivalist J.P. Seddon, where he learnt that architectural design could encompass not just buildings, but everything within them. He subsequently worked for Saxon Snell and George Devey, before setting up his own practice in 1881. However, as his first design for a building was not executed until 1888, in the meantime he made a living designing colourful wallpapers and textiles, filled with birds and patterns inspired by nature, and was initially much better known for these than for his architectural work. Voysey rejected the Georgian and neoclassical styles of architecture, believing them 'un-English'. He instead designed distinctive buildings that were 'a rational and artistic interpretation of the modern country cottage'[76] – long, low, often half-timbered with small windows, but more simple and elegant than the neo-Elizabethan style that was favoured at the time. In doing so, Voysey led the way in creating a new style that was later copied in a rudimentary way by hundreds of provincial builders, resulting in the many 'Voysey-style' suburbs found in Britain today. His own house, The Orchard, Chorleywood, which he designed in 1899, acted as a showpiece for his design capabilities. He also mentored numerous other bright young architects, including Charles Rennie Mackintosh (1868–1928).

Voysey was widely praised by his contemporaries at the turn of the century for his unusual linear style and clean simplicity. *The Studio* commented:

> [T]he value of Mr. Voysey's art is not in the use of any material, or on any mannerism, but in his evident effort to seek first the utilitarian qualities of strength and fitness, and to obtain beauty by common honesty… In these houses illustrated you can discover that it is neither Gothic nor Classic architecture which Mr. Voysey practises, but house building pure and simple.[77]

Voysey had a clear and forceful vision, supported by his strongly held views on what constituted 'good' design, which he was keen to spread as widely as possible not for his own popularity or profit, but for its own sake, in line with his father's own attitude towards religious preaching and reform.

Scrupulous and somewhat obsessive, Voysey always thought he knew best, which could sometimes lead to disagreements with clients. He was remembered fondly, however, by C.R. Ashbee (*see* pp. 70–85), who described Voysey's houses as 'like his own nature – clean and white, roughcast, and sunny'.[78]

Voysey's domestic practice flourished between 1890 and 1914, and his work was widely admired outside England, partly due to the reproduction of photography of his finished projects (see below), resulting in commissions from as far afield as Egypt and Massachusetts. Although he opposed the registration and systematic education of architects, he was elected a fellow of the Royal Institute of British Architects in 1929, and was awarded the gold medal for architecture in 1940. In 1924 he was elected Master of the Art Workers' Guild.

As well as buildings and fittings (such as locks and hinges), which incorporated natural forms such as birds and berries as well as his most famous motif, a heart, Voysey designed textiles, wallpaper, furniture and other objects, including a small number of clocks. This clock (*cat. no.* 24), on loan to the Fitzwilliam Museum from the Frua-Valsecchi collection (*see* pp. 3–4), is one of three known Voysey clocks made from aluminium, which were widely celebrated and exhibited throughout the early twentieth century.

Oxidised aluminium, designed to have a dull rather than a reflective surface, was an unusual choice of material. Discovered in the early 1850s by French chemist M.H. St-Claire Deville, the bright, white finish of aluminium made it an obvious choice for jewellery, and its light weight was also advantageous, making it the perfect material from which to produce new lightweight bicycles. But the oxidised finish seen on this clock was much more unusual. Aluminium had been incorporated into a small number of Continental clocks, including those designed by Viennese secessionist Joseph Olbrich (1867–1908), and a number of metal clocks were produced at this time by Arts and Crafts designers such as Archibald Knox (*see* pp. 94–8), although they were usually made from silver or pewter.[79]

The dial is similar to most other dials designed by Voysey in that the numbers on the face have been replaced by the letters that make up the Latin phrase TEMPUS FUGIT ('time flies'), followed by a cross, and the hour hand terminates in a pierced Voyseyan heart. Sleek and linear, with no surface pattern, it mixes Voysey's preferred aesthetic with an architectural form. This is thought to be taken from his 1894–96 design for a stables gatehouse at Greyfriars, Puttenham, Surrey, designed for the novelist and playwright Julian Sturgis – a rectangular gatehouse with a roof of ogee form, surmounted by a plain spike finial and with a stepped edge. Unusually,

CAT. NO. 24 Aluminium clock, designed by C.F.A. Voysey, c.1896. Made by W. H. Tingey at foundry of W.C. Barker, Strood, Kent, c.1896–1901

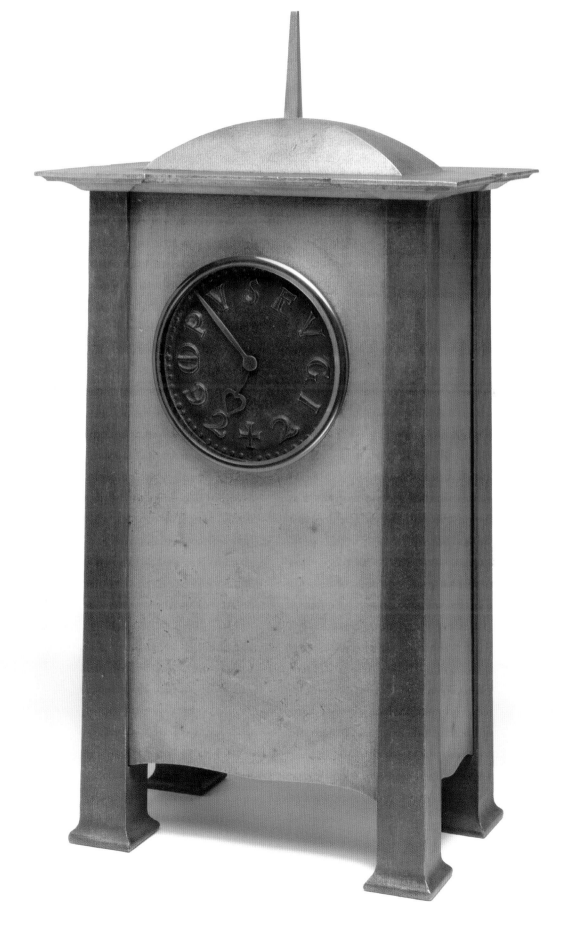

access to the movement is granted by means of a 'door' on the reverse (*below*), complete with miniature Voysey-style hinges, shrunk-down versions of Voysey's full-size designs for gates and doors.[80]

This particular form was a favourite of Voysey's and was used repeatedly by him in the design of various clocks of different materials and finishes. The original design is of the same shape but has an oil-painted mahogany case incorporating the phrase 'Time & Tide Wait for No Man' (an example of which survives in the Victoria and Albert Museum[81]); other painted and plain ebony and white examples were also made. Three are known to have been produced in aluminium between 1896 and 1901, of which this is one example. A second aluminium clock is in the collection of the V&A[82] and a third was formerly in the collection of John Scott, and sold through the Fine Art Society in 2014–15.

Voysey was aware of the advantages of good publicity, and he often commissioned photography of finished projects, which was then published by leading design journals and interiors magazines. These clocks were published widely throughout the first decade of the twentieth century, but have recently been distinguished from one another through careful examination of the small differences in the dials by silver expert Anthony Bernbaum.[83] If only three aluminium clocks were produced, then it was this clock (or one just like it) that was exhibited in

the ground-breaking First International Exposition of Modern Decorative Arts, held in Turin, Italy, in 1902. This exhibition was explicitly 'modern' in its outlook, with the organisers declaring that 'only original products that show a decisive tendency toward aesthetic renewal of form will be admitted. Neither mere imitations of past styles nor industrial products not inspired by an artistic sense will be accepted.'[84]

A photograph of it on top of an Ashbee desk was included in the widely read journal, *Deutsche Kunst und Dekoration*, as part of its coverage of the exhibition (*see fig.* 14). Voysey was described as

> an architect; his houses are highly characteristic for their simple proportions and original contours, and for their strict, smooth treatment of surfaces… Voysey wants to go entirely his own way and completely rejects every connection to existing traditions.[85]

The same clock appeared in another German art journal, *Dekorative Kunst*,[86] and in 1903 it was shown in London at the Arts and Crafts Exhibition Society exhibition (exhibit 394c), the seventh exhibition organised by the Society, which had been established in 1887 to promote the work and craftsmanship of Arts and Crafts designers. In the same year it also appeared in *House & Garden*,[87] and a year later it featured in another German periodical, *Der Moderne Stil*.[88]

Contemporary sources often refer to the clock as having been manufactured by William Harold Tingey. Tingey was not a craftsman but an amateur scientist, an alumnus of Trinity Hall, Cambridge, the owner of a large and successful cement manufacturers and a wealthy patron of Voysey's. However, Bernbaum has pointed out that an annotation in Voysey's address book,[89] next to Tingey's address (Rede Court, Rochester) mentions 'founder for castings of clock W.C. Barker, Strood,

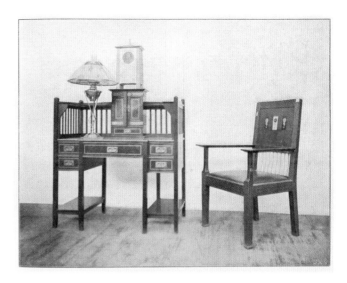

FIG. 14 Photograph from *Deutsche Kunst und Dekoration* 11 (October 1902–March 1903), p. 235. London, National Art Library

Kent'. It seems likely, therefore, that this foundry, established by William Cobbett Barker (1817–1902) and continued by his son and grandson, a short distance away from Tingey's residence on Gun Lane, was where the clocks were actually made, under Tingey's supervision. The identical size of all three clocks also intimates that they were cast from the same mould.

Although Voysey strongly rejected the idea that his architectural style prefigured modernism, there is no denying that his emphasis on line and silhouette, lack of surface ornamentation, and in this case the rough surface which echoes perhaps even the concrete finish of much post-war architecture, point to an aesthetic that was to reach its zenith thirty years after the design of this radical clock.[90]

GILBERT MARKS *1861–1905*

Marks was a successful silversmith who worked in a distinctive naturalistic style, producing silver and pewter by hand, whose early death allowed his significant contributions to the Arts and Crafts movement to be overlooked.

Born in 1861 in Croydon, London (where he remained until his death), Marks was the eldest child of John George Marks (*c.* 1838–1903) a shipping company manager, and Sarah Walker (1840–1880), both of whom were siblings of well-known artists, Henry Stacy Marks RA (1829–1898) and Frederick Walker ARA (1840–1875) respectively. On leaving school in 1878, Gilbert Marks was employed first as a clerk for a silversmithing firm, before joining Masurel & Fils, wool brokers, in around 1895. He seems to have developed his silversmithing skills in his spare time. In 1896, although still working as 'something in the City', he had two assistants, who helped him produce his silver plate.[91] However, by 1901 he was focusing solely on metalworking, as confirmed by his 1901 census entry in which he described himself as an 'Artist in metal' overwritten 'Sculp' to read 'Artist Sculp in Metal', working on his own account from his home in East Croydon.[92]

In around 1895 Marks was sponsored by the firm Johnson, Walker & Tolhurst; some early pieces bear its mark and Marks's signature. His first solo show, which consisted of 'salvers, rose-water dishes, goblets, and flower-vessel in repoussé … for the most part of floral forms treated in a *quasi*-Japanese manner',[93] was held at the firm's showroom in 80 Aldersgate Street, London, in 1895 and was favourably reviewed by *The Studio*:

> [W]e were, on the whole, most pleased with the manner in which the metal had been treated by the artist. The surfaces of the objects were not over-ornamented, pleasant plain spaces being left which served to accentuate the beauty of the designs. The objects were free from meretricious machine turning and polishing, and were left in the natural dull white colour on which silver looks at its best. The marks of the tools employed in chasing or hammering out the design were not obliterated, and the whole of the exhibits had that pleasant sense of 'handwork' which is entirely missing in the majority of wrongly called artistic work produced under the direction of 'the trade'.[94]

It is significant that the reviewer noticed and commented upon Marks's 'handwork'. Marks ensured that every piece was made by hand, and in this way truly embodied the

CAT. NO. 25 Britannia silver dish, made by Gilbert Marks, 1899

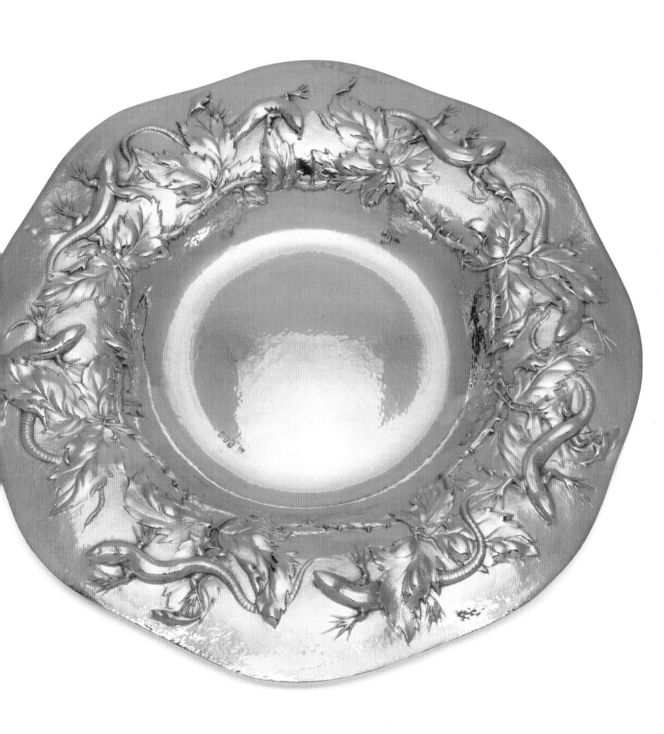

early Arts and Crafts notion that craftsman-ship should involve at least some degree of physical effort on the part of the maker. This hand-finishing was to become such a feature of Arts and Crafts silver and jewellery that by the early part of the twentieth century mass-produced pieces were being made to look as if they'd been hammered by hand. But in 1895 this was still novel enough to provide 'relief from the wearisome monotony of "trade"

designs'.[95] After his early death at the age of 46, his obituary in *The Burlington Magazine* referred to this, his insistence 'that the smith must be at once the designer, the artist, and craftsman. He would have no dies, no machinery, no repetitions.'[96]

Marks usually worked in silver, but also worked old pieces of pewter, as well as new, and occasionally even worked in silver-gilt.[97]

His work was almost exclusively finely repoussé and chased with large

wild-flower blooms, but also occasionally with fish or lizards. This large, exquisite dish of Britannia silver (*cat. no. 25*) is one of the finest surviving pieces of Marks's work. It depicts eight lizards darting among thorny bramble foliage, around a large spot-hammered dish with wavy rim. The lizards' heads have been supported on the underside of the dish by a small piece of silver, which allows them to stand proud of the dish. Although Marks claimed not to repeat pieces, similar examples have come to light, and Marks certainly used a very similar pattern, albeit smaller and plainer, on a circular pewter dish, three years later (*cat. no.* 26). The forms of his work, repeated often, are not particularly unusual, although he did experiment more after 1898 (branching out to include objects such as silver standards for electric lights).[98] However, he was well known for his attempts to harmonise form, function and ornament:

> What is more natural than that a rose-water dish should bear a border of leaves and rose-garlands? That on a beer-beaker there should be beaten up a decoration of cunningly devised hops? That a punch-bowl should be embellished with a tracery of poppies? His design was nearly always pure and felicitous, and the execution sound.[99]

CAT. NO. 26 (*opposite*) Pewter plate, made by Gilbert Marks, 1902

CAT. NO. 27 (*right*) Silver claret jug, made by Gilbert Marks, 1899

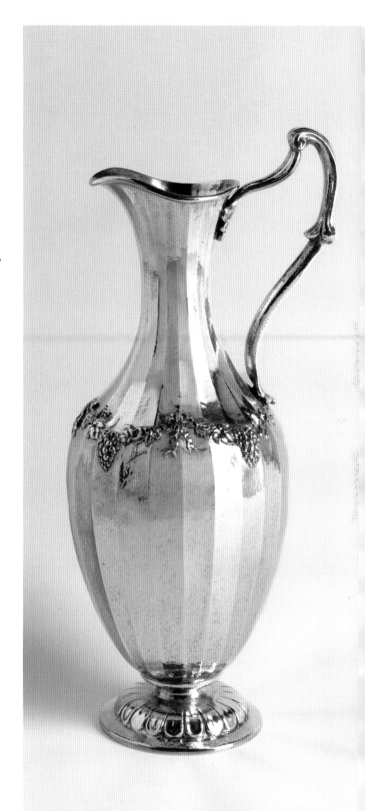

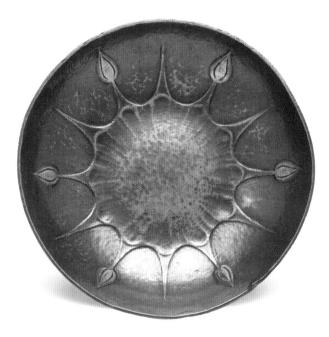

the 'ordinary highly polished specimens of the silversmith's art which are so lavishly displayed in the jeweller's shop windows'.[102] Instead, the 'dull yet exquisite grey of unpolished silver … is exceedingly pleasant to the cultivated eye'.[103]

This admiration for a more matt surface, alongside the growing fashion for less precious metals, may have encouraged Marks in his creation of pieces made from pewter, an alloy of mainly tin, mixed with small amounts of other metals such as copper or lead. After decades of elaborate, intricate and highly polished pieces of silver, the final decade of the nineteenth century saw those of a more artistic or aesthetic bent turn towards metal that was less showy and preserved its 'natural' appearance. In the same way that Arts and Crafts jewellers rejected diamonds for moonstones, and

This unity can be seen in the silver claret jug (*cat. no.* 27), a simpler piece than the lizard dish, but appropriately repoussé and chased with a vine and bunches of grapes. The quality of the chasing or 'hammering' of Marks's work was especially praised, with one reviewer of 1898 declaring, 'the effect of delicate undercutting is given, and yet the surface has a broken quality which is delightful',[100] while the author of his obituary urged people to appreciate 'the apparent ease with which he could work the yielding metal, play with his pattern and his ornament, and bring it up to accents of sharpness or caress it into liquid melting-ness'.[101] These pieces contrasted starkly with

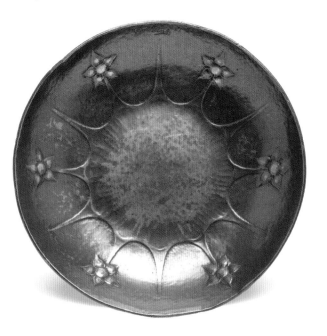

CAT. NO. 28 Pewter ashtray, made by Gilbert Marks, 1900

CAT. NO. 29 Pewter ashtray, made by Gilbert Marks, 1900

emeralds for enamel, metalworkers and silversmiths began to look elsewhere, often to more modest metals than those that had been used in the recent past, or to those that were still more commonly used in rural areas. A few years before Marks's foray into pewter, John Pearson and early members of the Guild of Handicraft began to work in copper (*see* pp. 75–6), as did Marks in a small way, and by 1902 less precious metals were so popular that West End department store Liberty commissioned a whole new range of pewter designed by Archibald Knox (*see* pp. 94–8), under the name *Tudric*, which followed on from their successful *Cymric* range in silver, launched in 1899.

In a long review dedicated solely to Marks's work, published in *The Artist* in July 1898, the reviewer commented on 'the old pewter plates he [Marks] has hammered up', which he had bought in the country, and which now look 'quite delightful'.[104] These two small ashtrays (cat. nos 28 and 29) were presumably some of the most affordable pieces produced by Marks, being of a smaller, simplistic form, and made from pewter instead of silver. The larger bowl (*cat. no. 30*), repoussé and chased with rose hips, sits on a small four-legged wooden stand, explicitly intended as a decorative object, and not as a functional one (except, perhaps, to hold a plant pot). The wooden stand was made to fit this bowl, but it is not known whether it is original or not. Marks certainly intended for bowls of this shape to

be placed on stands – numerous stands of this shape are illustrated in *The Artist* article of 1898, but these are all of cast bronze, displaying silver bowls. However, it would seem logical that the cheaper pewter bowls would stand on cheaper stands, which means that this elegant wooden stand, very much in the Anglo-Japanese fashion, may be original.

Marks entered his own mark at Goldsmiths' Hall in 1896, but unusually continued to denote his work with a signature, and often a date (*below on cat. no. 26*). All of the pieces bearing his signature date from between 1895 and 1902, just three years before his early death, displaying a highly productive and successful output, with his obituary estimating the number of pieces he produced as high as 750 or 800, although a fraction of those survive today. He continued to display work annually at Johnson, Walker & Tolhurst until 1901, but also exhibited work at Leeds City Art Gallery (Summer 1897); at the Arts and

Crafts Exhibition Society exhibition (1899), the only connection he had with the more formal aspects of the movement; at the Royal Academy in London (1899, cat. no. 1981), Glasgow and Liverpool; and at the Fine Art Society in 1899. This last was a large solo show consisting of 60 pieces, including the Museum's claret jug (*cat. no. 27*), described in the accompanying catalogue as 'Fluted Jug with vine festoons on the body', and the Britannia silver dish with lizards and brambles (*cat. no. 25*), described as 'Dish in Britannia silver; the edge shaped – lizard and blackberry design'.

His work was commented upon frequently in art publications throughout the late 1890s, often in the same breath as artists whose work remains well known today, including C.R. Ashbee, Henry Wilson and Alexander Fisher. The last signed work by Marks is dated 1902. At around this time he began to suffer from the effects of syphilis, dying three years later in 1905, cutting short what would have undoubtedly been a long and successful career.[105]

Although not formally connected to the Arts and Crafts movement, Marks was one of the first silversmiths to remove the industrial process from his production of metalwork. His rejection of the 'divorce' that occurred from putting the 'designing into one pair of hands, and the carrying out into another'[106] (Marks's own words) set him apart from much of the silver trade he had witnessed as a clerk in a silversmithing firm as a young man:

> I had been deeply and sadly impressed, and yet stimulated, by seeing the way in which the methods of manufacture adapted to meet the public demand were killing the spirit of craftsmanship in metals… The man who buys the stock plate is buying useful articles but not unique ones, whereas he who commissions an original work upon which the craftsman has bestowed his best personal labour is buying a work of art.[107]

This independence and involvement in the entire process afforded him the freedom and individualism to create unique works of art, which grew 'under the craftsman's hand' and into which he had 'put himself'.[108] This individualism, encapsulated by Marks's continuous use of a bold and obvious signature, was viewed by contemporaries as an important element in differentiating his work from the 'stock patterns' either made by hand in large trade workshops or produced by machine. However, like almost every other Arts and Crafts designer, Marks employed and supervised assistants, who no doubt carried out some of the work, especially in such a highly productive workshop.

CAT. NO. 30 Pewter bowl on wooden stand, made by Gilbert Marks, 1901

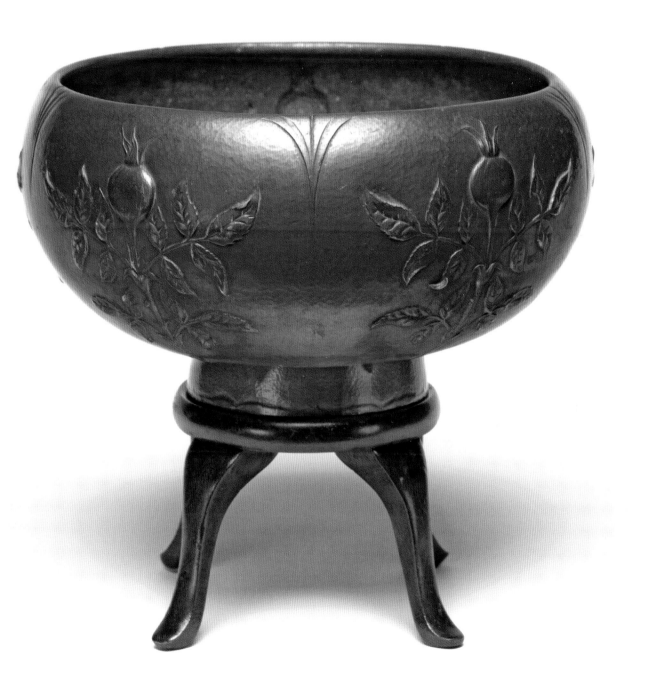

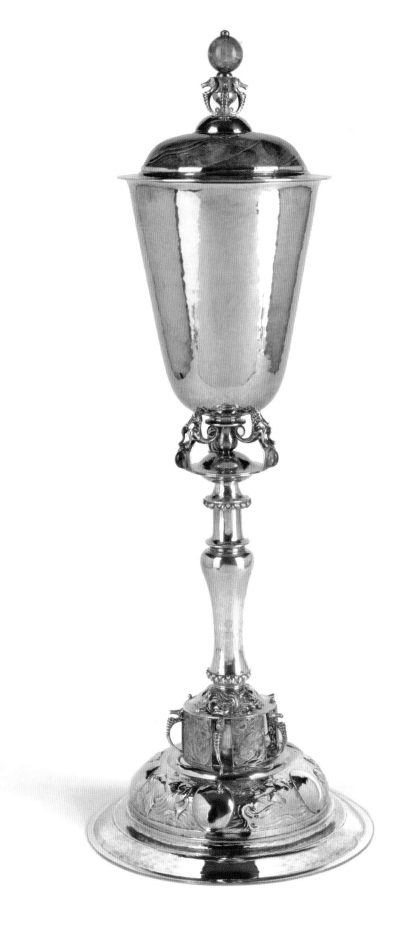

CHARLES ROBERT ASHBEE *1863–1942* &
THE GUILD OF HANDICRAFT *1888–1907*

A key proponent of the Arts and Crafts movement, Ashbee not only experimented and popularised a new, more naturalistic style but also attempted to put Arts and Crafts social ideals into practice through the creation of the Guild of Handicraft, training a group of craftsmen and employing them to work together.

The son of a wealthy textile trader and a suffragette, Ashbee was educated at Wellington College and subsequently at King's College, Cambridge (now home to his archive). He later trained as an architect under the Gothic Revival architect George Frederick Bodley (1827–1907). As was common in the late nineteenth century, he designed not only buildings but also interiors, including fixtures, fittings and furniture. A multi-talented designer with a socialist bent, he delivered extensive public lectures, wrote two utopian novels and was later appointed civic advisor to the British Mandate of Palestine, precipitating the move of his family to Jerusalem, where they lived between 1918 and 1923. In 1898 (his homo-sexuality notwithstanding) Ashbee married Janet Forbes (1877–1961). Although the two had a turbulent marriage, with affairs on both sides, they came to regard one another as 'comrades' and their union resulted in four daughters.

CAT. NO. 31 The Gardiner cup and cover, designed by Charles Robert Ashbee and probably made by William White, a silversmith at the Guild of Handicraft, Chipping Campden, 1904-05

However, it is for his pioneering social and artistic venture, the Guild and School of Handicraft, that Ashbee is best known. While working for Bodley, Ashbee lived at Toynbee Hall in Whitechapel, one of the most deprived parts of East London. His lecture series on John Ruskin and the dignity and levelling effect of manual work soon attracted attention and he began to form ideas about creating a new art school and independent workshop, based on the theories of craftsmanship of John Ruskin and William Morris. Like Morris, Ashbee believed in the fundamental importance and positive effect of the connection between craftsman and material, but was more willing to accept some low level of modern technology:

> Machinery is necessary in modern production, so also is human individuality … machinery in so far as it destroys human individuality is bad, in so far as it develops it, is good.[109]

The Guild was inaugurated on 23 June 1888 (one year after T.J. Cobden-Sanderson coined the term 'Arts & Crafts', and the same year as the creation of the Arts and Crafts

Exhibition Society), with the workshop based in a warehouse at 34 Commercial Street. The school received public funding for a two-year trial, with students taught metalworking, cabinetmaking and decorative painting by the workshop members, of whom there were just four originally, including two metalworkers, John Williams and John Pearson (*see p. 75*). The Guild was successful and grew to include more than 50 workers, including jewellers, enamellers, blacksmiths and printers. In 1891 the Guild moved to premises at Essex House in Mile End, London. The school failed, however, and was closed down on 30 January 1895.

The Guild continued to flourish. In 1898 Ashbee established the Essex House Press, which went on to produce over 70 titles

FIG. 15 Photograph of the members of the Guild of Handicraft, early 1892. John Pearson is at the far left of the back row. Silversmith William White is seated on the far left. Cambridge, King's College Library

CAT. NO. 32 Copper charger, made by John Pearson, 1890

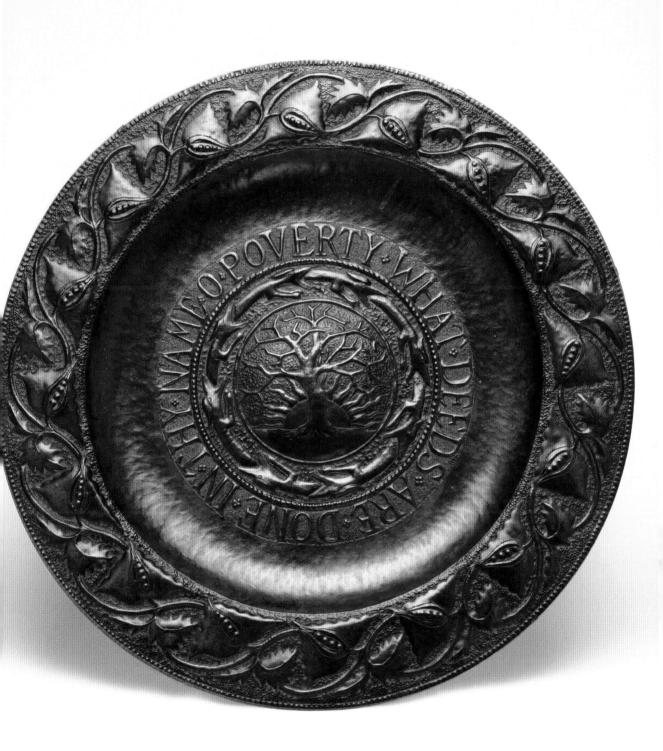

before it closed in 1910, and in 1899 opened a smart shop selling silver and jewellery at 16A Brook Street, in the West End of London, which was more accessible for Ashbee and the Guild's wealthier customers.

Although Ashbee was influenced by metalwork of the past – especially that of master Italian Renaissance goldsmith Benvenuto Cellini, whose treatises he had translated and published in 1898 – he was also interested in a new kind of innovative 'artistic' jewellery, the design of which was based on nature: animals, plants and organic forms. His 'revolutionary' principle, 'viz. that the value of a personal ornament consists not in the commercial cost of the materials so much as in the artistic

quality of its design and treatment', made him, according to writer and critic Aymer Vallance, writing as early as 1902, a 'pioneer of the artistic jewellery movement'.[110]

Towards the end of the nineteenth century Ashbee became convinced of the advantages of living in a more rural environment, and in an unprecedented move suggested to the Guild that they move the entire business and all of their families to the small town of Chipping Campden in the Cotswolds. Ashbee records in his journal of Christmas Day 1901 the results of the 'Campden pole' [sic]: 22 were for the move, 11 were against and 1 was undecided – 'The workshops and smithy are solid for going, the metal shop and press are divided.'[111] In 1902 the bulk of the Guild – 150 people in total – moved to Chipping Campden, vastly increasing the population of the small town. The shop at Brook Street, London, remained open in an attempt to hold on to the Guild's wealthy metropolitan client base.[112]

After settling in and taking over a disused silk mill in Sheep Street, the Guild initially thrived as it had previously, but by 1905 it was no longer in profit. The geographical distance from London meant that the Guild sold less than it had when based in the city, and the popularity of modern silver now made by hundreds of workers in Birmingham and retailed by stores such as Liberty (see pp.

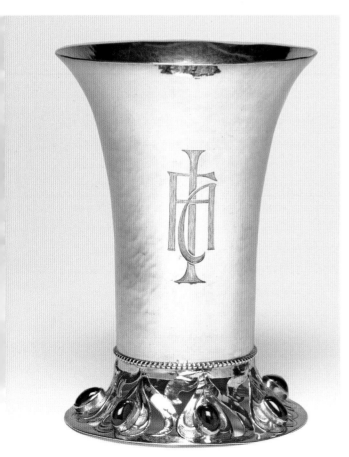

CAT. NO. 33 Silver beaker, designed by Charles Robert Ashbee, made by a silversmith at the Guild of Handicraft, 1900–1901

95–8) affected sales too. But Ashbee had been naive in imagining that such a large organisation could thrive in the country as it had in the metropolis; guildsmen and workers were unable to pick up casual work when demand for goods was low, as they had been able to do in London, which meant that they soon produced far more than they were able to sell. As a consequence the Guild grew too large as a single entity and unwieldy in its organisation. Directors of the Guild met in the autumn of 1907 and decided that liquidation was the only way forward. New rules were drawn up to allow the Guildsmen to continue working in Chipping Campden under their own names, but it was the end of the Guild as Ashbee had envisaged it.

Metalwork had always been at the core of the Guild's work. Although it is Ashbee who has always been seen as responsible for the designs and success of the 'metal shop', it was not he who was responsible for the immediate success of Guild metalwork, originally produced in copper, not silver. One of the founding members of the Guild, John Pearson, was responsible for 15 of the 17 metal items displayed at the Guild's exhibit at the first show organised by the Arts and Crafts Exhibition Society in October 1888 (three months after the founding of the Guild), all of which were large copper chargers, bowls and plaques with repoussé decoration in the form of stylised flowers, birds and animals.

According to *The Studio*, Pearson had been employed at the De Morgan tile

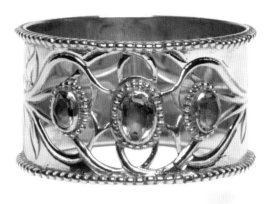

CAT. NO. 34 Silver napkin ring with amethysts, designed by Charles Robert Ashbee, made by a silversmith at the Guild of Handicraft, 1900–1901

works in Chelsea, although this cannot be verified. Apparently, Pearson, 'broken down in health and out of any regular employment, had carefully examined in the British Museum the Repoussé copper of the Middle Ages', and set himself the task of trying to replicate it.[113] It seems likely that Pearson came to the Guild with some metalworking skill, probably from attending classes run by the Home and Arts Industries Association, founded in 1884, or teaching himself from metalworking manuals by the American Charles G. Leland.[114] Pearson did much to kick-start the training of other metalworkers, but was to prove one of the more individually minded members of the Guild. Most pieces by him from this period are signed and dated (*cat. no.* 32), something which went against the Guild's decision that craftsmen should not individually sign or mark their pieces, with Ashbee referring to him at the end of 1888 as 'our quaint genius

J. Pearson, our strongest and our weakest point'.[115] According to the minutes of the Guild of Handicraft of 16 October 1890, Pearson was almost expelled from the Guild of Handicraft for supplying metalwork to William Morris and employing two others to help him. He finally resigned in the summer of 1892, shortly after this photograph of most of the founding members of the Guild was taken (*fig.* 15). He later taught metalworking in the artists' colony at Newlyn, Cornwall, before returning to London and working independently.

John Keatley, the owner of Pearson's fine and larger-than-average copper charger (*cat. no.* 32), has suggested that the unique design of a skeletal tree in front of a rising or setting sun, surrounded by a chain of

eight dogs all eating one another, coupled with the unique inscription 'O POVERTY WHAT DEEDS ARE DONE IN THY NAME', may refer directly to Pearson's falling out and near-expulsion from the Guild in 1890 (the same year that this charger was made). The 'dog eat dog' motif and seemingly plaintive inscription can be read together as justification of Pearson working 'on the side' and supplying metalwork work to William Morris in order to increase his income.

By the late 1890s, there was less demand for this heavily repoussé and chased work and so the Guild changed the style of its silver output, instead following Ashbee's designs for silver with smooth, undecorated surfaces, a flash of colour provided by small hardstones or sections of enamelling. Tableware such as this beaker (*cat. no.* 33) and napkin ring (*cat. no.* 34), both set with amethysts, proved popular, as did a number

CAT. NO. 35 Silver two-handled bowl and cover, designed by Charles Robert Ashbee, made by a silversmith at the Guild of Handicraft, Chipping Campden, 1906–07

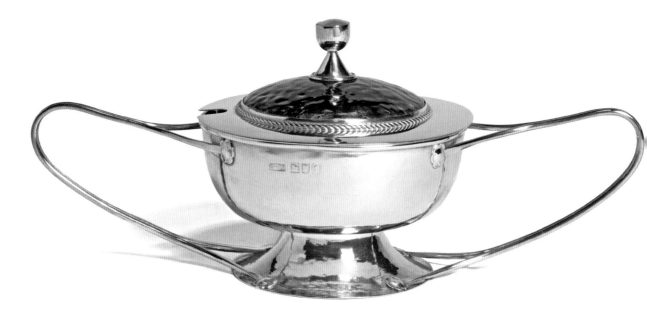

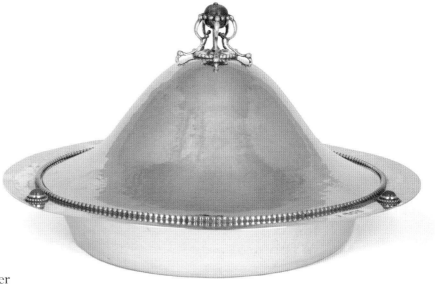

of classic designs,
produced in high
numbers but with slight
variations, such as this
covered muffin dish
(*cat. no.* 36) and bowl and cover
(described in Guild catalogues as a
jam or butter dish) with two wide, looping
handles (*cat. no.* 35), a design feature that
became most closely associated with Guild
silver. The lack of decoration and simplicity
of design proved immediately popular with
critics:

> For Mr Ashbee gains an effect of superb
> richness the right way. That is to say, he
> knows when to be silent, when to let the
> broad sweep of undecorated surface prepare
> you for the final ornamentation which
> heightens the beauty of the object, instead of
> hiding it underneath a superfluous mass of
> applied decoration.[116]

Ashbee was keen to recruit talented
students who had shown aptitude at the
school's metalworking classes but who had
not been tainted by previous association
with the trade, one of whom was William
A. White, who joined the Guild in February
1890, remaining until 1906, by which time
he had become head of the metal shop. The
two men clashed occasionally, according to

Ashbee's excoriating description of White in
his journal entry of 20 January 1903:

> He [White] came to me as a pupil in the
> classes at Toynbee Hall in 1888 and it is by
> seniority alone that he holds his position
> now. He has character too and a fine gift
> for design, but no more tact than shall we
> say a seal or a whale – in the shop they
> call him the WHALE, or the OLD MAN, as
> the mood has it, and they make burlesque
> jests concerning his large flat feet and the
> boots that have no bends in them. I never
> knew anyone so singularly tactless, and this
> militates against his management of men.[117]

Ashbee even weighed up 'carting him off'
but considered it disloyal, as 'when a man
has put at your service the 14 best years of
his life he is entitled to some corresponding
recognition. ... In the workshop reconstruc-
tion at which we aim, that sentiment
and regard for the dumb loyalty of men
even those that are partial failures must
have place.'[118] However, seeing as Ashbee

admitted that the metal shop was always in 'wholesome ferment',[119] his wife Janet provided a more measured view of White, describing him in an alphabet booklet of March 1900 as 'the great overseer, the difficult Metalshop's Charioteer; But he drives his team well, if you think of the Race, and the mixture of breeds in such very small space!'[120]

White was clearly not as unskilled as Ashbee suggests, as it was he who, according to *The Studio* of 1905 (*fig.* 16),[121] designed the incredibly fine Gardiner Cup and Cover (*cat. no.* 31). The design also appears in Ashbee's *Modern English Silverwork* (1909) (*fig.* 17), which might suggest that it was Ashbee's design but was made by White, or that the two collaborated on it. Little is known about this cup and cover. In 1905 *The Studio* described it as 'at that interesting centre for decorative art in Brook Street' (the Guild's West End shop), where it presumably remained for some time until it caught the eye of one of Henry Gardiner's four sisters, who purchased it and had it engraved in 1907, as a 'token of their affection and gratitude for many years as their trustee'.

Henry John Gardiner (1843–1940) was born in Bristol to a family of wool merchants, rising to become director and subsequently president of the textile company Bradbury, Greatorex & Co., as well as holding roles on a number of boards. In 1919 he was made High Sheriff of the County of London. In 1870 he had married Clara

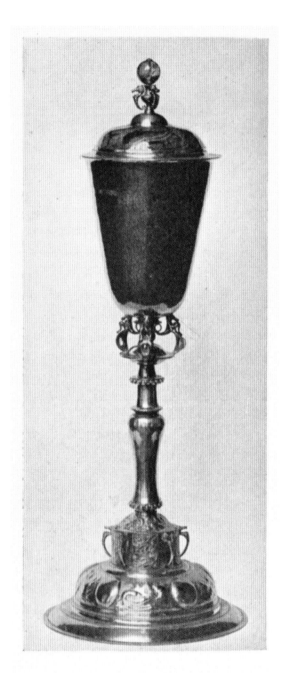

FIG. 16 Photograph of the Gardiner cup and cover (cat. no. 31) from *The Studio* 35 (1905), p. 236

SILVER CUP DESIGNED BY W. WHITE FOR THE GUILD OF HANDICRAFT

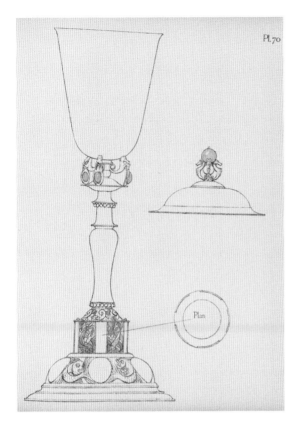

FIG. 17 The Gardiner cup and cover (cat. no. 31) illustrated in Ashbee's *Modern English Silverwork* (1909)

presentation of this cup to Henry Gardiner by his four sisters on this date is unknown, the inscription intimates that he was also kind and generous to them.

Enamelling had appeared on Guild silver as early as 1895, mostly done by Guildsman Arthur Cameron, but it improved dramatically when enamellers William Mark (1868–1956) and Fleetwood Charles Varley (1874–1959) joined the Guild in around 1900. Varley was a watercolourist and Mark an Australian who had learnt enamelling from master enameller Nelson Dawson (1859–1941). Long after the liquidation of the Guild, Ashbee reflected

Elizabeth Honey (d. 1879), by whom he had two sons, the teacher and composer Henry Balfour Gardiner (1877–1950), and the Egyptologist Sir Alan Henderson Gardiner (1879–1963). Although somewhat austere and rigid (apocryphally, he once quietly informed visiting relatives that by being late for dinner they had 'wasted three minutes of his life' and apparently chose Clara over her two sisters because she wore a plain petticoat and they wore frilled),[122] he was also a generous host, and a kind father to his two sons, who had lost their mother shortly after the birth of Alan in 1879, financially enabling them to follow their own passions later in life. Although the precise reason for the

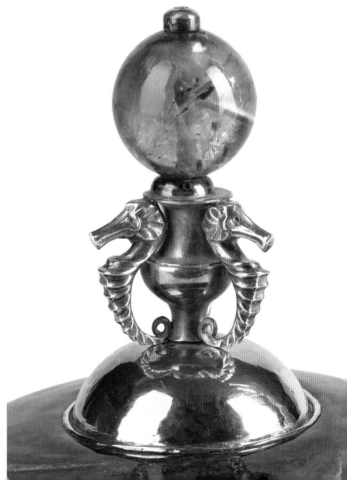

on Mark, 'a prince among workmen',[123] and acknowledged that although he had 'a superb sense of colour … his drawing is not good. His most successful work, like that of many of the old enamellers has been to record in colours the drawings of others.'[124] As Alan Crawford has noted, Mark's and Varley's pictorial enamels, often depicting landscapes and forest scenes, marked a turning point in that enamels were no longer simply a decorative feature of silver produced by the Guild, providing a flash of colour, but became the focal point of pieces, as can be seen on this circular covered bowl, formerly in the collection of another Cotswold designer, Robert Welch (*cat. no. 37*).[125] Another form

CAT. NO. 37 Silver bowl and cover, made by a silversmith at the Guild of Handicraft, Chipping Campden, 1902–03

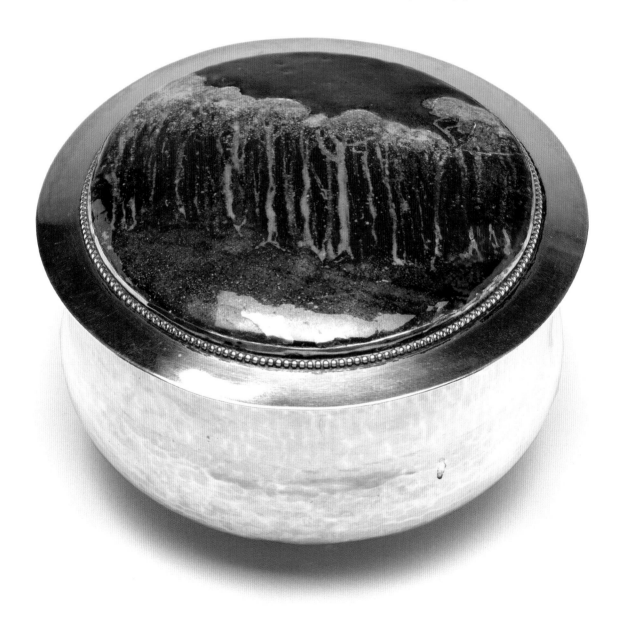

of enamelling, plique-à-jour (in which the enamel is set within metal 'cells', but is not backed by a metal plate), is rare on Guild pieces, but appears occasionally. Small panels of it appear in the upper part of the foot on the Gardiner cup and were presumably made by Mark or Varley. Although they are spirited and colourful, the placement of them does not show them off to their best, as the spacing of them in front of the cup stem does not allow them to be properly lit from behind, which is the benefit of this form of 'backless' enamelling (*right*). The fish depicted is reminiscent of the fish seen in the pottery designed by William De Morgan.

The longest legacy of the Guild is the Hart silversmithing dynasty, which continues to this day. The workshop remains in the original Guild premises in the old silk mill on Sheep Street, Chipping Campden. George Henry Hart (1882–1973) joined the Guild in 1901 as a metalworker and moved with the Guild from London to Chipping Campden in 1902. After the liquidation of the Guild, George stayed on and continued to run the workshop, and even by as early as 1914 it was clear that he was going to make a success of the firm and remain after others had left, which Ashbee put down to the 'quality of his sticking power, his diligence, his doggedism',[126] characterising him as a man who has 'developed into a good workman who is always to be relied upon to execute an order on time, he will not let you down, he will always be as good as his

word', and whose craftsmanship was 'solid if a bit hard'.[127]

The workshop flourished during the 1920s, with the commission of a huge processional cross for Gloucester Cathedral, later used in the 1953 coronation of Queen Elizabeth II, and the creation of the Royal Ascot Hunt Cup, following George Hart's winning design in a competition run by the Worshipful Company of Goldsmiths.

George's sons, Henry and George Philip (1912–1990) joined the workshop in 1928 and 1933 respectively, but George (the younger) left in 1950 to pursue farming. Although

Henry too was a keen farmer, he took over the running of the workshop, and his sons David (b. 1938) and Rex joined the family firm in 1956 and 1971 respectively. However, like his uncle, Rex left in 1984 to pursue his interest in farming. David Hart continues to run the workshop today with his son William (who joined in 1990), nephew Julian (who joined in 1994) and Derek Elliott (who joined in 1982). The firm continues to make high-quality silver and jewellery in the Arts and Crafts style, mostly using George Henry Hart's design drawings from the early twentieth century. This large archive is now cared for by the Hart Silversmiths Trust.

Among Hart's regular patrons were Peter and Olive Ward, who kindly bequeathed some pieces from their collection to the Fitzwilliam Museum. The Wards had strong connections to Cambridge; the pair met while studying in Exeter (they married in 1955), but Peter (1932–2007) subsequently read Economics and Law at Emmanuel College as a mature student in the mid-1960s, and Olive (d. 2015) was elected a Schoolteacher Fellow at Clare College in 1976, after having become Head of Science at Cheltenham Ladies' College. It was whilst at Cambridge that Peter met Richard Ames-Lewis, Ashbee's grandson, and first became interested in the Arts and Crafts movement. In 1971 the Wards purchased

CAT. NO. 38 Silver headband, designed and made by Henry Hart, 1970–71

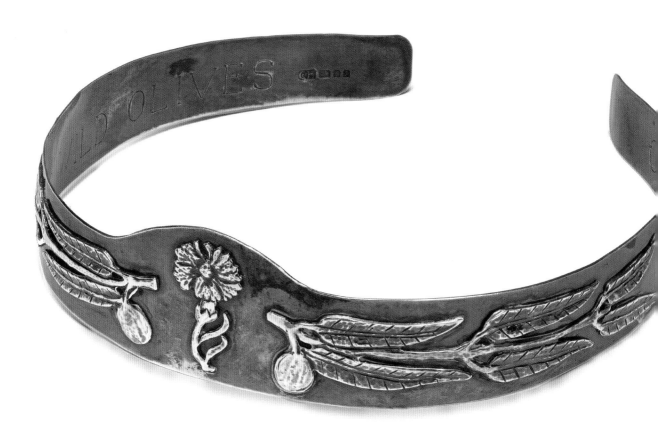

Wells Head Farmhouse, near Cheltenham, and began collecting English silver and Arts and Craft metalwork, books and furniture.[128]

A silver headband (*cat. no. 38*) was made in 1970 to commemorate Peter and Olive's wedding of 1955, incorporating olive branches and the stylised pink, or carnation, which was the logo of the Guild of Handicraft. In 1979 the Wards commissioned a gold brooch (*cat. no. 39*) to commemorate Peter's parents' wedding anniversary, based on a 1906 design by George Henry Hart (*fig. 18*), which he had purchased from the workshop. Before selling it, Henry Hart copied the design, which remains in the collection of the Hart Silversmiths Trust. This is a fine example of

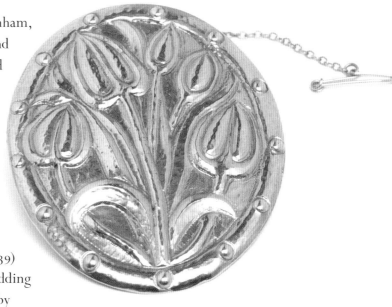

CAT. NO. 39 Gold brooch (*enlarged*), made by Henry Hart, 1979–80, to George Hart's pendant design of 1906

FIG. 18 Drawing, design for a pendant by George Hart, 1906. Cambridge, Fitzwilliam Museum.

the ongoing popularity of Arts and Crafts design.

One of the other pieces given by the Wards' estate is a hand mirror designed by the sculptor and Guildsman Alec Miller (1879–1961) (*cat. no.* 40). Born in Glasgow to a cabinetmaker, Miller trained as a woodcarver under Mrs C.P. Mackay (née Anstruther) and was offered a job by Ashbee after meeting him in London in 1902. He made his own way directly to Chipping Campden and became very close to Ashbee, building an intellectual rapport that Ashbee had not found among the other craftsmen. Miller was a talented carver and sculptor and, after the Guild failed, he stayed in Chipping Campden for some time (headed notepaper from 1909 shows that he was working in Chipping Campden as an architectural sculptor and carver with colleagues Fred Miller and William T. Hart).[129] Miller completed many architectural commissions, especially for devotional spaces, notably the Church of St Mary and St Michael of Great Urswick, Cumbria, but he also began to work as a sculptor. Throughout the 1920s and 1930s his work became more in demand in the United States, and he emigrated to California in 1939. According to Julian Hart, it seems likely that this mirror was designed and the model probably carved by Alec Miller, but that the mirror was made (cast, repoussé and chased) by the Hart workshop, in the early decades of the twentieth century.[130] The subject of this hand mirror

is probably the Greek mythological tale of Hylas, companion of Heracles, being abducted by water nymphs.[131]

Work by another former Guildsman is also represented in the Museum's collection. This carved horn hair comb (*cat. no.* 41) was made by Frederick James Partridge. Born in Barnstaple in 1877, Partridge trained at the Birmingham Municipal School of Art between 1899 and 1901. Here he met his future wife, the talented jeweller and enameller May Hart (no relation to the Hart family). He returned to Barnstaple after leaving Birmingham, moving to Chipping Campden in 1902 to

work for Ashbee as a jeweller at the Guild of Handicraft. His stay was short and he left in 1903. Partridge moved to London, marrying May in 1906. He worked from several addresses in the capital, receiving commissions from private individuals as well as supplying jewels to Liberty. He is also believed to have spent time in Branscombe, Devon, working with Ella Naper, whom he is thought to have met whilst teaching at the Camberwell School of Art. After May's death in 1917, Partridge moved to Ditchling with his daughter Joan in order to join his sister, the famous weaver Ethel Mairet. There he continued to make jewellery as well as objects in wood, including buttons for Ethel's garments and tools for weaving. He died in Ditchling in 1945.[132]

This comb represents some of Partridge's best work. The subtle combination of materials and the sculptural quality of the leaves, achieved by soaking the horn in chemicals until soft enough to curve and carve, produce a more delicate effect than seen in other horn jewellery produced in Britain during the early part of the twentieth century. Although not as various and diverse in design as horn objects made in France, where jewellers created a multitude of small and intricate bees and flowers, horn jewellery (especially hair combs) remained popular in England until the 1920s, when horn was replaced by early plastics, which were cheaper and easier to work.

HENRY WILSON *1864–1934*

An architect-turned-metalworker, Wilson was one of the most influential figures of the early twentieth century in promoting the organisation, education and professionalisation of metalworkers, as well as designing jewellery and silver with a uniquely three-dimensional, sculptural quality, incorporating gemstones and richly toned enamelling.

Born in West Derby, near Liverpool, Wilson studied at Kidderminster School of Art and subsequently worked for architect Edward James Shrewbury in Maidenhead, before moving to London and training in the practices of John Oldrid Scott, John Belcher and J.D. Sedding. After Sedding's sudden death in 1891, Wilson took on much of his work, completing his schemes. However, his architectural work soon shifted towards more decorative aspects of design, including plasterwork, and a growing interest in craftsmanship, especially metalwork. In 1896 Wilson set up his own studio at 17 Vicarage Gate, Kensington, employing silversmith Lorenzo Colarossi on a part-time basis, from whom he learnt the more technical aspects of metalworking. Over the next three years the pair produced a range of metalwork, jewellery, church plate and furnishings. In 1901 Wilson married his fiancée of ten years, Margaret Morse, and the pair moved to Kent to supervise the building of their new home, known as 'The Thatched House', near Sevenoaks. Workshops and cottages for workers were also built on the plot, allowing Wilson to move his entire enterprise there

from London. However, the proximity to London enabled him to maintain his involvement with numerous educational and artistic institutions.

Wilson's strengths lay not only in designing unusual and intricate jewels, but also in teaching, educating and organising many of the craftspeople who formed the loose Arts and Crafts movement. From 1896 Wilson taught at the Central School of Arts & Crafts, and from 1901 taught metalwork at the Royal College of Art. He was also Visiting Examiner at the Vittoria Street School for Jewellers and Silversmiths at Birmingham School of Art between 1905 and 1917. His students and assistants often went on to hugely successful careers of their own. They included John Paul Cooper (*see* pp. 116–21), whose work was greatly influenced by Wilson's style, and H.G. Murphy (*see* pp. 132–7), who learnt a great deal from Wilson but broke away and designed silver in a noticeably more restrained and modern style.

Wilson was the first editor of *Architectural Review* (1896–1901) and in 1903 published his very popular practical handbook *Silverwork and Jewellery*. This surprisingly pragmatic

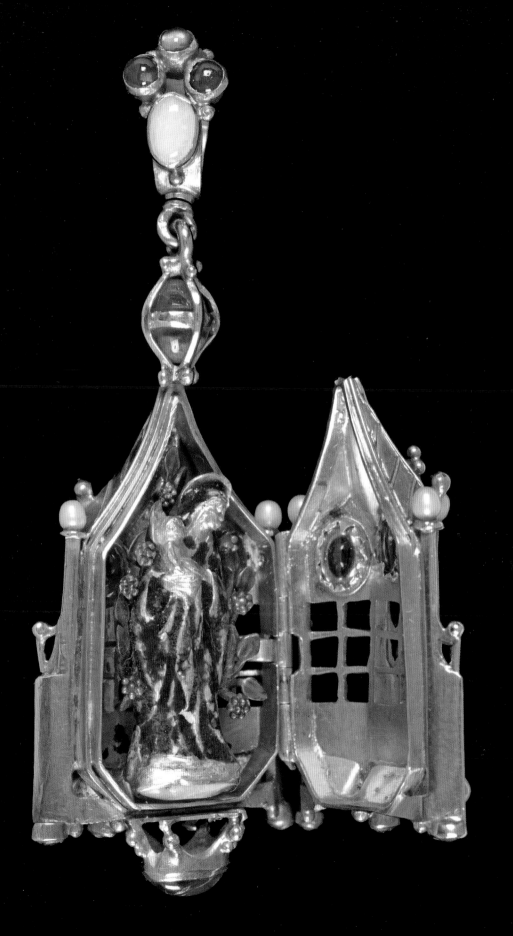

E.660(170)-1955

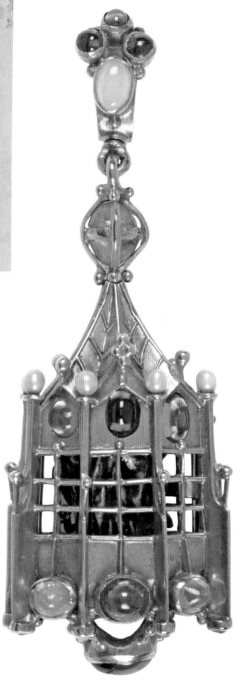

FIG. 19 Wilson's sketch for the reliquary pendant (cat. no. 42). London, Victoria and Albert Museum

CAT. NO. 42 Gold reliquary pendant (*enlarged*), designed by Henry Wilson, *c*.1897–1912

manual displays Wilson's thorough grasp of the physical making of metalwork and jewellery, explaining methods, terms and the importance of using correct and good-quality materials, but it also summarises his philosophy of design, focusing on the importance of process and of makers remaining humble, using their 'native powers' and attending 'faithfully to [their] instincts'.[133] Wilson was appointed chairman of the newly formed Goldsmiths', Silversmiths' and Jewellers' Art Council in 1908 and was chosen to select the British jewellery for the Paris Exhibitions of 1914 and 1925. From

1915 to 1922 he served as president of the Arts and Crafts Exhibition Society, organising the major Arts and Crafts exhibition at the Royal Academy in 1916. After having become a member of the Art Workers' Guild in 1892, he was elected Master in 1917, and was a member of the International Society of Painters, Gravers and Sculptors. In 1922 Wilson emigrated first to Paris, and then, after the death of his wife in 1931, to Menton, where he died in 1934.

Much of Wilson's success derived from his ability to juggle many different tasks, organisations and people, and to balance Arts and Crafts maxims with a pragmatic approach to producing beautiful, profitable objects, which enabled craftspeople to earn a living. For example, Wilson was not against the use of machinery in order to make nails, buttons and mass-produced objects, as creating these by hand would bring no improvement to the object, or joy to the worker, but he believed that making artistic objects by hand would always produce a finer outcome than using a machine. Wilson paid attention not only to the quality of work and living conditions of those who worked for him, and those employed more widely in the trade, but to the nature and type of education provided by a multitude of institutions, as well as to the public representation of the trade, and the successes it achieved at international exhibitions. Gordon Craig's description of Wilson as a 'practical idealist' – combining attention to detail, even in the face of mountains of bureaucracy, and a distinct flair and skill in creating his own designs – seems an apt one.[134]

From early on in his career, Wilson was recognised as talented, and made a generally favourable impression on those who met him, including Janet Ashbee. Retelling a rehearsal meeting of the Art Workers' Guild Masque in 1899 (for which Wilson designed the stage), Janet Ashbee described him as looking 'like a seedy bank clerk, and … perhaps the greatest artist of the lot',[135] while just three years later C.R. Ashbee described him as 'one of the few real architects … that can be numbered on the fingers of one's two hands', different to the 'slaves of the lamp who will just do the dirty work in the usual commonplace way'.[136]

Initially, metalwork was an agreeable digression from his main architectural

CAT. NO. 43 Enamelled gold and black opal ring (*enlarged*), designed by Henry Wilson, c. 1900–1920

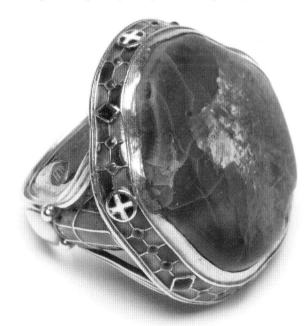

practice. However, Wilson's interest in building waned (his last commission to be built was finished in 1901) and by 1908 he insisted that he 'would rather be known as a goldsmith than anything else in the world'.[137] He made little domestic silver, favouring instead church plate and jewellery, including, unusually for Arts and Crafts designers, tiaras, which were viewed by many artistic people at the end of the nineteenth century as overly formal.[138]

Wilson's output was prodigious, totalling a huge number of individual pieces. A mounted album (dated 1897–1912), now in the Victoria and Albert Museum, contains 510 of Wilson's designs, mainly for jewellery, and shows a vast range, taking inspiration from architecture, Renaissance jewels, myths

FIG. 20 Wilson's sketch for a necklace now in the collection of The Wilson, Cheltenham, the angel pendant of which is similar to that of cat. no. 44. London, Victoria and Albert Museum

CAT. NO. 44 Gold necklace (*enlarged*), designed by Henry Wilson, c.1900-1910

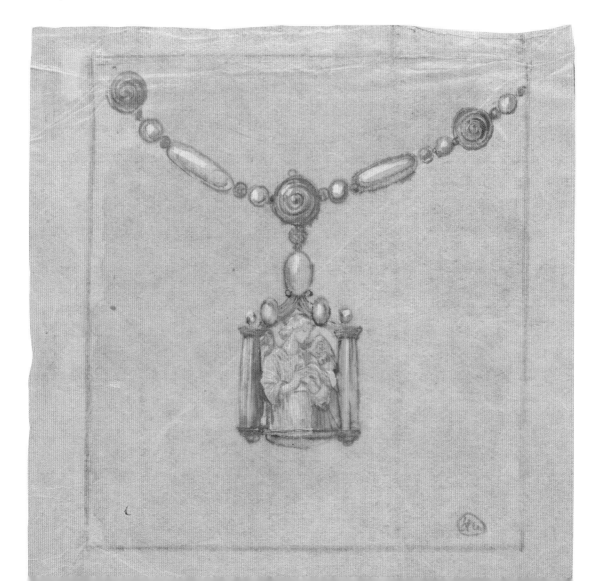

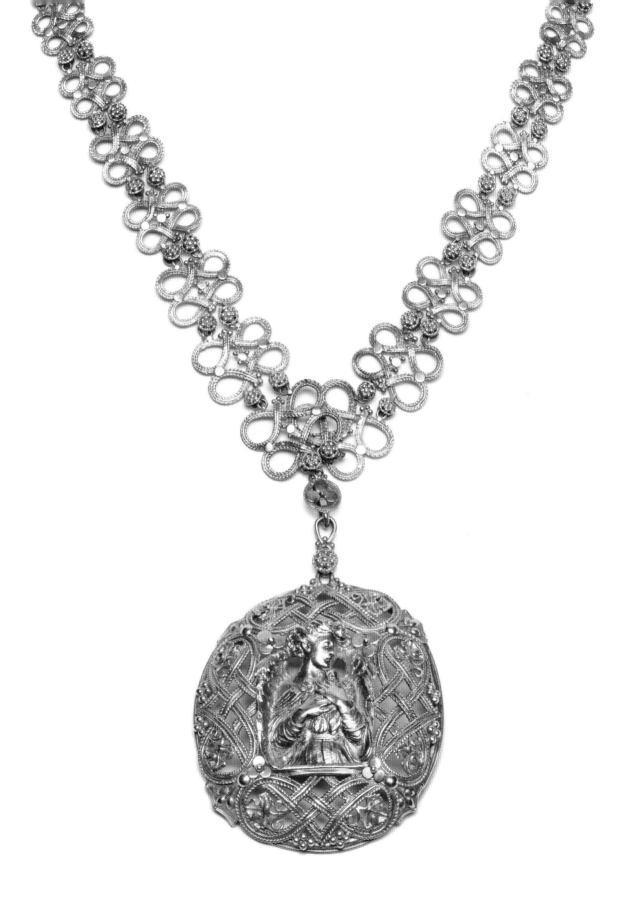

and legends. Wilson's jewellery – unusually for the period – is often in gold, and usually three-dimensional in form, with a significant sculptural quality, which can probably be attributed to his architectural training. Like other goldsmiths from this period who paid special attention to the use of materials, Wilson favoured simple, less expensive, polished gemstones, which contrasted with the faceted, sparkling gems used more often by commercial jewellers, described by Wilson as being cut with 'infinite ingenuity and intolerable hideousness'.[139]

The gold pendant in the form of a Gothic reliquary shrine (a common sight in churches during the Middle Ages, containing religious relics, often body parts of saints) encloses an enamelled Virgin and Child group (*cat. no. 42*). It is designed in the round, and Wilson's working sketch for it (*fig. 19*)[140] shows the attention he paid to the form, as well as the decoration. The ring, mounted with a large black opal (*cat. no. 43*), was formerly in the collection of the artist Charles Haslewood Shannon, and was presumably made for him or, more likely, for his slightly more flamboyant partner, Charles Ricketts (*see* pp. 99–115). It has also had more attention paid to the shoulders and under gallery than is common, and is made to be viewed from different angles. A similarly sculptural ring with

enamelled shoulders is illustrated in Wilson's sketchbook.[141]

A gold necklace features an angel holding a dove (*cat. no. 44*), a motif that clearly appealed to Wilson, featuring as it does in this design for a necklace (*fig. 20*), the pendant of which is identical to that on a necklace by Wilson now in the collection of The Higgins Bedford[142] and similar to a pendant on a necklace that Wilson made for the stained-glass artist David Strachan, in about 1910.[143] Various different sketches for the figure-of-eight chain links can be found on a separate page of the album.[144]

The hair comb (*cat. no. 45*) is attributed to Henry Wilson, based on the similarities between it and a sketch for a hair comb in Wilson's sketchbook (*fig. 21*).[145] Unlike the less successful 'backless' plique-à-jour enamelling on William White's cup and cover (discussed on p. 81), here the use of plique-à-jour is much more successful; once the comb was stuck upright in a woman's fashionable coiffure, the light would have been able to shine straight through, illuminating these spirited designs. Although more simplistic than the ship design, this hair comb uses the same techniques, and the tulips are seen to their best advantage when the comb is held up to the light.

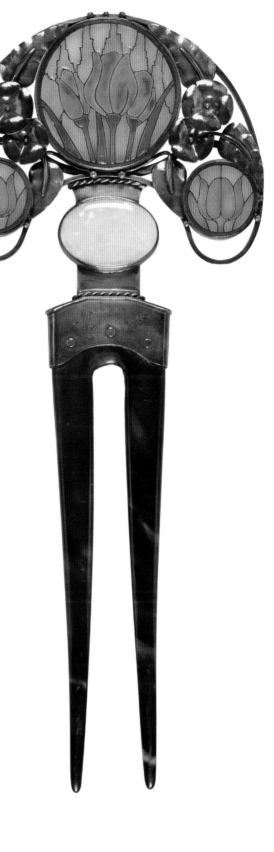

CAT. NO. 45 Tortoiseshell hair comb with plique-à-jour enamelled plaques, design attributed to Henry Wilson, c.1900–1905

FIG. 21 Wilson's sketch for a hair comb now in the collection of Glasgow Museum, and similar to cat. no. 45. London, Victoria and Albert Museum

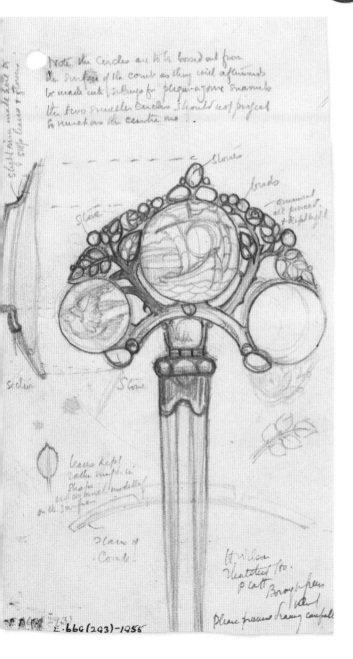

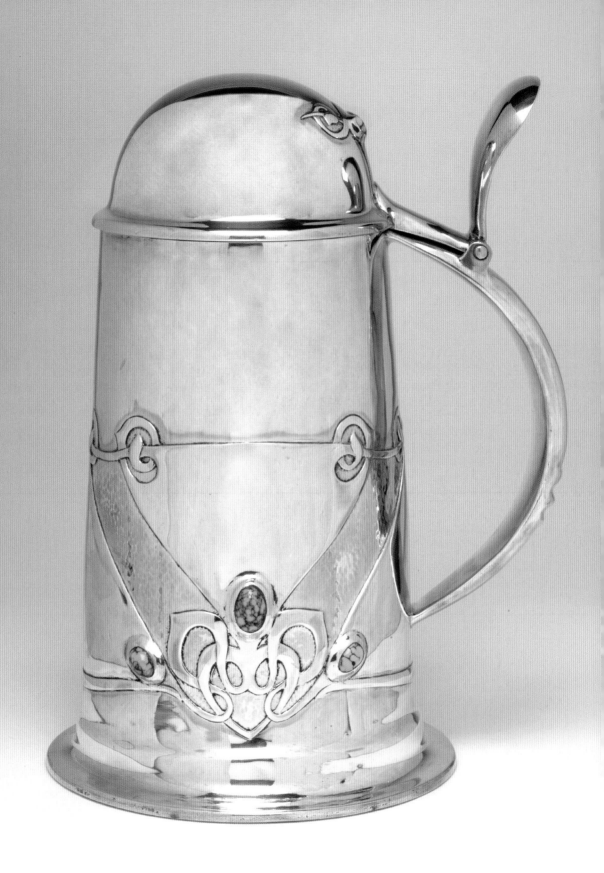

ARCHIBALD KNOX *1864–1933*

Knox was heavily influenced by the Celtic designs found on the Isle of Man and subsequently became one of the most productive designers of this period. His numerous swirling designs were produced for the London store Liberty and have become synonymous with English art nouveau.

Born on the Isle of Man to Scottish parents, Knox was educated at Douglas Grammar School and subsequently Douglas School of Art (1878–84), where he remained as a student teacher until 1888. In 1892 he began to work in the Douglas studio of architect M.H. Baillie Scott before leaving in 1897 to teach in London. During the 1890s he began to design for commercial designers and manufacturers, including the Silver Studio. The Studio sold five of Knox's textile designs to the London department store Liberty, which seems to have been the first connection between them.

Liberty was founded by Arthur Lasenby Liberty (1843–1917) in 1875, originally selling imported Chinese and Japanese objects, favoured by the Aesthetic set, before branching out into the Arts and Crafts and art nouveau. Liberty immediately noticed Knox's distinctive style, inspired by both the Manx Celtic monuments of his youth and the emerging whiplash and curvilinear style of art nouveau. From this time until 1912 the store commissioned hundreds of

pieces from Knox, including most of the designs for *Cymric* and *Tudric*, ranges of silver and pewter respectively, as well as for textiles and ceramics. There are competing theories surrounding the origin of the *Cymric* silver range. Many of the early designs (now housed in the archive of the Museum of Domestic Design and Architecture, Middlesex University) are unsigned and historically have been attributed to many different silversmiths; some of them, including cat. nos 47 and 48, are now thought to be early designs by Knox.[146] As Liberty insisted that the designers it worked with remain anonymous, the full extent of Knox's work for the store will never be fully known, but it numbers at least 5,000 pieces. Knox moved away from London in 1912 after being forced to resign from his job at Kingston School of Art (a post he had held since 1904) because of the advanced nature of his teaching. His students greatly admired him, however, and founded the Knox Guild of Craft and Design, rescuing some of his designs for Liberty which he had discarded on his departure from Kingston. Knox tried his luck in America but returned to teaching

on the Isle of Man. Liberty continued to sell his designs until the 1930s.

Knox continued to design Celtic-inspired monuments and tombstones (including that of Arthur Lasenby Liberty) and also painted watercolours of the Manx landscape. He never married. He died suddenly at home in 1933. His designs, however, have remained popular ever since, and have been central to the art nouveau movement in Britain. The swirling, asymmetric, 'whiplash' design, which proved so popular across Continental Europe, did not ever fully take hold in Britain, where the softer, more naturalistic style of the Arts and Crafts ruled, long after the work of the original designers fell out of fashion. But Knox's designs edged more closely to European art nouveau than most others. Drawing on Celtic motifs as well as European patterns, his stylised motifs and interlaced designs proved to be exceptionally popular with the public, as well as with

CAT. NO. 47 *Planta* silver waist clasp, probably designed by Archibald Knox, made by Liberty & Co., 1900–1901

Arthur Lasenby Liberty, who found that Knox could easily transpose his trademark style onto a myriad different objects.

These waist clasps (*cat. nos 47 & 48*) are typical of the period. Knox designed many different naturalistic, plant-like variations, often with delicate and swirling tendrils. The most iconic is probably the *Planta* clasp (*cat. no. 47*), which appeared in Liberty's catalogue of 'Yule-Tide gifts' in 1899, and

CAT. NO. 48 *Floris* silver waist clasp, probably designed by Archibald Knox, made by Liberty & Co., 1899–1900

was much reproduced. These waist clasps were made to be threaded through fabric belts worn by fashionable women of the artistic set around the turn of the century, and survive in great numbers. Both clasps were made for Liberty in London. The large silver tankard, however (*cat. no. 46*), is hallmarked Birmingham, and was probably produced by one of the Birmingham firms engaged by Liberty in order to meet demand for the popular *Cymric* range of silver launched in 1899, of which the tankard is

an example. It was most likely made by the firm of William Hair Haseler, who created so much of the *Cymric* range that eventually a subsidiary company was formed, known as Liberty & Co. (Cymric) Ltd, registered on 17 May 1901.[147] The separation of design and manufacture is evident in the difference between the sometime stiff and regimented flicks and curves of the finished object and the abstraction and freedom of Knox's initial designs, a small number of which survive.[148]

Another firm licensed to produce Knox's designs, Murrle Bennett & Co., produced the designs in Pforzheim, Germany, where the company had been founded, and subsequently imported them into England. It was this high-pressured production, with silversmiths in Birmingham using increasing mechanisation in order to turn out Knox's fashionable designs, that so irked many Arts and Crafts designers, especially as Liberty had originally made its name through selling more unique pieces of craftsmanship. As C.R. Ashbee (*see* pp. 70–85) later put it, 'the lassooing [*sic*] of the school of "Arts & Crafts" to the yoke of capitalism is the ingenious discovery of the Liberty Lasenby man.'[149] Writing in 1914, Ashbee noted the problem as he heard it from former Guild of Handicraft enameller William Mark:

> The Great Art School there [Birmingham] is playing more and more into the hands of the capitalist… The 'Liberty' producing department … it appears now take[s] in clever girls 10, 20, 30, studying at the art school, allow[s] them to work in the shops, for nothing – on the basis of practical experience, and having made them up turn[s] them out to make for others.[150]

These women then set up in business, making objects for Liberty, which sold them at a mark-up of '400%', which according to Mark was the mark-up they applied to his work too. It is easy, therefore, to see why Liberty perturbed so many craftspeople, but the popularity of the products retailed by them is undeniable. In Italy, the art nouveau style is referred to as 'Stile Liberty', demonstrating the huge and far-reaching influence of this trailblazing store.

CHARLES DE SOUSY RICKETTS RA *1866–1931*

Aesthete, collector, painter, illustrator and sculptor, Ricketts is remembered as one of the most talented and flamboyant artists of the late nineteenth century. His short-lived experiments designing jewellery resulted in some of the boldest and most unique pieces of the turn of the century.

Charles de Sousy Ricketts (1866–1931) was born in Switzerland to a retired English naval officer and his Italian wife, Cornelia Marsuzi de Aguirre.[151] He spent his youth travelling in Switzerland and France, receiving little formal education. After his mother's death in 1880, he returned to England with his father and sister. As he was thought too delicate to attend school, he spent the next few years reading and visiting museums until he entered the South London Technical School of Art in Kennington, in 1882. Here he met Charles Haslewood Shannon (1863–1937), who became his life partner. Together they founded *The Dial* (1889–97), an occasional art journal, and began to illustrate books both for friends and for commercial publishers. The pair are immortalised in this painting of 1920 (*fig.* 22), painted by their friend Edmund Dulac, in which they are depicted as a pair of medieval saints in monastic habits.

In 1894 they set up a publishing company, the Vale Press, which produced over 80 volumes, many of which were reprints of poetic works, each one designed by Ricketts. He lost interest in this venture after a fire destroyed his stock in 1899, but continued to illustrate books for friends, including Michael Field (see below). He painted and sculpted, producing works of art that were romantic or tragic in theme, often based on mythology. He was elected ARA in 1922, and RA in 1928. Ricketts was best known, however, for his theatre design, beautiful watercolour illustrations of which survive in the Victoria and Albert Museum. The productions he designed for included Oscar

Wilde's salacious *Salomé* (1906), as well as new plays by W.B. Yeats and George Bernard Shaw.

Connoisseurial as well as artistic, Ricketts and Shannon were eclectically acquisitive, and together they amassed a large and wide-ranging collection that encompassed classical and Egyptian art, works on paper by European artists including Burne-Jones, Delacroix, Van Dyck, Goya, Holman Hunt, Rodin, Rossetti, Rubens, Tiepolo and Watteau, as well as Japanese woodcuts. On Shannon's death, some paintings were bequeathed to the National Gallery, while the bulk of the Japanese material was sent to the British Museum. Everything else, including the ancient art and drawings, came to the Fitzwilliam Museum. On Ricketts's death in 1931, a small part of the collection had been received on loan, but this was joined by other material and was bequeathed to the Museum by Shannon on his death in 1937. A small exhibition of the material was held in 1966, on the centenary of Ricketts's birth, followed by a much larger exhibition in 1979, *All for Art*, which did much to raise the profile of these distinct collectors.

Ricketts was offered, but declined, the directorship of the National Gallery, but acted as art advisor to the National Gallery of Canada in Ottawa (1924–31). He wrote some slim volumes of short stories, but the

final years of his life were overshadowed by Shannon's illness. Whilst hanging a picture in 1929, Shannon fell and suffered brain damage. Ricketts cared for him, but the strain of providing income to cover their nursing expenses no doubt contributed to his sudden death in 1931. Shannon lived for another six years.

Ricketts was incredibly astute, but also very sensitive – a piece of gossip from writer Lawrence Housman, recorded by Janet Ashbee in April 1900, paints a picture of Ricketts's mood swings:

> The talk turned on Ricketts and the press – 'oh I should give Ricketts a wide berth if I were you,' he [Housman] said with a twinkle – 'I'm engaged on keeping away from him just now – most people are – even Shannon you know – he's such a touchy fellow, can't bear a word of criticism. And Shannon used to temper the wind to the shorn lamb of him so beautifully; I remember once when —— blurted out some adverse review of his work – Ricketts turned silver with rage (he always does turn silver you know) – and poor Shannon muttered, 'There's my peace of mind gone now for a month – what did you tell him for? I've been keeping it from him for ever so long!'[152]

However, Ricketts was also witty and vivacious and could be excellent company. Tiny in stature, with wispy pale red hair (*see figs* 22 & 23), he was seriously affected by the visual stimuli around him, and is credited with being of the 'last and most resolute generation of the Aesthetic Movement'.[153]

FIG. 22 Edmund Dulac (1882–1953), *Charles Ricketts and Charles Shannon as Medieval Saints* (1920), tempera on fine linen over board. Cambridge, Fitzwilliam Museum

FIG. 23 William Rothenstein (1872–1945), *Charles Ricketts* (1894), chalk on paper. Cambridge, Fitzwilliam Museum

Although Ricketts is best known for his illustrations and theatre design, he undertook a brief but productive period of jewellery design. This partly stemmed from his love of Renaissance jewels, but also from his growing interest in sculpture (especially in the work of contemporary French sculptor Auguste Rodin), which he moved on to after his brief stint designing jewellery. His sketchbook of 58 designs, now in the British Museum, entitled *'Designs for Jewellry [sic] done in Richmond 1899, C. Ricketts'*, displays a highly innovative approach to creating jewellery with a sculptural

quality, incorporating Renaissance-style polychromatic enamelling, grotesque masks and gemstones, and occasionally the sinuous curves employed by art nouveau designers such as Henri Vever and René Lalique.[154] He was an admirer of the sixteenth-century jewellery of Hans Holbein and Benvenuto Cellini and of the Renaissance jewels designed 'to express ideas and allegories' which 'combined precious stones with enamelling on gold, cast and chased into human, animal and hybrid forms'.[155] Ricketts enjoyed looking at and working with gemstones and believed that 'there is no good in any gem we do not raise to the mouth as a sweet'.[156] According to his great friend the writer and artist Thomas Sturge Moore (1870–1944), these stones were used as a starting point; 'Ricketts kept a collection of precious stones in a drawer; after arranging a few on a piece of paper, he would design settings for them, with pen and water-colour'.[157] Ricketts's talents did not include the requisite skills to make the jewels physically himself; for this he employed the firm of Giuliano (*see* pp. 24–7), whose neo-Renaissance jewels and fine enamelling suited his designs.[158]

Ricketts created one-off pieces, always with the intention of giving them as gifts. His intentions were never commercial. The recipients of his unique designs included Edith Broadbent, known as Ryllis Llewellyn Hacon during her marriage to William Llewellyn Hacon, a partner in the Vale Press, for whom Ricketts made a medallion

jewel incorporating her profile (now in the Ashmolean Museum),[159] and May Morris (daughter of William Morris), for whom he designed a ring that she later bequeathed to the Victoria and Albert Museum.[160] However, Morris only wore it for a week, causing Ricketts to complain that 'she is an indolent woman'.[161] Instead, he preferred to design for his and Shannon's close friends Katherine (sometimes Katharine) Bradley and Edith Cooper, known together as Michael Field, whom they had met on New Year's Day 1894. At that time, Ricketts and Shannon were living in the former home of the painter James Abbott McNeill Whistler in Chelsea, filled with Ancient Greek vases, Japanese woodcuts and old-master drawings, deemed by Oscar Wilde to be 'the one house in London where you will never be bored'.[162]

Bradley and Cooper's relationship mirrored Ricketts and Shannon's in that it broke the rules dictated by nineteenth-century society. Katherine Bradley was Edith Cooper's aunt but the two enjoyed a long and devoted romantic relationship, sharing a house and a life together. In this way, their relationship mirrored that of Ricketts and Shannon, and thus enabled an open and relaxed relationship between the two couples, who could be themselves among similar company. After their first proper outing together as a foursome (also accompanied by Cooper's sister Amy) on 22 May 1894, Cooper seems relieved to have met people with whom they could have fun

and wrote, almost with relief, 'He [Ricketts] is an ardent lover of Shannon … loving him as my love loves me … these 2 men live & work together & find rest & joy in each other's love just as we do.'[163] They left that evening with a sense 'we have walked into friendship as deep as moving grass.'[164] The relationships of Bradley/Cooper and Ricketts/Shannon have been written about previously with some degree of coyness, but it is clear that neither pair was simply 'good friends' as referred to throughout most of the twentieth century. Ricketts and Shannon were more circumspect because of the law (which recognised and punished only male, not female, homosexuality), but it is safe to say that both relationships were romantic, with Bradley and Cooper's certainly including an erotic physical aspect.

The women wrote poetry and plays together under the single male pseudonym Michael Field. Their real identities were soon discovered; although this undoubtedly affected their commercial success, the two women did not drop the pseudonym, instead embracing the notion of themselves as a combined identity throughout the rest of their lives. Katherine Bradley referred to herself as 'Michael', whereas Cooper was known as either 'Field' or 'Henry'. In their joint diary, entitled *Works and Days*, the pair refer to themselves by these names and often use male pronouns too. Often they refer to themselves as 'the Poets' while Ricketts and Shannon were 'the Painters' or 'the

Artists'. Ricketts was also known as 'The Painter' or 'Fairy Man' or 'Fay' because of the wizardry of his talents. However, their penchant for male nicknames was not reflected in the pair's aesthetic. Purposely ignoring the mannish attributes associated with the liberal and educated 'New Woman' of the 1890s (who was often automatically linked to lesbianism irrespective of her actual sexuality), the pair shopped often, purchasing dresses from Liberty, and enjoyed their feminine appearance, often praising one another's beauty in their joint journal.

Ricketts's intense period of jewellery design corresponded exactly with a period during which the two couples were particularly close. In 1898, Ricketts and Shannon had moved to Richmond, and a year later persuaded Bradley/Michael and Cooper/Henry to move there too, into their first independent home. They found a charming eighteenth-century house for the pair, aptly named 1 The Paragon, just ten minutes' walk from their own home, and the two women proceeded to fill it with Ricketts's paintings, Shannon's erotically charged lithographs, Japanese prints, Persian plates, porcelain, glass, silk and jewels, sharing a curtained bed designed by William Morris.[165] They insisted on formal dress and gave elaborate if intimate dinners, hosting 'the Painters' at least once a week. This unusual level of intimacy between the friends lasted

FIG. 24 Ricketts's design for a pendant (cat. no. 49). London, British Museum

for three years until Ricketts and Shannon moved to a large apartment in Holland Park in 1902, haughtily nicknamed by Field 'The Palace', although they continued to visit.

Bradley/Michael and Cooper/Henry were gifted a large portion of Ricketts's jewels, only some of which survive. The occasion of each gift is noted in Field's diary, giving us unusual insight into how they were received. Of the jewels in the Fitzwilliam (bequeathed to the Museum by Bradley/Michael), the first to be shown was not actually intended for either of the women. On 5 December 1899 Cooper/Henry recorded seeing the sinuous, art-nouveau inspired pendant (*cat. no.* 49 & *fig.* 24):

> Suddenly he [Ricketts] produces a pendant worked by Giuliano from his design and a thrush-egg turquoise the stone supported by two pearls, & the golden enamelled curved ending in an amethyst-drop of March-rain, rather dark and almost broken in sphere. We try it on – as I have a sailor knot & rough blouse I try it on my back – effectively! It is to be painted as hanging on the breast of Icarus in a new picture – he keeps silent about any other fate & a delicate terror of a snub keeps us admiring it impersonally. At last Michael says she would like her pendant to resemble this one, & it then appears that if she is very good, & when Icarus has his pendant safely painted, this very one may be Michael's.[166]

Sure enough, the pendant was later given to Bradley, who wore it on a gold chain.[167] On

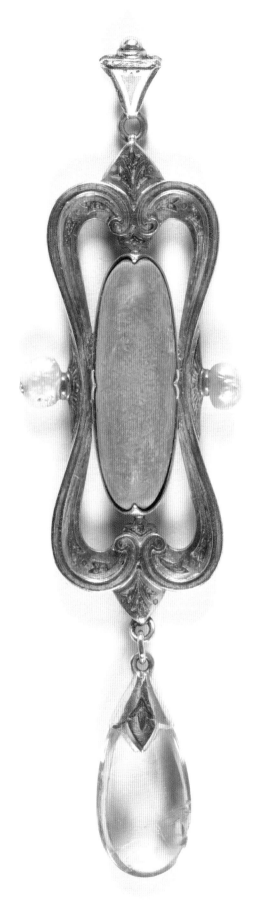

CAT. NO. 49 Enamelled gold and green turquoise pendant (*enlarged*), designed by Charles de Sousy Ricketts, made by Carlo & Arthur Giuliano, 1899

this day Ricketts also presented a blue bird brooch, inspired by classical Roman doves. There are four versions of this design in Ricketts's sketch book (see fig. 25 for the most complete)[168] and it is likely that it was inspired by a blue bird brooch designed by Burne-Jones when it was shown at the New Gallery in 1892.[169] The brooch was intended for Cooper/Henry's birthday on 12 January 1900, but Ricketts presented it to her earlier and she wore it on Christmas Day 1899. Bradley/Michael records her wearing it as follows:

> Henry wears his beautiful new toy, that dove that surpasses the Phoenix in colouring, having her feathers of green & blue enamel, & pecking daintily at corals on a golden bough.

There is some confusion as to the exact chronology of this brooch, as Cooper/Henry also records being given a similar brooch by Bradley/Michael on her actual birthday, 12 January 1900, just over two weeks later, unless this was simply a re-presentation. In their journal, Cooper/Henry wrote: 'My love has given me L'Oiseau bleu – the brooch designed by Ricketts – Byzantine, wonderful.'[170] However, a blue bird brooch was sadly lost on the way home from church on Easter Day 1909:

> Returning home I find my Blue Bird Brooch gone! Fay's first design for a jewel, a design so admirable and admired <u>even</u> by his enemies. It is this that striked [sic] me faint – someone will pick up a pretty little brooch, but the world will have lost a creation of

genius. The church is searched, the Police and Presbytery apprised, notices & reward prepared.[171]

Either there were two brooches, and one was lost, or the one brooch was subsequently found, or another made later to the same design, but whichever is the case a brooch matching exactly this description was left to the Fitzwilliam Museum (*cat. no. 50*).

Less than a year later, on 2 May 1901, a day recorded in Field's diary as 'Miniature Day', Ricketts presented Bradley/Michael with a miniature of Cooper/Henry. Ricketts insisted that Field visit him at Spring Terrace in their 'best array', which gave Bradley/Michael the feeling that 'distinctly something great will happen'. In a typically

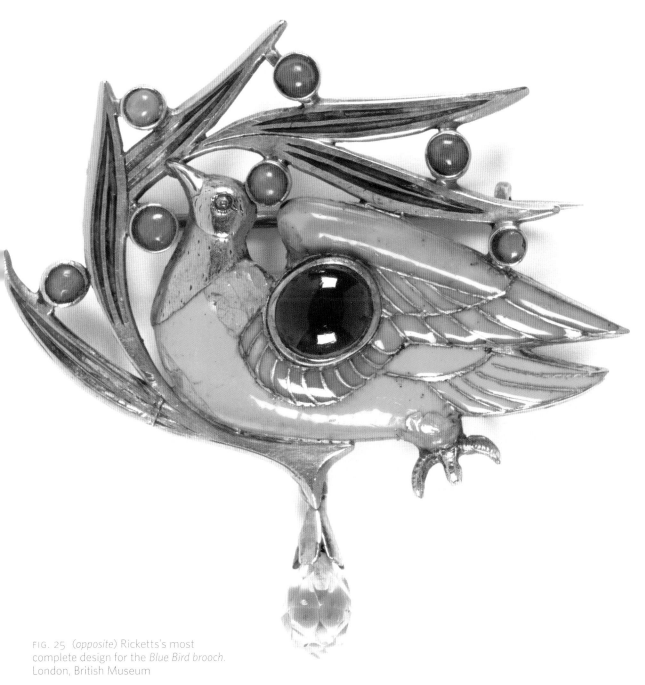

FIG. 25 (*opposite*) Ricketts's most
complete design for the *Blue Bird brooch*.
London, British Museum

CAT. NO. 50 Enamelled gold *Blue Bird
brooch* (*enlarged*), designed by Charles
de Sousy Ricketts, made by Carlo &
Arthur Giuliano, 1901

playful way, Ricketts showed them some jewels, then, as Bradley/Michael records, he said:

> 'There are more miracles' & points to an inverted … saucer. I must turn it back, I tremble, fearing something will start & jump… I look down – her face is there: my eyes grow wet as I look, then I turn to the painter & look long, not speaking. Indeed one cannot speak or write. Afterwards Shannon comes in & asks, 'what was the first exclamation.' 'A charming blush is the response', I am grateful he [Ricketts] does not chronicle the exclamation of tears.[172]

The portrait is monogrammed 'MF' for 'Michael Field', again emphasising the combined identity of the couple. Ricketts consulted Michael Field as to the design of the pendant to house the tiny miniature, which was made later in the year and was nearing completion by the end of September, when Ricketts saw it in Giuliano's workshop (*cat. no.* 51 & *fig.* 26). In a letter dated 22 September 1901 he described seeing 'the glorious Giuliano' (probably Arthur Giuliano) who 'received me in emeralds', and was pleased with what he saw:

> I found the casting and chasing had turned out quite excellently, so well in fact that we must expect something faulty in the enamelling, and I almost regretted that that mask and horse are not to remain mere gold.[173]

Just a couple of days later, Ricketts wrote in his diary that he thought 'the pendant looks a little thick',[174] but it was presented

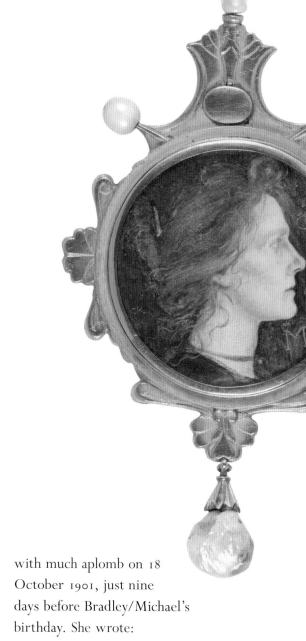

with much aplomb on 18 October 1901, just nine days before Bradley/Michael's birthday. She wrote:

> I experience bliss on this day. We dine at Spring Terrace – After dinner the jewel is shown. It is handed about as we wear it alternately: the men button up their coats, look like ecclesiastics wearing some starry symbolic gem. Then Ricketts reads me from his closing portion of a letter written to me & not sent, saying the jewel looked like one taken from his hat by Sir Philip Sidney & presented to Queen Elizabeth. He says

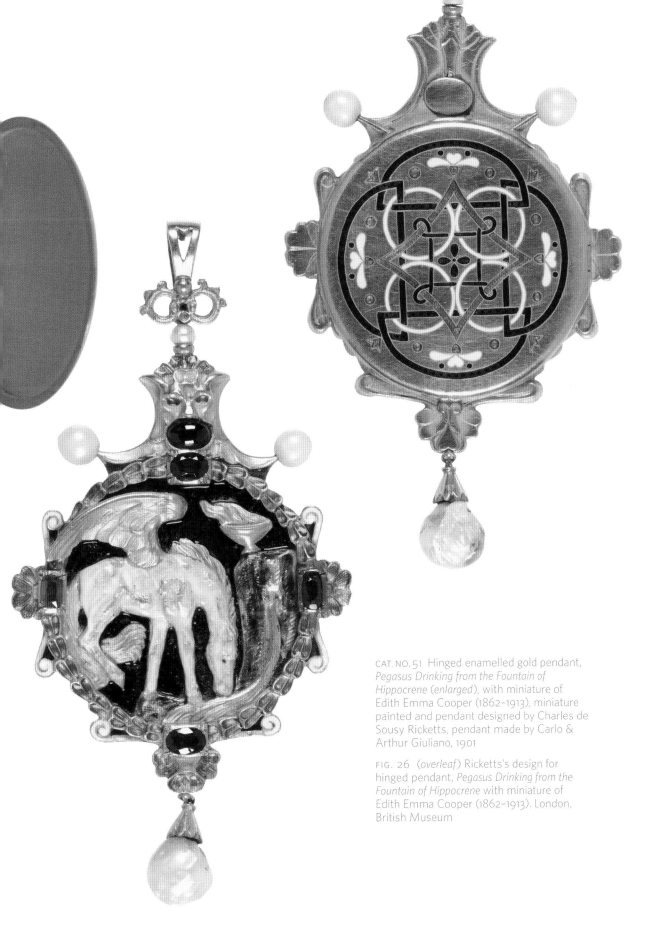

CAT. NO. 51 Hinged enamelled gold pendant, *Pegasus Drinking from the Fountain of Hippocrene (enlarged)*, with miniature of Edith Emma Cooper (1862–1913), miniature painted and pendant designed by Charles de Sousy Ricketts, pendant made by Carlo & Arthur Giuliano, 1901

FIG. 26 *(overleaf)* Ricketts's design for hinged pendant, *Pegasus Drinking from the Fountain of Hippocrene* with miniature of Edith Emma Cooper (1862–1913). London, British Museum

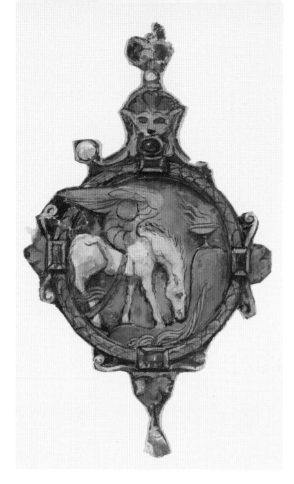

also he was so delighted with it the first few days, he thought it could not be more perfect, then like God, on Sunday, he began to reflect on his work, & discovered how in over two places the work had failed.[175]

This complex Renaissance-style jewel with an enamelled back incorporates garnets and a natural pearl, as well as a grotesque mask and two twinned rings above the pendant, representing Michael Field and the intertwined nature of their lives.[176] Both Ricketts and Shannon and Michael Field (and indeed Thomas Sturge Moore, see below) were greatly interested by classical myths and legends and incorporated the deities and half-deities into their work, both written

and visual. Field had written a collection of poems on the myths of couples such as Eros and Psyche and Adonis and Aphrodite in 1881, entitled *Bellerophôn*. The myth of Pegasus drinking from the Hippocrene (a spring on Mount Helicon, formed by Pegasus' hooves, the water from which inspired the imbiber with poetry) was well known to them.

The inspiration for the actual composition, with Pegasus stooping to drink, may have been taken from a classical carved gem in the Marlborough Collection. The entire collection was sold at Christie, Manson & Woods on 26–29 June 1899, where a sard intaglio of Bellerophon watering Pegasus at the Hippocrene appeared as lot 329 (sold for £9.10. – to 'Whelan'). As this sale coincided with the height of Ricketts's fascination with gems, he no doubt viewed the collection before it was sold. Alternatively, Ricketts may have taken the composition from the illustration in Oskar Seyffert's *A Dictionary of Classical Antiquities, Mythology, Religion, Literature & Art*,[177] which was a standard contemporary reference work.

CAT. NO. 52 Painted fan, *Psyche's Reception by the Gods*, painted by Charles de Sousy Ricketts, c.1901

Occasionally during this period, Ricketts's gifts to Field took other forms. Later the same year, Ricketts presented Cooper/Henry with a fan (*cat. no. 52*), probably as an early Christmas present. In a beautiful and delicate entry in Field's diary on Tuesday 17 December 1901, she records:

Ricketts brings me the fan. It is a miracle of Rainbow-Colour. The gods are watching Eros as he enfolds Psyche at the threshold of heaven – all on the space of a tropical butterfly's wing, caught by a handle of pearl. There are 14 figures on it and one half-figure – that of a little Love bolting into heaven. Blue & emerald & dull gold & a cloud of red make a living mottle. There is a dedicatory inscription & roses & stars sprinkle the intervals of sky & greenery & the various throng of feasting deities. The kiss of Cupid & Psyche is passionate and lovely. It is a great strain to handle the fan all evening, as I have never been devoted to the use of fans. I feel like a wind-mill that has just begun to work. But the iris of the colours is most becoming to my face, & this, I trust, makes amends of my conscious see-saw of the precious object.[178]

The fan depicts the conclusion of the story of Psyche and Eros, who, after many trials, were allowed to marry (they can be seen embracing on the left). Field had written about this epic love story in their 1881 volume, and perhaps felt an affinity with the love-struck couple of the myth, who overcame great challenges to be together. Once again, similar to the miniature presented by Ricketts earlier that year, the fan is inscribed 'To M. Field', emphasising the single entity by which Bradley and Cooper wished to be acknowledged.

In December 1903 Ricketts promised to make a ring for Michael/Bradley (*cat. no. 53*). The form was inspired by the jewel supposed to have been given to the hero in Michael Field's unpublished play *A Messiah* (1902), based on the story of Sabbatai Sebi (1626–1676), a Jewish mystic, who, having proclaimed himself Messiah in Jerusalem, was later converted to Islam. The architectural ring was inspired by the ring given to Sabbatai by the Sultan of Constantinople, which was based on the shrine of the Mosque of Omar, and which made him change his mind. It was designed to appeal to four senses: sight and touch, as most jewellery, but also smell (the ring was originally smeared with ambergris, a strong-smelling waxy substance from the digestive system of sperm whales

often used in creating perfume) and hearing (a loose emerald moves around inside it, and would have risen up 'to fill the window spaces like glass').[179] Bradley/Michael summed it up, writing:

> such an exquisite building – a little gem of space-composition enshrining a Presence, an emerald green as jealousy – a song that water brooks make.[180]

The ring may have been made by Giuliano but it is not marked. The wax model for it was completed on 8 January 1904, at which time jokes about the numerous windows and possibility of doors were made,[181] and on 5 February 1904 the ring was given to Bradley/Michael by Ricketts:

CAT. NO. 53 Gold and sapphire *Sabbatai ring* (*enlarged*), designed by Charles de Sousy Ricketts, probably made by Carlo & Arthur Giuliano, 1904

The Sabbatai ring is there – the generous ring:– the shrine and the presence, & the blue dome. I see also a worthless ring given to a model for a bet – the distance is immeasurable. 'This ring will cause much offence' Painter says, & I add 'that pleases you'.[182]

Five days later Ricketts visited, bringing the ring with him. He was disgusted that Roger Fry had not noticed him wearing it at the Burlington Fine Arts Club earlier in the week, but Bradley/Michael was delighted with it, and when she went to change for dinner wore it on a chain around her neck. Cooper/Henry wrote:

> When we came down dressed for dinner, Fay [Ricketts] is charmed by the ring Solomon in Michael's 'entre sein' [cleavage] – We talk toilette – how the breasts run wild in the new Samothrace corsets – They should be lifted somewhat like wine bottles raised for pouring![183]

Another beneficiary of Ricketts's penchant for creating jewels was Maria Sturge Moore (née Appia), wife of the poet and artist Thomas Sturge Moore. Moore was a great friend of both Michael Field and Ricketts and Shannon, but was especially close to Ricketts. The two formed a close and intense bond after having met at the South London Technical School of Art in Lambeth, and Moore, who was four years younger, fell completely under the spell of Ricketts: 'The energy and rapidity of his mind, his savage fastidiousness and his brilliant talk excited in Tom [Sturge Moore]

feelings not this side of idolatry.' Sturge Moore had long been close to his cousin Maria, but when the two finally decided to marry in 1903 Moore dreaded telling his friend, as he knew that Ricketts regarded 'marriage as a kind of death'.[184] Moore wrote to the artist on 12 July, beginning the letter:

> When I spoke to you last night about jewelry [sic], I was wanting you to either make or find rings for me and my cousin Maria Appia as we have quite recently become engaged against all expectation. But I was afraid you were not in the right mood to hear such a shocking confession.[185]

Ricketts composed himself enough to write back on behalf of himself and Shannon, congratulating the couple and promising:

> I shall have a great pleasure in seeing to the ring if you wish it, but in such as a case one chosen by yourselves might be more charming. At any rate I shall turn jeweller on my own account and make for your wedding the pendant of pendants which will tear all lace and scratch babies.[186]

Thomas and Maria were engaged and married in 1903, but the pendant, depicting Psyche descending into Hell, came later, after being completed in 1904 (*cat. no. 54*). It is the most ambitious of all of Ricketts's surviving pendants and displays a subtle complexity, interweaving the design of the main scene with that around the edge, and using gemstones in a completely asymmetric but imaginative way. Moore was fascinated by the myth of

Psyche all his life, and thus this pendant was made more for him than for his bride, although it can also stand as a sly comment about marriage from Ricketts, who chose to commemorate this particular moment in the myth. It depicts Psyche's descent into the underworld and her meeting with Cerberus. In her hand she holds a box (in green enamel), which held the honey cakes offered as a distraction to the three-headed monster, and coins for Charon, the ferryman. Ricketts had designed a similarly composed scene previously, in his illustrations for the 1897 Vale Press edition of Apuleius' *Cupid and Psyche*. According to the younger child of Thomas and Maria Sturge Moore, Henriette (Riette), Ricketts was pleased with the end result, created once again by the Giuliano firm, but 'had reservations about the quality of the enamelled ornament at the back'.[187] This enamelling incorporates the initials of the pair, 'TM' and 'MA'. This jewel, and the curved pendant originally made for Katherine Bradley (*cat. no.* 49) were left to the children of Thomas and Maria Sturge Moore, Riette and Daniel, who sold the pieces to the Fitzwilliam Museum in 1972, as, 'in view of the Michael Field jewels, designed by Ricketts, already in the Fitzwilliam Museum, we feel that this would be the right place for them'.[188]

However, these glorious experiments in jewellery were short-lived. Although

Ricketts was usually pleased with the pieces once they were finished, and he was happy for them to be shown in public and private, he often spotted errors in them over time, and was not always completely satisfied with the goldsmiths' work. In Sturge Moore's opinion, the 'goldsmith always failed to rise to the occasion' in creating Ricketts's pieces:

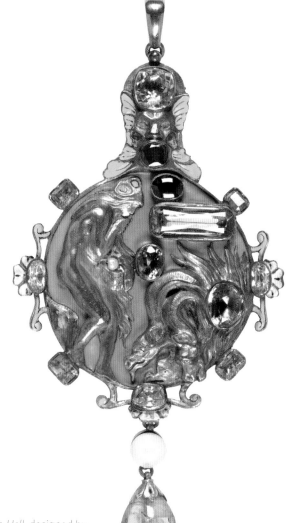

CAT. NO. 54 Enamelled gold pendant, *Psyche Descending into Hell*, designed by Charles de Sousy Ricketts, made by Carlo & Arthur Giuliano, 1904

They thought it a point of honour that work should not easily break, but the old jewellery that Ricketts admired had broken only too easily. Wearers should be as flower-like as fairies, or circumspect as seraphs whose wings are all eyes. The delicacy he admired would have rivalled gold wreaths made for the dead, for whom economy as well as taste dictated a butterfly frailty. But Shannon calculated that over £100 had gone in a single year on gifts of jewellery, one piece alone having cost over £40, and Ricketts reluctantly admitted that this branch of design had better be given up.[189]

The cost of these pieces was enormous. Ricketts often lied to Shannon about the price of the jewels, and Michael Field were so concerned about the cost of the Pegasus jewel that they considered selling some of their beloved clothes to a Gypsy pedlar, and were relieved when the royalties of their play, *Race of Leaves*, arrived and solved the problem.[190] Ricketts even inserted the constant stream of bills from Giuliano into a play he and Michael Field were writing together based on the story of Madame de Chateaubriand and her jewels at the court of Francis I, to be called 'Giuliano or Never Never Let Us Part'.[191]

Although Ricketts spent very little time designing jewellery, the pieces he created have proven to be some of the most popular and influential designs of the period, warranting inclusion in a number of major exhibitions throughout the twentieth century. The pendant depicting Psyche was lent by Mrs Sturge Moore to the Royal Academy Winter Exhibition of 1933,[192] and to the seminal exhibition of Victorian and Edwardian Decorative Arts held at the Victoria and Albert Museum in 1952.[193] The Fitzwilliam Museum also lent the blue bird brooch[194] and locket containing a miniature of Edith Cooper to both of these exhibitions,[195] as well as lending the Sabbatai ring and fan to the Royal Academy exhibition only.[196] All four of these jewels were also lent to the *International Exhibition of Modern Jewellery 1890–1961*, held at Goldsmiths' Hall in 1961.[197]

JOHN PAUL COOPER *1869–1933*

Although at first inspired by the metalwork and jewellery of Henry Wilson, John Paul Cooper went on to develop his own style and began to incorporate a wide range of different materials into his jewellery and metalwork, also single-handedly reviving the art and popularity of shagreen.

Cooper was born in 1869 to John Harris Cooper (1832–1906), a successful self-made businessman, and Fanny Loder (1834–1921), a well-educated daughter of an antiquarian bookseller. The eldest of four children, Cooper was educated at Bradfield College, Berkshire, and subsequently moved to London to study architecture. At the end of 1888 his father tried to place him as an apprentice at Norman Shaw's architectural practice, but it was full, so Shaw's assistant W.R. Lethaby (who became a great friend of Cooper's), suggested the practice of J.D. Sedding (1838–1891) at 447 Oxford Street, next door to the showroom of Morris & Company. Cooper was accepted for three years in the first instance and became a close friend of Sedding's chief assistant, Henry Wilson (1864–1934) (*see* pp. 86–93), with whom he attended drawing classes and often travelled to the Continent to sketch.

As mentioned previously (*see* p. 86), after Sedding's sudden death in 1891 the practice was taken over by Wilson and there was a gradual shift towards more decorative aspects of design, including plasterwork, and a growing interest in craftsmanship. Wilson and then Cooper became more interested in metalwork. Throughout the 1890s, Cooper continued to work on architectural commissions, including plasterwork for the chapel and library wing of Welbeck Abbey, Nottinghamshire, but from 1896 he began to keep accounts of his own work in a stock book and separate costing book, and in 1897 set up his own studio and a small workshop at 16 Aubrey Walk, Kensington, close to Wilson's studio at 17 Vicarage Gate.

Cooper began working in shagreen (shark or ray skin) in early 1899, sending a piece to the exhibition of the International Society of Sculptors, Painters and Gravers in April 1899 and four pieces to the sixth exhibition of the Arts and Crafts Exhibition Society in September that year, where it was deemed incredibly innovative:

> Mr J.P. Cooper … seems to have revived almost the only handicraft which has escaped the notice of the other members of the Arts and Crafts Society. The design and workmanship of these boxes are as delightful as their colour.[198]

By the late 1890s Cooper was employing Lorenzo Colarossi, a silversmith who worked

CAT. NO. 55 Silver and
abalone shell buckle
(*enlarged*), made by John
Paul Cooper and Lorenzo
Colarossi, c. 1902

at Wilson's studio on a part-time basis, so
that he could learn the technical aspects of
metalworking from him and formally enter
metalwork and jewellery in exhibitions. He
also employed his second cousin May Morgan
Oliver (1876–1954), whom he would later
marry. Late in 1901 Cooper took up the
post of enamel and metalwork master at
Birmingham Municipal School of Art after
having spent the summer under intensive
practical tuition at Wilson's studio. Cooper
married May, and the pair, together with
Colarossi, moved to Birmingham, setting up
a studio at Kyrle Hall, Sheep Street, which
Cooper intended to run whilst teaching at
the School. Although Cooper had planned to

reform the course entirely at Birmingham, which was considered a very second-grade institution by many, responsible for training students to turn out inferior 'trade' jewellery and silver, he became more and more involved in the work of his own studio. This prospered, leading to a clash with the School and his resignation in 1906. Refusing Wilson's generous offer of his own role at the Royal College of Art, in 1907 Cooper moved May, their children, Colarossi and two other metalworkers to Kent, in order to set up a full-time workshop, in the vicinity of

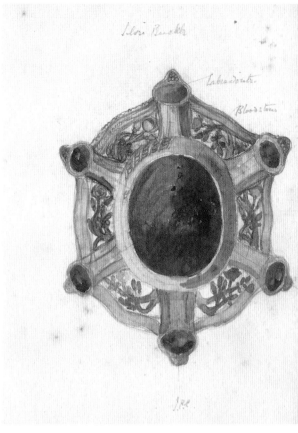

FIG. 27 John Paul Cooper's pen-and-ink sketch for buckle (cat. no. 55). Cooper Family Archive

FIG. 28 Cooper's painted sketch for buckle (cat. no. 55). Cooper Family Archive

Wilson's own workshop. In 1908 he became a member of the Art Workers' Guild.

From this point onwards, Cooper's workshop went from strength to strength. Shagreen work proved immensely popular and Cooper began to exhibit internationally, as well as in London. He contributed 84 pieces to 'the largest and most comprehensive show of British Arts and Crafts ever held abroad',[199] the *Exposition des Arts Décoratifs de la Bretagne et d'Irlande*, held at the Louvre's

Marsan Pavilion, at the Musée des Arts Decoratifs, which were highly praised.

Throughout the 1920s Cooper's workshop received many high-profile liturgical commissions and continued to exhibit internationally, as well as holding exhibitions at the Three Shields Gallery, Kensington, which kept his work in stock and received commissions for him. In 1931 Walker's Galleries in Bond Street held a retrospective of his work, an event which not only sealed his reputation as a successful and unique craftsman, but also drew the patronage of Queen Mary, lover of metalwork, boxes and small things, who visited and bought four pieces. As Queen Mary often bought objects as gifts for others, she may well have parted with Cooper's pieces, but two shagreen caskets remain in the Royal Collection today that may have been purchased by the Queen in 1931: a trunk-shaped casket and a square casket.[200]

On 3 May 1933 Cooper died suddenly and unexpectedly after suffering a heart attack on a bus travelling from Westerham to London. Later that year a memorial exhibition of 236 works by Cooper was held at the Rembrandt Gallery, Vigo Street, London, from which the Museum's shagreen casket was purchased (cat. no. 56).

This large silver buckle, with abalone shell and polished labradorites (cat. no. 55) is one of the earliest pieces of metalwork and jewellery created by Cooper, who had only completed three pieces prior to 1901. The sketches for this buckle remain in the Cooper Family Archive (figs 27 & 28) although the original design shows a bloodstone, instead of the abalone shell that was eventually used. Cooper's sketchbook (I, p. 35, no. 35) records this buckle with a small sketch and states that it cost him £4 9s 9d to make.[201] The description reads 'Silver Buckle bloodstone & labradorite' but 'M of P' has been written above the word 'bloodstone', again suggesting that this was perhaps changed at the last minute. It was sold (purchaser unknown) for £9 9s.

Cooper's Costing Book I (p. 72) shows the breakdown of the total cost of £4 9s 9d, detailing that chasing cost £1 10s (presumably Cooper's own time), the silver 9s 9d and the stones 10s (again, listed as labradorites and bloodstone, not mother-of-pearl) and that 64 hours of Laurie's time came to a total of £2. This contrasts starkly with the £5 for 50 hours that Laurie was paid for the shagreen casket (below), but shows the significant rise in his wages over an estimated 30-year period.

The rectangular shagreen casket, also in the Museum's collection (cat. no. 56), appears in Cooper's sketch book (no. II, p. 23, no. 23), described as 'Big Oblong rough skin', and shown as costing £9 12s to make, alongside a sketch (fig. 29). The precise costings appear in Cooper's costing book (no. IV, no. 1000), and show that the casket cost exactly £9 11s 10½d and that Colarossi spent 50 hours making the box (for which he was paid £5). Cooper himself made the

clasp at a cost of 10 shillings; his designs for it and other 'catches for shagreen' remain in the family archive (*fig.* 30). This casket was exhibited at the memorial exhibition of Cooper's work held at the Rembrandt Gallery, Vigo Street, London, from which it was purchased by Ernest Marsh of the Contemporary Art Society, using the Arts and Crafts Fund. In 1944, Marsh presented it to the Fitzwilliam Museum.

Objects and caskets incorporating shagreen were some of Cooper's most commercially successful items, especially during the 1930s. Shagreen (the skin of rays, dogfish and certain small sharks) had been used widely during the late eighteenth century, filed down and dyed, resulting in a smooth,

usually green, surface and used principally to cover cases containing étuis, pocket watches and snuff boxes. However, by the late nineteenth century it was regarded as something of a curiosity, occasionally used by cabinet-makers to smooth down wood. Cooper first became aware of shagreen through the publisher Andrew Tuer. The pair carried out many experiments on it, both filing it down and leaving it in its natural noduled state, and staining and dying it different colours, but Tuer's early death in 1900 left Cooper as the sole promoter of shagreen, most of which he purchased from W.R. Loxley, who imported it, mostly prepared, from China.

This made good financial sense, as preparing the shagreen from its raw state was laborious and time-consuming. Instead, Cooper and his workmen could simply stain, polish and mount it onto wooden carcasses,

FIG. 29 Rectangular shagreen casket (cat. no. 56) in Cooper's sketchbook (no. II, p. 23, no. 23). Cooper Family Archive

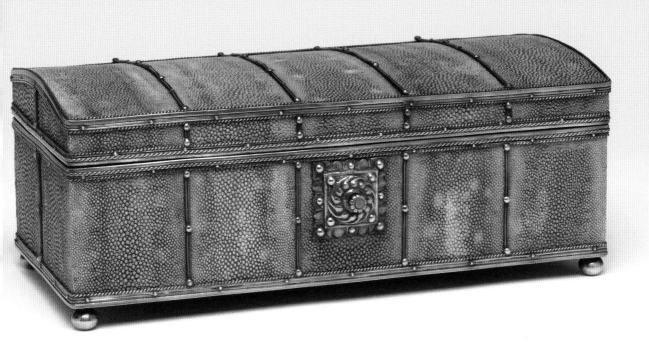

with silver mounts and catches. The shape of these caskets changed over time, but the Museum's example, a casket shape with thin, sleek silver mounts (hiding the joins of the tail skins used) is a good example of Cooper's later shagreen work, where the

nodules are left completely intact, the stark contrast in graining visible. There was a constant stream of customers waiting to buy shagreen from Cooper; his workshop produced around 948 pieces in total, 460 of them made between 1920 and 1930.[202]

CAT. NO. 56 Shagreen casket, the casket made by Lorenzo Colarossi, the clasp made by John Paul Cooper, c. 1932

FIG. 30 Cooper's designs for 'catches for shagreen'. Cooper Family Archive

OMAR RAMSDEN *1873–1939*

Combining charm and business acumen with a knack for designing silver that appealed to more conservative tastes, Ramsden was the most commercially successful silversmith of the 1920s and 1930s. The survival of his encoded workbooks gives an insight into working practices of a busy and productive workshop.

Born in Fir Street, Nether Hallam, Walkley, Sheffield, to a family of engravers, cutlery manufacturers and ivory importers, Ramsden learnt basic silversmithing skills from a silver manufacturer in Sheffield, before winning annual scholarships to study design at Sheffield School of Art, from 1894. There he met a similarly eager young silversmith, Alwyn Carr (1872–1940), and together they attended summer schools at the Royal College of Art and the Victoria and Albert Museum, and travelled around Europe. After Ramsden won an open competition to

design a civic mace for the city of Sheffield, they moved to London to set up a workshop together in order to work on it (and to indulge their love of theatre, more readily available in London than in Sheffield).[203] They registered a joint mark at Goldsmiths' Hall in 1898.

The pair maintained a successful workshop in a studio in Chelsea and a workshop in Fulham. The work, which trod a fine line between traditional and fashionable, combined with Ramsden's genial charm, ensured that the business went from strength

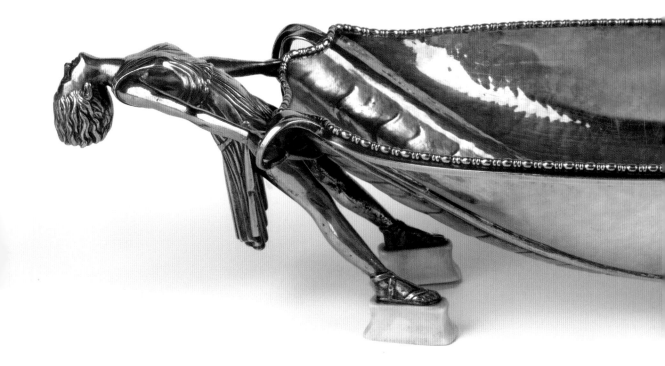

to strength. Ramsden and Carr's designs from this period are varied, influenced by both contemporary art nouveau and Arts and Crafts designs (including those of C.R. Ashbee and the Guild of Handicraft, *see* pp. 75–85) and the early-twentieth century historicist trend, referencing Renaissance silver. This fashionable waist clasp (*cat. no. 58*), dating from 1903, just five years after the pair started working together, demonstrates this combination of styles. Although the enamelled plaque lacks sophistication, the colours (blues and green) and the subject (a lyre bird) are clearly influenced by other work produced by Arts and Crafts designers at that time. The spot-hammered finish too is of this movement, but the curving drapery-like decoration of the mount, especially the inward curl at the top edge, hint at the more extreme and asymmetric whiplash of art nouveau.

The two men continued in business until 1914, when Carr joined the army (the Artists' Rifles). Ramsden continued alone, registering his own mark in 1918, with the partnership formally dissolved a year later. Ramsden's commercial success continued during the inter-war period, as the workshop increased to accommodate over 20 men, including apprentices. Ramsden received numerous private and public commissions and became the leading silversmith of domestic, ceremonial and church plate, 'catering to the conservative taste of a moneyed inter-war society'.[204] His interest in Renaissance silver deepened and his larger pieces became slightly heavier and more conservative. Arguably his style was diluted, but perhaps proved more commercially successful because of it. Although Ramsden

CAT. NO. 57 Silver-gilt *Draped Nymphs Bowl*, made by Omar Ramsden, 1935–36

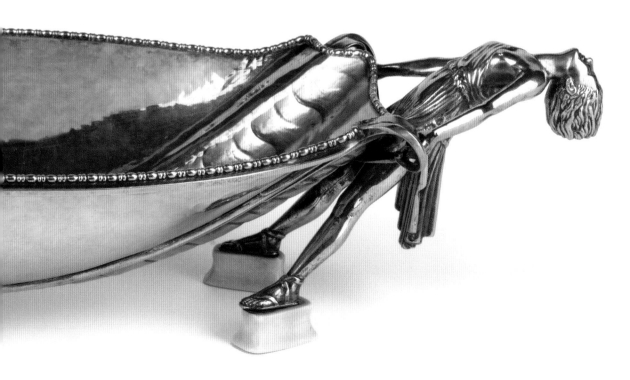

CAT. NO. 58 Silver and enamel waist clasp, made by Omar Ramsden and Alwyn Carr, 1903

presented by George V to the Cathedral of St John the Divine, New York; and the Three Kings Mazer of 1937, which celebrated the unusual occurrence of three monarchs in one year (1936), described not long after its creation as 'one of the world's outstanding works in gold'.[205] Ramsden was the most high-profile silversmith of this period, exhibiting widely, taking part in professional debates and contributing articles on modern silver design to the *Goldsmiths' Journal*. He received many honours, although latterly his reputation has been relegated somewhat to that of a talented entrepreneur. Although there is some truth in this, Ramsden must be credited with reviving an appreciation of silver, both in individuals and in churches, organisations and livery companies, and this

FIG. 31 Ramsden's Work Book entry for the 'Lewes' chalice and paten (similar to cat. no. 59). London, Goldsmiths' Company

CAT. NO. 59 (*opposite*) Silver chalice and paten, made by Omar Ramsden, 1935-36

publicly emphasised how important he felt it was that each object clearly be made by hand, many production pieces were partly made by machine, bought in as blanks from Birmingham, or made by external contractors, and simply finished in the workshop. Similarly, although each piece claims OMAR RAMSDEN ME FECIT ('Omar Ramsden made me'), Ramsden did not work on any of the later pieces himself, instead focusing on design and dealing with the ongoing demands of his many customers, alongside his business-minded wife, Annie Emily Downes-Butcher (1871–1950).

High-profile commissions included the ceremonial collar commissioned by the Honourable Company of Master Mariners, in 1929; the alms dish

resurgence in enthusiasm for silver after the war helped bolster and boost the trade more widely, a trend which lasted until the introduction of purchase tax in 1940.[206]

The Fitzwilliam Museum is fortunate to have many examples of Ramsden's work, only some of which are included here. All of these pieces have designs in the library of the Goldsmiths' Company, which holds 19 of Ramsden's workbooks, alongside five portfolios of working drawings and contemporary photographs of his work, covering the period 1921 to 1939. These, along with 34 boxes of small artefacts from Ramsden's workshop, were donated by the silversmith Leslie Durbin, who trained under Ramsden. Written in code (to which, thankfully, a key has been provided), these workbooks provide a huge amount of information about Ramsden's process and costings. Each page includes a design number, a small sketch of the object, the date of production and a breakdown of cost (materials and labour), and 'P.O.R.' ('Profit Omar Ramsden'). This silver chalice and paten (*cat. no. 59*) was made in 1935–36, but is similar in design to the 'Lewes' chalice and pattern in silver gilt, first made in September 1924 (*fig. 31*).[207] A silver-gilt example, made for the Pontificio Collegio Beda, Rome, survives in a contemporary photograph in the Ramsden archive at Goldsmiths' Hall.[208] Ramsden's coded costings show that the total cost of the original design in silver gilt was £19, but with an oak box it would retail for £35. The Museum's example has an extra band of chased and repoussé decoration around the foot and an inscription engraved on the underside to an H. Thomas, a friend of Ely (*Amici Elienses*).

The unusual dish in the form of fabric pulled taut, held by two draped nymphs, was one of two made on 11 November 1935 (*cat. no. 57*). According to the workbook page, a further example of rounder shape was made on 12 October 1938 (*fig. 34*).[209] The cost of each of the two original bowls was £32, with a price given as £53 6s 8d, 'not including any costs for O.R. [Omar Ramsden] design etc'. This dish demonstrates the effect of other contemporary metalwork trends on Ramsden's designs, notably the dynamic female forms employed in lots of art deco statuary. A bronze nymph, from which those on the dish were cast, survives in the remnants of Ramsden's workshop, also held by Goldsmiths' Company (*fig. 33*).

Finally, this small silver dish (*cat. no. 60*), the central medallion bearing the word PAX (Peace), was one of two made on 15 October 1938 (*fig. 35*). It was made to commemorate the signing of the Munich Agreement by Germany, Italy, France and England in the early hours of 30 September 1938, allowing Nazi Germany to annex part of Czechoslovakia in order to avert war. On the same day, the British prime minister Sir Neville Chamberlain signed a separate peace treaty with Hitler, the Anglo-German declaration. On his return, Chamberlain delivered a famous speech in which he said, 'I believe it is peace for our time.' This dish, made just a few days later, represents Ramsden's hopes for the future, the four sides and number '4' above the medallion representing the four countries that signed the Munich Agreement, the fruit and sheaves of corn in the centre representing a forthcoming period of fruitfulness, which, unfortunately was not to be. As of 2011, an identical dish was in the possession of Neville Chamberlain's descendants, perhaps given to Chamberlain by Ramsden himself as one of the flurry of gifts that the prime minister received in the weeks after the agreement was signed.[210]

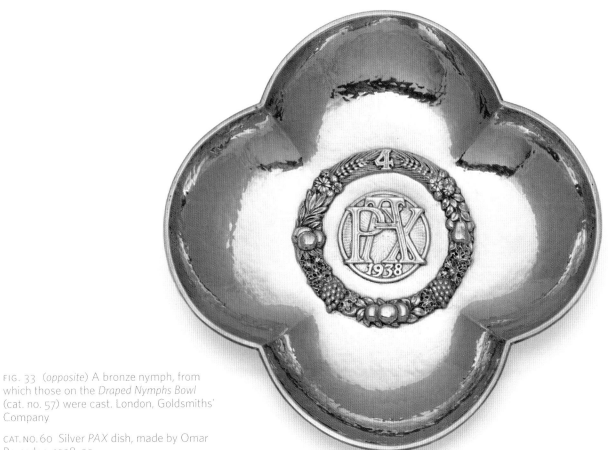

FIG. 33 (*opposite*) A bronze nymph, from which those on the *Draped Nymphs Bowl* (cat. no. 57) were cast. London, Goldsmiths' Company

CAT. NO. 60 Silver *PAX* dish, made by Omar Ramsden, 1938–39

FIG. 34 Ramsden's Work Book entry for *Draped Nymphs Bowl* (cat. no. 57). London, Goldsmiths' Company

FIG. 35 Ramsden's Work Book entry for *PAX* dish (cat. no. 60). London, Goldsmiths' Company

BARKENTIN & KRALL *1873–1932/5*

A successful partnership, Barkentin & Krall became well known for its Gothic Revival ecclesiastical metalwork, made in a wide range of materials. The firm received numerous important commissions and was also the preferred silversmith of architect-designer William Burges.

The firm of Barkentin & Krall was established in 1873, when a young German silversmith of Czech descent, Carl Cristof Krall (*c.* 1844–1923), joined Jes Barkentin (1800–1888), of Danish descent, at 291 Regent Street, London. Barkentin had been in business formerly with two other silversmiths, George Slater and then Alfred Bullock. Although he had made his name with the silver presentation vase given by the Danish residents of Britain to Princess Alexandra on her wedding in 1863, the business did not fare well – Barkentin filed for bankruptcy in 1866 and again in 1867. Nevertheless, he maintained a workshop, and after Krall joined the business the situation improved. In 1877 the firm took on another premises nearby (289 Regent Street) and created the magnificent bronze and rock-crystal throne for Tyntesfield, to a design by French Gothic Revival architect Eugène Viollet-le-Duc.[211] According to the census return, by 1881 the firm employed 15 men, one clerk and ten boys.[212]

Barkentin & Krall specialised in Gothic Revival metalwork, creating pieces from copper, bronze and wrought iron, as well as silver. Most of their work was ecclesiastical, such as their commission for the Lady Chapel of St Mark's Church, Philadelphia (1907/8), which included a silver altar, bronze and silver altar rails, a credence, memorial tablet and sanctuary lamp, praised at the time as having been 'designed and executed with an elaboration and magnificence that make the achievement extraordinary in the history of the craft'.[213] The firm was also responsible for creating most of the silverwork designed by William Burges (pp. 16–23). In 1867 Barkentin had replaced the firm of John Keith as silversmith to the Ecclesiological Society, with which Burges was heavily involved. Barkentin (and subsequently Barkentin & Krall) became Burges's favoured silversmiths. Examples of work made by the firm for Burges include a cup and cover in the British Museum,[214] a goblet and book binding in the National Museum Wales[215] and a spectacular dessert service in the V&A.[216]

This morse (a large clasp used to fasten a cope worn by a member of the clergy; *cat. no.* 61), which dates from 1898–99, may have formed part of Barkentin & Krall's magnificent display in the Art Metalwork

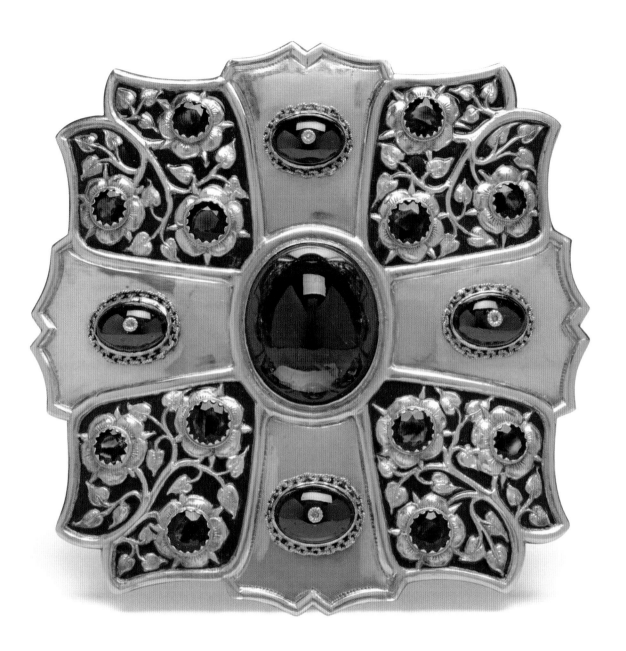

CAT. NO. 61 Enamelled silver morse,
made by Carl Cristof Krall, 1898–99

Exhibition of 1898 – the firm's was the only stall to contain silver, in contrast to the other stalls, which displayed only bronze and wrought iron.[217] Featuring thorny roses on enamelled panels, set with open-backed amethysts, the centre set with a large cabochon amethyst, the morse combines a high-church aesthetic and hints of the newly fashionably Arts and Crafts metalwork, with naturalistic motifs and cabochon stones.

CHILD & CHILD *1880–1915*

A fashionable family-run firm, Child & Child produced a range of jewellery in a number of different styles and received the patronage of Queen Alexandra and Sir Edward Burne-Jones, among others.

Child & Child was founded by brothers Walter (1840–1930) and Harold Child (1848–1915) in Seville Street, London, in 1880. The firm initially produced mainly plate, before moving to 35 Alfred Place West (now Thurloe Street) by 1892, where it focused more on jewellery. The partnership was dissolved in 1899, but the firm continued trading under the same name, managed by Harold Child, until his death in 1915. As well as their hallmarks, their work is often marked with their trademark sunflower flanked by two Cs. This logo can still be seen in the plasterwork above the ground floor window at 35 Thurloe Street, opposite the entrance to South Kensington tube station. The firm is best known for its high-quality enamel-ling, which came to the attention of Queen Alexandra, who granted the firm a royal warrant, and of the artist Edward Burne-Jones, who commissioned some pieces made to his designs (although the more complex pieces were sent to Giuliano; pp. 24–7).

Child & Child dabbled in various different styles, including Renaissance Revival, British Arts and Crafts, and French art nouveau. Both pieces in the Museum's collection are in the Arts and Crafts style and feature

popular motifs. Hair combs were one of the most common and useful forms of jewellery during the Edwardian period, where hairstyles required the hair to be drawn up onto the top of the head. This example (*cat. no.* 62), enamelled with ivy interspersed with garnets, mirrors the fashion among women in more artistic circles of wearing real flowers in their hair. Ivy was a symbol of eternal love, but also of friendship (because of the way it clings), and as such this would have been a fashionable and appropriate gift between two wealthy women.

The brooch in the form of a peacock (*cat. no.* 63) features one of the most popular motifs of the late nineteenth century. In Christian iconography, the peacock is a sign of the Resurrection. Historically, they were thought to be unlucky. But as a key motif in the Aesthetic style they were symbols of pride and decadence. The palette of the peacock, and its tail too, influenced wallpaper, textile designs and fabrics favoured by the artistic set. Dark blues and greens were popular, as was the dark chartreuse colour seen here at the tips of the peacock's feathers. This 'greenery-yallery' colour became so ubiquitous with

the artistic set that it was used as an easy shorthand by which to mock them. Gilbert & Sullivan's successful operetta *Patience* (1881),[218] a satirical portrait of the Aesthetic Movement, includes a verse in which a young male aesthete is described as

> A pallid and thin young man,
> A haggard and lank young man,
> A greenery-yallery, Grosvenor Gallery,
> Foot-in-the-grave young man!

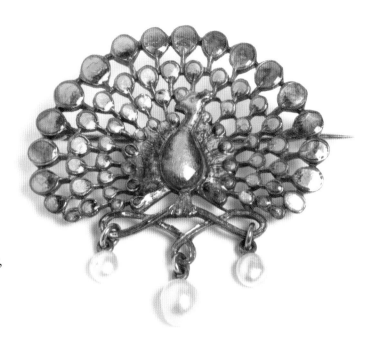

CAT. NO. 62 Tortoiseshell and enamelled silver hair ornament, made by Child & Child, *c.*1892–1910

CAT. NO. 63 Silver-gilt and enamel peacock brooch, made by Child & Child, *c.*1892–96

H.G. MURPHY 1884–1939

H.G. Murphy's radical transformation from Arts and Crafts jeweller to one of the few silversmiths in Britain working in the art deco style garnered him an international reputation, and many of his designs from the 1930s remain synonymous with that period.

Henry (Harry) George Murphy was born in Birchington-on-Sea, Kent, and moved to London as a small child. At the age of ten, Murphy walked past the Arts and Crafts Exhibition Society's show and met the architect, silversmith and jeweller Henry Wilson (pp. 86–93), who introduced him to William Morris and Walter Crane, who happened to be standing in the room at the time. This serendipitous meeting led to Wilson requesting permission from Mrs Murphy to take Harry out of school, in order for him to become an apprentice at Wilson's own studios in Kensington Gate and subsequently St Mary's Platt, Kent, from 1899 until 1905. Murphy also studied at the Central School of Arts and Crafts and later taught both there and at the Royal College of Art (arranged by Wilson). After finishing his apprenticeship in 1905, Murphy continued to work in Wilson's London studio, alongside John Paul Cooper (pp. 116–21), until 1910, and then near Wilson's Kent studio, until 1912, where Murphy met his future wife, teacher Jessie Church.

In 1912 Harry travelled abroad to work as foreman in the workshop of Emil Lettré (1876–1954), one of the most eminent goldsmiths working in Berlin at that time, but after discovering that Lettré was a demanding employer, and growing homesick, Murphy returned to Britain later that year in order to establish his own premises at 41 Kempsford Gardens, Earls Court. Success followed quickly, necessitating a move just one year later to larger premises, at 5 Kenton Street, Russell Square, where he employed ten people. This workshop was disbanded during the war, during which Murphy served as an officer in the Royal Navy Air Service (later the Royal Air Force).

After the war, Murphy returned to teaching at Central School, but also travelled widely, visiting Germany, Prague and Geneva, taking in the designs of avant-garde European modernism, including those of the Bauhaus school. He made the miniature Crown jewels for Queen Mary's dolls' house in 1924, and in 1928 set up a new full-time workshop and shop (run by Jessie) at 58 Weymouth Street, Marylebone, named the Falcon Studio (after its logo, designed by engraver George Friend).[219] Again, like his first studio, the Falcon was immediately

CAT.NO.64 Silver cigarette box and cover, made by H.G. Murphy, 1938-39

successful. One year later, Murphy was elected a Freeman of the Goldsmiths' Company and of the City of London, and subsequently elected to the Art Workers' Guild.

Although the workshop continued to be successful, the repercussions of the financial crash of 1929 caused a drop in income. Worrying about his finances, Murphy took up the post of Head of Silversmithing at Central School in 1932, just as business picked up. From here on in, Murphy's reputation soared as he and the studio began to create pieces in the new art deco style, with an emphasis on geometric form and line decoration. He received many commissions for trophies, cups and ecclesiastical pieces and began to exhibit internationally, winning the gold medal at the Milan exhibition of 1933 for his geometric tea set. Still plagued by money problems, Murphy applied for the role of principal at Central School and was successful, the first silversmith to hold this prestigious post. He died suddenly in 1939.[220]

More than any other silversmith, Murphy's style changed dramatically over the course of his career. His early jewellery, made under the tutelage of Henry Wilson, was in a similar style to that of his mentor, and indeed some pieces marked as by Wilson may have in fact been made by Murphy. Sometimes in a neo-Renaissance or neo-Gothic style, often comprising naturalistic motifs and cabochon gemstones, Murphy's early jewellery sits comfortably within the loose Arts and Crafts style, but his later jewellery follows the contemporary fashions for strong geometric blocks of colour, architectural forms and linear decoration (if any was required at all). His range of inexpensive silver jewellery, made at the Falcon Studio, proved very popular.

It was Murphy's domestic silver, however, that earned him international renown. His silver from the first four decades of the twentieth century is more diverse than that produced by any other English silversmith, and he was one the most successful in Britain to work in the art deco style. The silversmithing he witnessed in Europe had a huge effect on him, as he described in a lecture given in the 1930s:

> European craftsmen have for the past 20 years been creating new and fresh forms in silver. Among these craftsmen are artists who have caught the real spirit of modernism … these men are moved by an aesthetic philosophy close to the spirit of the times which insist on results obtained by vigorous attention to functional requirements, and the simple straight-forward use of materials.[221]

Murphy's silver and that of other leading silversmiths, such as Harold Stabler, was never as extreme as that produced in Continental Europe and subsequently America. More restrained, it always retained a sense of balance and equilibrium of ornament and form. However, one of Murphy's earliest cigarette boxes, first produced in 1931 (cat. no. 64), covered in

applied simple whorl decoration, has been described as 'a pioneering example of abstract modernism',[222] and was produced a second time in 1938–39 (the date of this example).[223] The turned knob prefigures other contemporary 'turned' designs, including Keith Murray's designs for ceramics firm Wedgwood. The original box dating from 1931 was included in the *British Art in Industry* exhibition at the Royal Academy in 1935, an exhibition that was intended to prove the success with which artist and industry could work together, marking

> a new period of prosperity for those British industries in which tasteful design plays, or should play, a prominent part: for it is by keeping well to the front in attractiveness as well as soundness that British wares will be able to assert their claims in home and foreign markets.[224]

The exhibition included a huge variety of British design, over 2,200 objects across a range of media, including 10 by H.G. Murphy. Later that year, Murphy worked with freelance designer R.M.Y. Gleadowe CVO (1888–1944), in creating a set of six vases for the Livery tables of the Goldsmiths' Company. Gleadowe worked with numerous silversmiths from 1929 onwards, as well as holding the post of art master at Winchester College, and later Slade Professor of Fine Art at the University of Oxford. He was made Commander of the Victorian Order (CVO) for his design of the Stalingrad sword, a

ceremonial sword presented by Winston Churchill to Josef Stalin in November 1943, as a token of thanks from Britain to the Soviet defenders of the city during the Battle of Stalingrad.

This particular vase (*cat. no. 65*), the fluted detail designed to showcase the skill of the silversmiths, was one of the original six commissioned by the Goldsmiths' Company (five remain in that collection today), but in a curious twist of fate left the collection after being given by the Company to R.E.A. Morris.

Reginald Morris (1893–1967) served in the London Rifle Brigade during the First World War and was injured at the Battle of the Somme. After the war, he worked for the London Assurance Company, before joining the Goldsmiths' Company. He was appointed Clerks' Clerk on 11 August 1925, and was responsible for administering the Court 'behind the scenes', preparing agendas, writing the minutes and running the social side of the Company.[225] He performed an especially valuable role during the Second World War, finding the house at Reigate to which the Assay Office could be evacuated, and then liaising between the Office and Goldsmiths' Hall, tasks that led to his election to the Livery, in 1942. On his retirement on 6 July 1958, the Wardens agreed to present him with a gift worth £25. Morris responded stating he would like a vase similar to those six fluted vases commissioned from Murphy in 1935. An

FIG. 36 London transport poster for Exhibition of Modern Silverwork, held at Goldsmiths' Hall in 1938. Designed by Edward McKnight Kauffer (1890-1954). © E. McKnight Kauffer/Victoria and Albert Museum, London

CAT. NO. 65 Silver fluted vase, designed by Richard Yorke Gleadowe, CVO, c. 1935, and made by H.G. Murphy, 1935-36

annotated draft staff minute of 4 June 1958 notes that although the original cost of each vase in 1935 was £25, to have one made in 1958 would exceed £100. However, as Morris was so fond of the design, the Wardens decided to give him one of the six original vases instead, engraving it on the base to thank him for 32 years of service.[226]

Once again, the influence of European silversmiths on the design of this vase is clear. Fluting was a popular motif in the early designs of Josef Hoffmann for the workshops in Vienna (Wiener Werkstätte), and subsequently those of Otto Prutscher. The design of this vase was deemed to be so timely and so contemporary that it was the single object chosen to appear on one of the posters for the first public display of modern silver to be held at Goldsmiths' Hall (*fig. 36*) – the Exhibition of Modern Silverwork held in July 1938 – set against an abstract background.

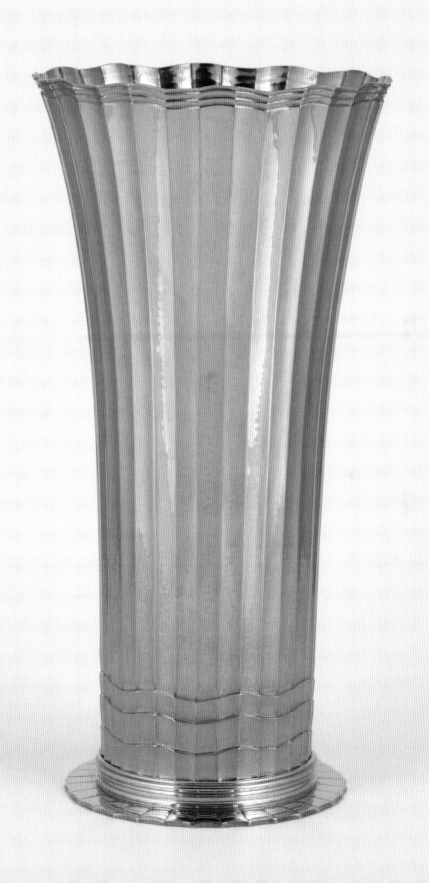

SIBYL DUNLOP *1889–1968*

The dramatic and eccentric workshop run by Sibyl Dunlop specialised first in Arts and Crafts jewellery and then in a new style, each bejewelled piece described as a 'carpet of gems', orchestrated by workshop master W. Nathanson.

Little is known about Sibyl Dunlop's early life. According to Peter Hinks, Sibyl Dunlop learnt about jewellery and enamelling when she was sent away to school in Brussels. Throughout the 1920s and 1930s, her shop, with an enormous copper lantern hung outside, was a memorable sight in Kensington Church Street, London. This workshop and showroom allowed clients to watch up to four workmen working away at pieces, Dunlop's own 'Nanny Frost' looking after the accounts, with Sybil, 'a dramatic figure costumed in an embroidered caftan and Russian boots', presiding over everything.[227] It was not to everyone's taste, though. Mrs Hull Grundy, the Museum's major jewellery donor (*see* pp. 1–3), once commented, 'I dislike the work of Sibyl Dunlop and had to leave her shop, as it made me sick.'[228]

In the early 1920s Dunlop was joined by W. Nathanson, who became her principal craftsman. Fresh out of the Sir John Cass Technical Institute (now part of London Metropolitan University), Nathanson was less fond of the Arts and Crafts style that Dunlop had favoured. The kind of trailing foliate work as seen in this brooch (*cat. no.* 66) was gradually phased out, as Nathanson introduced a bolder, more geometric aesthetic, dominated by what he called a 'carpet of gems', brightly coloured stones cut precisely and set edge to edge. This cross (*cat. no.* 67) is a fine example of the technique, which was apparently achieved by means of two identical sets of brass gauges, one in the studio in Kensington, another in a stone-cutting workshop of a supplier in Idar-Oberstein, Germany, where the stones were cut. These identical gauges enabled Nathanson to request precise sizes and shapes of stones, and guarantee that they would be cut precisely to fit.

Stone-cutting was not the only outsourced skill. The fine enamelling on the reverse of this cross was the work of Henri De

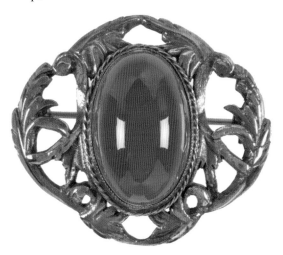

CAT. NO. 66 Silver and carnelian brooch (*enlarged*), made by Sybil Dunlop, 1928–29

CAT. NO. 67 Gem-set and enamelled silver cross (*enlarged*), made by Sibyl Dunlop, the enamelling on reverse (*see* p. 156) by Henri De Koningh, *c.* 1930

Koningh (b. 1866), a Genevan enameller who had worked in London from around 1900, supplying a huge number of UK jewellers and silversmiths with enamelled work (including Omar Ramsden; pp. 122–7). In 1926 De Koningh translated a volume on enamelling by the Swiss enameller Louis-Élie Millenet, *Enamelling on Metal*, and a year later published his own volume, *The Preparation of Precious and Other Metal Work for Enamelling with a Brief Historical Survey*, which he described as a combination of 'text book on the art of enamelling' and 'an exposition of the craft of the metal worker'.[229] Both remain useful sources today from which to learn about traditional enamelling techniques.

In the preface to this book, De Koningh highlighted the interconnectedness of the trade. He stressed that, unlike the 'early and medieval days', when a piece of jewellery might be created wholly under the auspices of the workshop master (even if different tasks were done by different craftspeople), by the 1920s an object was not wholly created in one workshop. Instead, 'the decorative work, engraving, engine-turning, enamelling, settings, etc., will be executed not only by different individuals, but by separate and entirely distinct firms, who, while working independently, must yet work in harmony with one another, as well as with the actual maker of the article.'[230] This sums up perfectly the working practices of workshops and showroom such as that owned by Sibyl Dunlop.

The firm carried on until the outbreak of war in 1939. Sibyl's ill health meant that she was unable to return to the shop; however, after serving as a fireman during the Blitz, Nathanson returned to the business and kept it afloat until his retirement in 1971, an impressive feat in light of the post-war purchase tax that marked the end of so many smaller businesses that had operated on tight profit margins before the war.

ARTIFICERS' GUILD *1901–42*

Long overlooked, the high quality and wide variety of metalwork and jewellery produced by one of the most successful guilds of the early twentieth century, run by designer Edward Spencer, is now beginning to be recognised.

The Artificers' Guild was founded by Arts and Crafts polymath Nelson Dawson (1859–1941), best known for his silver and enamelled jewellery. His intention was to work exclusively for the Guild for five years, but by 1903 financial distress caused him to rethink this decision. The Guild was rescued by Birmingham solicitor and art enthusiast Montague Fordham, who purchased it and promoted Edward Napier Hitchcock Spencer (1873–1942). Spencer, an architect-designer who had initially trained under Henry Wilson (*see* pp. 86–93) and who had worked under Nelson as a junior designer, was made chief designer and a director of the business. The workshops were situated in Hammersmith, but Fordham moved the Guild's showroom to his eponymous gallery in Maddox Street, where he already retailed the work of May Morris, Henry Wilson and John Paul Cooper. This clearly proved a success, as in 1906 Fordham renamed the gallery 'The Artificers' Guild Art Metalworkers'. After the First World War the Guild flourished, employing over 40 people (including, anecdotally, orphaned boys

for whom Spencer felt sorry), and opened showrooms in Oxford and on King's Parade, Cambridge.

The Guild was one of the few guilds inspired by Ashbee and the Arts and Crafts movement to prove commercially successful. This was mainly down to the success of Edward Spencer, 'an earnest and inventive work-master',[231] who, as well designing the majority of Guild designs, also published articles on metalwork, had the Guild's work

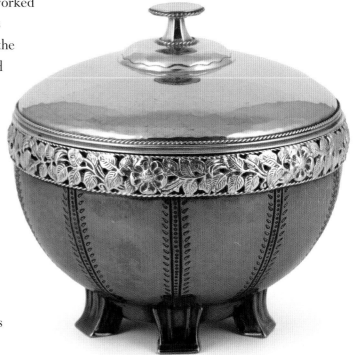

featured in *The Studio* and exhibited with the Arts and Crafts Exhibition Society. Many of Spencer's signed designs survive in the library of the Goldsmiths' Company, alongside many unsigned, some of which may be by one of the Guild's other designers, architect John Houghton Maurice Bonner (1875–1917). Another reason for the Guild's success, just two years after Spencer took charge, was its willingness to 'include within its influence the consumer as a necessary co-worker in the cause of right production',[232] a hint that Spencer had a talent for predicting what customers would like, and took this into account, balancing the need for commercial success with a workshop structure that tried to adhere to Arts and Crafts principles.

Spencer's designs show the breadth and variety of the Guild's output, ranging from church plate to domestic silver and metalwork, jewellery and stained glass, all responding to changes in fashion. Although the pieces illustrated here are relatively plain, Spencer was influenced by designers such as John Paul Cooper (*see* pp. 116–21) and often incorporated other materials such as mother-of-pearl, shagreen, ivory and glass. Spencer's death in 1938 marked the unofficial end of the Guild. The onset of the Second World War led to its formal dissolution in 1942.

CAT. NO. 68 (*opposite*) Gunmetal bowl and cover, designed by Edward Spencer, made by the Artificers' Guild, c. 1930

CAT. NO. 69 Silver standing cup/chalice, probably designed by Edward Spencer, made by the Artificers' Guild, 1935–36

The existence of the standing cup (*cat. no.* 69) and pair of salt cellars (*cat. no.* 70) in the collection of the Fitzwilliam Museum stands as testament to the contemporary high esteem in which Spencer and the Artificers' Guild were held. These objects were given to the Museum in 1941, just three years after Spencer's death, by the Arts and Crafts branch of the Contemporary Art Society. Although made a few years earlier, they were seen as high-quality examples of the Guild's output and worthy of entering the Museum's collection. The restrained but distinct Arts and Crafts-inspired style appealed to the English taste, which continued to favour the

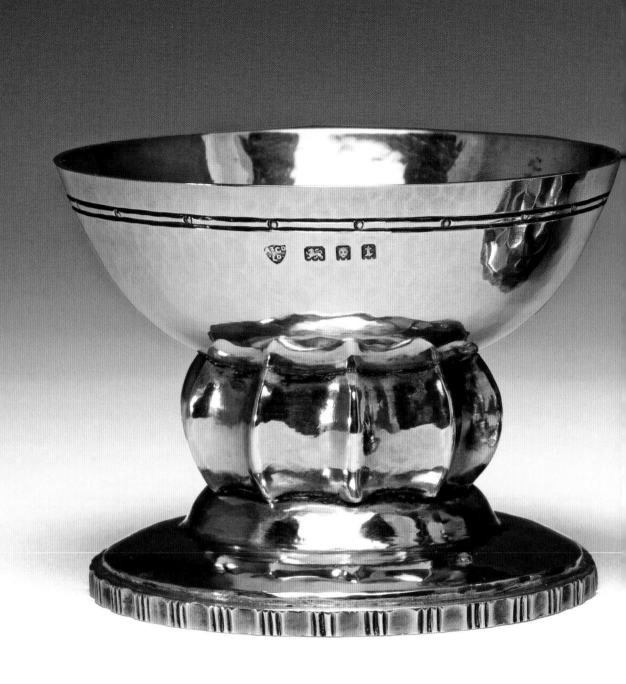

aesthetic of the Movement long after the death of many of its originators. Although made in 1935–36, this cup still fits the description of one made 30 years earlier, 'beauty in the chalice being as much the effect of the undecorated cup, of surface delicately varied with the fine traces of the tool'.[233]

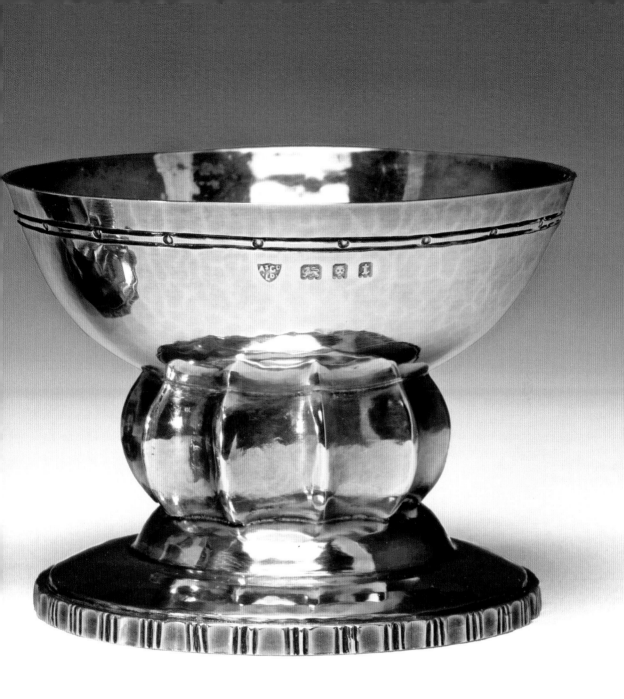

This bowl and cover, made from gunmetal (*cat. no.* 68) and dating from *c.* 1930, is a late survival of the taste for 'dull', unpolished metal. By this time, many other modern silversmiths, such as H.G. Murphy (pp. 132–7), were producing pieces with a high polish, but Spencer and the Artificers' Guild still occasionally produced pieces such as this, firmly in the Arts and Crafts taste.

CATALOGUE

1 Brooch, gold, cast and chased in the shape of a ring with a stylised ram's head with ornate twisted horns, a small vase suspended inside the ring from its collar, with pin fastening, marked Castellani [interlaced Cs], town mark for Rome, 18 carat gold, 1815–72, 3.3 × 3.1 cm. Made by Castellani in Rome, *c.* 1860–70. *Given by Mrs Hull Grundy. M.26-1984*

2 Pair of altar candlesticks, bronze, each candlestick with a shallow, concave removable drip pan with zigzagged edge, on a fixed drip pan with wavy edge, supported by four foliate openwork scrolls, twisted four-sided upper stem, straight four-sided lower stem broken up by red painted lines, set with glass cabochons, the sections separated by different shaped collars, with a splayed octagonal base with four straight sides painted with red crosses and gilt spots, and four curved sides set with claw-set circular glass cabochons, with four outward curving scrolls, 69.9 × 18.7 cm and 69.5 × 18.9 cm. Designed by William White, *c.* 1860–64. *Given by the Friends of the Fitzwilliam Museum. M.3A & B-1994*

3 Decanter, body of dark green blown glass, mounted in silver with applied and engraved ornament, set with malachite panels, moonstones, sards, agates and amethysts, cloisonné enamels, four seventeenth-century coral cameos (two depicting a nymph's head, two depicting Cupid holding a basket and garland), a Roman first-century AD nicolo intaglio of a sleeping hound, a Sassanian fifth- or sixth-century cornelian intaglio of a personal device and six silver-mounted ancient coins; on the neck, a Thracian silver drachm, struck at Byzantion (*c.* 340–320 BC) and a Roman silver siliqua of Julian II (361–63) dating from 361–363, possibly struck at the mint of Arles, France; on the body, a Byzantine gold light-weight solidus of Justinian (527–565), a Byzantine electrum histamenon nomisma of Nicephorus III (1078–81), a Roman silver argentus of Constantine I (307–337) issued during his time as Caesar, dating from 305–307 and struck at the mint of Trier, Germany, and a Byzantine gold histamenon nomisma of Basil II (976–1025). The hinged cover with a Chinese rock crystal Buddhist lion surrounded by leafy foliage (two pieces missing) and a silver palisade, surmounted by a hoop with silver bell, the underside of the cover with an agate,

surrounded by silver foliage. The cast silver handle is in the form of a winged lion with a carved ivory head, and the spout is cast in the form of an antelope's head with emerald eye, with a silver stopper attached by a chain. The foot is engraved with a hedgehog, a frog, a mouse and a wren with a worm in its beak, and the signature 'I WREN' for Jenny Wren. The partly obscured inscription on the neck reads: 'WILLIELMUS BURGES ME FIERI FECIT ANNO DI MDCCLXV EX HONS ECCL[ESI]AE CONSTANTINOPOLITANAE'. The silver mounts hallmarked variously on front and on foot Josiah Mendelson, Queen Victoria duty mark, lion passant, London, 1865–66, and on the hoop over finial George Angell, lion passant, Queen Victoria duty mark, 27.3 × 19 cm. Designed by William Burges in 1864, the silver mounts made by George Angell and Josiah Mendelson, 1865–66. *Purchased from Thomas Stainton, executor of the Handley-Read Estate with the Perceval Fund and with the Regional Fund administered by the Victoria and Albert Museum. M.16-1972*

4 Pendant, a second-century Roman Imperial cameo of Medusa, carved onyx, the reverse left rough, set by means of seven gold claws in an oval gold openwork frame enamelled in black and white and alternately set with four pearls and four cabochon rubies, with a smaller pearl, an enamelled gold 'tassel' and a larger pearl beneath, gold ring and enamelled gold suspension loop above, 8.2 × 3.8 cm, applied plaque with 'c.g' on mount. Probably made by Pasquale Novissimo for Carlo Giuliano, c. 1874–95. *C.B. Marlay Bequest, 1912. MAR.M.276-1912*

5 Bracelet, silver, composed of 15 cast and chased silver panels, each cast with three four-petalled flowers each in a sunken square, surrounded by beading, fastened by means of a gold bolt passing through the panels, applied plaque with 'c.g', 4 × 18 cm. Made by Carlo Giuliano, c. 1874–95. In slightly later maroon leather case, lined with white silk printed in gold with a crown and 'c. & A. GIULIANO/115 PICCADILLY/LONDON', c. 1896–1911. *Given by Mrs Hull Grundy. M.29 & A-1983*

6 Bracelet, silver, cast and chased, composed of 12 hinged panels, each cast with a lion's head in relief flanked by two four-petalled flowers in a sunken beaded square, fastened by means of a bolt passing through the panels, both parts of catch with spiral decoration, safety chain, applied plaque with 'c.g', 4.3 × 18.5 cm. Made by Carlo Giuliano, c. 1863–95. *Purchased by Mrs Hull Grundy from Wartski, Grafton Street, and subsequently given to the Museum. M.47-1984*

7 Brooch, gold, cast and chased in the shape of a twig bearing four oak leaves and an acorn, set with a pearl, pin fastening, marked 'F.G' and '18' in two rectangular reserves on reverse of acorn, 2.9 × 5.9 cm. Attributed to Federico Giuliano, c. 1876–1903. *Given by Mrs Hull Grundy. M.38-1984*

8 Brooch, gold, cast and engraved in the shape of an openwork caduceus, two snakes enamelled in green with red eyes, winding around a winged staff, the wings enamelled in red and white, set with a white topaz and open-set amber-coloured grossular garnet, reverse engraved with details of snakeskin and feathers, 4.7 × 3.4 cm. In original dark cream leather case, the cream silk inside printed in black 'BEATRICE CAMERON,/102, MOUNT STREET, W./ Art Jewellery by/FERDINAND GIULIANO'. Made by Ferdinand Giuliano, c. 1903–10. *Purchased by Mrs Hull Grundy from Wartski, Grafton Street, and subsequently given to the Museum. M.5 & A-1983*

9 Toast rack, electroplated nickel silver, rectangular open base on cylindrical feet, seven fixed 'triple arch' struts, the central

with a large square handle, marked 'RP',
James Dixon & Sons (with bugle), [model
no.] 67, 'Chr Dresser' facsimile signature,
11.3 × 16.1 × 11.5 cm. Designed by
Christopher Dresser in 1879, made by James
Dixon & Sons, Sheffield, c. 1880. *On loan from
the Keatley Trust. AAL.23-2005*

10 Letter rack, silver, curved open base on four
bun feet with one central taller fixed rack,
flanked by three shorter racks on each side,
with slots at the base that enable them to move
backwards and forwards, marked Hukin and
Heath [JTH over JWH], lion passant, 1892–93,
Birmingham, 13.1 × 17.7 × 10.2 cm. Designed
by Christoper Dresser, made by Hukin &
Heath, Birmingham, 1892–93. *On loan from the
Keatley Trust. AAL.1-2011*

11 Sugar bowl and sifter spoon, silver, the
bowl cast, chased and engraved in the form
of a lotus flower with a parcel-gilt interior,
supported by a bent tubular stem, and two
curled leaves with engraved veins and tubular
stems branching out to right and left of main
stem; the sifter spoon has a twig-shaped
handle with forked terminal and lightly gilt
bowl pierced with a pattern of lozenges
and roundels, hallmarked Hukin & Heath,
lion passant, London, 1884–85, Queen
Victoria duty mark, bowl 7.8 × 13.1 cm,
spoon 13.5 × 4.5 cm. Design attributed to
Christopher Dresser, made by Hukin & Heath,
1884–85. *Purchased from the Fine Art Society in
1998 with the Rylands Fund. M.2 &A-1998*

12 Pendant cross, gold, openwork set with large
cabochon sapphire in centre and smaller back-
painted sapphires and four pearls, the reverse
with a small empty compartment under
glass, with beaded loop ring for suspension,
in original case, marked 'E.R' in rectangular
cartouche and '3', 10 × 7.5 cm. Made by
Ernesto Rinzi, c. 1860–65. *Purchased by Mrs Hull*

*Grundy from Wartski, Grafton Street, and given to
the Museum. M.48 &A-1984*

13 Necklace, gold, composed of 91 drops,
consisting of short bars terminating in spheres,
on an articulated band, forming a fringe with
long hooked catch. In original dark brown
leather case, the inside of the lid printed in gold
on purple silk beneath a crown 'PHILLIPS,/23,
COCKSPUR ST/LONDON.', 39 cm long. Made
by Phillips Brothers, c. 1855–69. *Given by Mrs
Hull Grundy. M.60 &A-1982*

14 Necklace and brooch, gold and *theva* work
green glass, the necklace a flexible, woven
gold strip, from which are suspended four gold
leaves, each attached to a shamrock-shaped
pendant of Pratapgrah green glass, with chased
and pierced gold inlay depicting plants and
animals, mounted in gold with rope-twist
border, an octagonal clasp of the same
materials, marked in relief on applied plaque
'RP', 39.5 cm long. The brooch, en suite with
the pendants, with a pin fastening across the
back, marked as above, 2 cm wide. The suite
in original red leather case, the silk lining
of the lid printed in gold beneath a crown
'PHILLIPS./23 COCKSPUR ST/LONDON'.
Made by Phillips Brothers, c. 1855–69. *Acquired
by Mrs Hull Grundy from Wartski, Grafton Street,
and given to the Museum. M.18 &A & B-1983*

15 Necklace, silver, composed of 30 double-
spiral links connected by curved loops, the
clasp engraved 'PHILLIPS BROS & SON/23
COCKSPUR STREET/London'. 44 cm long.
Made by Phillips Brothers & Son, c. 1870.
*Acquired by Mrs Hull Grundy from Wartski, Grafton
Street, and given to the Museum. M.33-1984*

16 Pendant and earrings, silver, the pendant in
the form of three cast and engraved laurel
leaves with veins and a berry, the stems of
which are curved to form a wide suspension
loop, the earrings both in the form of a single

leaf and berry, the stem of which is curved to create a hook for a pierced ear. In original brown leather case, the inside of the lid printed in gold on purple silk beneath a crown 'PHILLIPS,/23, COCKSPUR ST/LONDON.', pendant 8.8 cm long, earrings 7.2 cm long. Made by Phillips Brothers, *c.* 1855–69. *Given by Mrs Hull Grundy. M.60A-C-1983*

17 Brooch, gold, slightly convex mount with swirling gold filigree, granulation and navy and white cloisonné enamel bosses, set with a curved slice of banded agate, pin fastening at back with enamelled catch, engraved 'M.P.K/Christmas, 1865' and 'K.J.K.', marked in relief on applied plaque 'RP', 4.8 × 3.2 cm. Made by Phillips Brothers, *c.* 1865. *Acquired by Mrs Hull Grundy from Wartski, Grafton Street, and given to the Museum. M.56-1982*

18 Brooch, horned helmet shell cameo, carved, depicting an angel in profile to the left with index finger on left hand raised, mounted in gold and surrounded by a border of four strands of gold ropework, pin fastening, marked 'W&B', 7.2 × 5.9 cm. In original red leather case blind-stamped 'MO', lined with white silk and printed in blue 'PARIS FIRST CLASS & LONDON PRIZE MEDALS/[image of 1851 enamelled vase]/WATHERSTON & BROGDEN,/Goldsmiths,/MANUFACTORY,/16, Henrietta St./Covent Garden, WC/LONDON.' Made by Watherston & Brogden, 1862–64. *Given by Mrs Hull Grundy. M.64 & A-1982*

19 Brooch, gold wire incised to imitate gold filigree, openwork set with four pearls, four garnets and a cabochon lapis lazuli, pin fastening, maker's mark 'BROGDEN' in relief on applied plaque, 4.2 × 3.5 cm. Made by John Brogden, *c.* 1864–85. *Given by Mrs Hull Grundy. M.12-1983*

20 Brooch, gold, cast and engraved in the shape of two birds each with one wing outstretched,

flanking an oval cabochon banded agate surrounded by pearls, the reverse with a glazed compartment containing a piece of blue ribbon, pin fastening, 2.7 × 5.2 cm. In original maroon leather case blind-stamped 'WB' for William Betteridge, lined with pale blue silk and printed in gold 'Watherston & Son/12 Pall Mall East,/London.' Made by Watherston & Son, 1881–98. *Given by Mrs Hull Grundy. M.11 & A-1983*

21 Brooch, gold and white gold, in the shape of a pair of outstretched wings, with blue, green and red cloisonné enamelled feathers, set at the centre with a moonstone carved in the shape of a sphinx's head, flanked by gold cobras, pin fastening, 5.3 cm long. Made by Watherston & Son, *c.* 1906. *Purchased by Mrs Hull Grundy from Wartski, Grafton Street, and given to the Museum. M.16-1983*

22 Brooch/hair ornament, gold, cast and chased in the form of a spray of dog roses, the larger flower with oxidised petals, with leaves and thorned stem, the brooch pin fastening detachable by means of a screw attachment, which can instead be replaced by a two-pronged pin stored in a compartment at the bottom of the original maroon velvet case, lined in white silk with remnants of gold printed stamp, 9 × 7 cm, pin 12.1 cm long. Made by Hunt & Roskell, *c.* 1850. *Purchased by Mrs Hull Grundy from Wartski, Grafton Street, and given to the Museum. M.55 & A & B & C-1982*

23 Pendant, *The Helper*, gold and enamel, quatrefoil gold frame set with enamelled plaque depicting an angel helping the figure of Christ to carry the cross, an enamelled roundel on either side of the frame, with three drops below, enamelled to resemble opals and suspension loop above, the back inscribed in black 'the/helper/PAT [monogram] 1903', the gold on the reverse of each drop scratched

with PAT monogram, 7.6 × 6 cm. In red
leather case. Made by Phoebe Anna Traquair,
1903. *Given by Mrs Hull Grundy. M.6 & A-1983*

24 Clock, sand-cast aluminium case of
architectural form, the top of ogee form,
surmounted by a plain, spike finial and with
a stepped edge, the four side panels plain
with an undulating lower edge, each corner
supported by a plain pillar with a flared foot,
the circular dial of copper, the numerals
substituted with the letters TEMPUS FUGIT
+, the hands of copper, the minute hand
terminating in a pierced heart, the minutes
marked by a row of raised dots around
the circumference, the back plate with a
rectangular door supported on strapwork
hinges of iron, the latch a stylised scroll with
the door pull a plain, copper wire loop, with
pendulum movement, 49.5 × 26.7 × 17.8 cm.
Designed by C.F.A. Voysey, *c.* 1896. Made
by W.H. Tingey at foundry of W.C. Barker,
Strood, Kent, *c.* 1896–1901. *On loan from the
Frua-Valsecchi Collection. AAL.49-2016*

25 Dish, Britannia silver, cast in rounded
eight-sided shape with wide wavy rim,
repoussé and chased with eight lizards among
bramble foliage on a spot-hammered ground,
hallmarked Gilbert Marks, Britannia standard,
lion's head, 1898–99 and engraved 'Gilbert
Marks 1899', 5.8 × 42.4 cm. Made by Gilbert
Marks, 1899. *Given by Miss Ellen Bicknell. M.18-
1980*

26 Plate, pewter, cast, repoussé and chased, with
three lizards among foliage on spot-hammered
ground, circular in shape with small deep
well, engraved 'Gilbert Marks 1902',
2.8 × 23.8 cm. Made by Gilbert Marks, 1902.
Given by Mrs Hull Grundy. M.19-1983

27 Claret jug, silver with gilt interior, cast,
repoussé and chased, faceted and spot-
hammered ovoid body, the shoulders repoussé

and chased with a swag of vine leaves and
bunches of grapes on ribbon tied in bows,
slightly domed circular foot with border of
stylised leaves and cast harp-shaped handle
with shell terminals, hallmarked Gilbert
Marks, lion passant, London, 1898–99, also
engraved 'Gilbert Marks 1899', 30.8 × 13.8
cm. Made by Gilbert Marks, 1899. *Given by
Miss Molly Challoner. M.9-1990*

28 Ashtray, pewter, cast, repoussé and chased
with alternating flower heads and points
radiating from a flower-shaped outline in the
centre, on spot-hammered ground, circular
with curved sides, engraved 'Gilbert Marks
1900', 1.8 × 11.7 cm. Made by Gilbert Marks,
1900. *Given by Miss Ellen Bicknell. M.66-1984*

29 Ashtray, pewter, cast, repoussé and chased
with alternating flower heads and points
radiating from a flower-shaped outline in the
centre, on spot-hammered ground, circular
with curved sides, engraved 'Gilbert Marks
1900', 2.1 × 11.9 cm. Made by Gilbert Marks,
1900. *Given by Miss Ellen Bicknell. M.65-1984*

30 Bowl, pewter, cast, repoussé and chased
with five sprays of leaves, each bearing a rose
hip, alternating with five points extending
downwards from the rim, on spot-hammered
ground, bowl circular with deep curving sides
on small foot ring, engraved 'Gilbert Marks
1901', 12.4 × 23.2 cm, on circular wooden
stand with four legs, 21 cm high when on
stand. Made by Gilbert Marks, 1901. *Given by
Miss Ellen Bicknell. M.64 & A-1984*

31 The Gardiner cup and cover, silver, cast
and chased, deep tapering cup with spot-
hammered surface, cover with large enamelled
panel depicting dolphins and a knop with
three cast seahorses and spherical amethyst,
the interior of the cover is engraved 'HENRY
JOHN GARDINER/FEBRUARY 16TH 1907'
and 'FROM HIS FOUR SISTERS AS A TOKEN

FOR/MANY YEARS AS THEIR TRUSTEE/ JANE FEDDEN/MARY HOPKINS/MARGARET POGSON/LOUISA MACARTNEY', on stem with beaded central knop of three cast seahorses and three cabochon amethysts, upper part of the foot chased with dolphins, separated from lower foot by five cast seahorses separating five plique-à-jour enamelled panels depicting fish and a mermaid, lower foot chased with plain roundels and stylised dolphins and seahorses and a flat flange, hallmarked Guild of Handicraft Ltd, lion passant, 1904–05, London, 56.7 × 21.5 cm. Designed by Charles Robert Ashbee and probably made by William White, a silversmith at the Guild of Handicraft, Chipping Campden, 1904–05. *On loan from the Keatley Trust. KTL.3 & A-1997*

32 Charger, copper, cast, repoussé and chased, a wide flat bowl with a raised dome with a tree in front of a rising/setting sun, surrounded by a circular chain of eight hounds, and the inscription 'O POVERTY WHAT DEEDS ARE DONE IN THY NAME', with wide flat rim with continuous scrolling design of stylised leaves and berries, engraved 'J. Pearson 1890 359 [ringed]', 51.3 cm diam. Made by John Pearson, whilst still a member of the Guild of Handicraft, London, 1890. *On loan from the Keatley Trust. AAL.2-2015*

33 Beaker, silver, cast, spot-hammered surface with engraved monogram (possibly 'FHAI'), the foot chased and pierced and set with cabochon amethysts, hallmarked C.R. Ashbee, lion passant, London, 1900–1901, 12.2 × 8.8 cm. Designed by Charles Robert Ashbee, made by a silversmith at the Guild of Handicraft, 1900–1901. *Given from the estate of the late Peter and Olive Ward. M.6-2016*

34 Napkin ring, silver, pierced, flat chased and set with three faceted amethysts with beaded border, hallmarked C.R. Ashbee, lion passant, London, 1900–1901, 2.7 × 4.6 cm. Designed by Charles Robert Ashbee, made by a silversmith at the Guild of Handicraft, 1900–1901. *Given by Mrs Hull Grundy. M.27-1983*

35 Bowl and cover, silver, shallow bowl on spreading trumpet foot between two wide looped handles, which divide into stylised flowers at joining the foot and rim, cover with a cut-away section for spoon, with green enamelled panel and knob set with mother-of-pearl, hallmarked Guild of Handicraft Ltd, lion passant, London, 1906–07, 10.3 × 25.2 cm. Designed by Charles Robert Ashbee, made by a silversmith at the Guild of Handicraft, Chipping Campden, 1906–07. *Given by the Friends of the Fitzwilliam Museum. M.1 & A-1978*

36 Muffin dish and cover, silver, cast, spot-hammered dish with flat edge and row of beading set with three cabochon chrysoprases, each with a beaded surround, the cover with a malachite knob on a central support with five curved decorative stems, hallmarked C.R. Ashbee, lion passant, London, 1900–1901, 12.1 × 22.2 cm. Designed by Charles Robert Ashbee, made by a silversmith at the Guild of Handicraft, 1900–1901. *On loan from the Keatley Trust. KTL.2-1991*

37 Bowl and cover, silver, cast deep bowl with spot-hammered surface, on circular foot, the cover with enamelled panel depicting a forest scene, hallmarked Guild of Handicraft Ltd, 1902–03, lion passant, London, 7.6 × 10.5 cm. Made by a silversmith at the Guild of Handicraft, Chipping Campden, the enamel by William Mark, Fleetwood Varley or Arthur Cameron, 1902–03. *Given from the estate of the late Peter and Olive Ward. M.8 & A-2016*

38 Headband, silver, applied decoration of a stylised pink or carnation (the logo of the Guild of Handicraft), and two olive branches with leaves and a single olive, engraved on the inside

'OLIVE GROVES N PETER WARD 1955 — A CROWN OF WILD OLIVES', hallmarked Guild of Handicraft Ltd, lion passant, London, 1970–71, 3.5 × 14.3 cm. Designed and made by Henry Hart, Chipping Campden. *Given from the estate of the late Peter and Olive Ward. M.9-2016*

39 Brooch, gold, spot-hammered surface with repoussé and chased decoration, three tulips surrounded by a plain border with 13 roundels, suspension loop, pin fastening and safety chain, hallmarked Guild of Handicraft, crown [gold], 916 [22 carat], London, 1979–80, 5.7 × 5 cm. Commissioned by Peter and Olive Ward for Peter's mother's golden wedding anniversary on 27 May 1979, and subsequently inherited. Made by Henry Hart, to his father's pendant design of 1906. *Given from the estate of the late Peter and Olive Ward. M.16A-C-2016*

40 Hand mirror, bronze, cast, repoussé and chased, inset with an oval mirror with a bevelled edge, the reverse decorated in shallow relief with a scene of three nymphs bathing, one of whom clasps the arms of a young man, probably Hylas, on the riverbank, a narrow wedge-shaped rustic handle hollowed on the reverse and enclosing a nude figure of a standing woman, unmarked, 30.2 × 12.3 cm. Designed by Alec Miller, probably made by silversmiths at the Hart workshop, Chipping Campden, c. 1900–1930. *Given from the estate of the late Peter and Olive Ward. M.7-2016*

41 Hair comb, carved horn, two poppy heads with cabochon moonstone centres and dark blue enamelled anthers, with two prongs on a silver hinged mount, one prong marked 'PARTRIDGE', 10.4 × 6.6 cm. Made by Fred Partridge, c. 1905–10. *Given by Mrs Hull Grundy. M.54-1982*

42 Pendant in the shape of a Gothic reliquary shrine of architectural form, hinged, gold, set with open-set cabochon emeralds, blue and green sapphires and rubies, the 'buttresses' with pearl finials, the 'roof' culminating in an enamelled suspension loop with three sapphires and a moonstone. The pendant opens on a hinge to reveal a three-dimensional enamelled group of the Virgin and Child with oxidised silver foliage and opal on base, 7.2 × 2.6 cm. Designed by Henry Wilson, c. 1897–1912. *Given by Mrs Hull Grundy. M.32-1984*

43 Ring, bezel in the form of a large open-set black opal, gold mount formed around it, the edge of the bezel with gold wire and red, purple, green and blue cloisonné enamel decoration with four roundels with white cloisonné enamel crosses on red ground, the under gallery and shoulders similarly enamelled, the shoulders flanked by cast gold crossbars, interior of shank marked 'HW' in diamond cartouche, bezel 3 × 2 cm. Designed by Henry Wilson, c. 1900–1920. *Bequeathed by Charles Haslewood Shannon. M/P.7-1937*

44 Necklace, gold, imitating filigree, chain composed of figure-of-eight knots of graduated size, separated by pairs of roundels with floral motif, the fastening flanked by two circular studs, pendant of an angel holding a dove, surrounded by open fretwork, ivy leaves and berries, pendant 6.1 × 4.4 cm, chain length 42.7 cm. Designed by Henry Wilson, c. 1900–1910. *Given by Mrs Hull Grundy. M.59-1982*

45 Hair comb, tortoiseshell two-pronged comb mounted in silver with large oval opal, and a silver wire frame with openwork cast silver leaves, four gold roses and three plique-à-jour enamelled plaques, depicting pinky-orange tulips on green and blue grounds, 17 × 7.2 cm. Design attributed to Henry Wilson, c. 1900–1905. *Given by Mrs Hull Grundy. M.28-1983*

46 Tankard, silver, cast cylindrical body with hinged cover with thumbpiece, round handle,

the body and cover chased with smooth sections of swirling design, some hammered sections, set with small turquoises, hallmarked Liberty & Co. [L & C in conjoined diamonds], Birmingham, lion passant, 1901–02, stamped 'Cymric', 19.5 × 14 cm. Designed by Archibald Knox, made by Liberty & Co., 1901–02. *On loan from the Keatley Trust. KTL.1990*

47 *Planta* waist clasp, silver, in two equal parts, cast and chased with stylised plant design, the front lightly hammered, each half hallmarked Liberty & Co. [LY & CO in rectangular cartouche], lion passant, London, 1900–1901, one half twice stamped 'T E', 5.2 × 10.3 cm. Probably designed by Archibald Knox, made by Liberty & Co., 1900–1901. *Given by Mrs Hull Grundy. M.3 & A-1983*

48 *Floris* waist clasp, silver, with separate rectangular loop for belt, cast and chased in sinuous design of two tulips and foliage, hallmarked Liberty & Co. [LY & CO in rectangular cartouche], lion passant, London, 1899–1900, 5.1 × 7.9 cm. Probably designed by Archibald Knox, made by Liberty & Co., 1899–1900. *Given by Mrs Hull Grundy. M.58 & A-1982*

49 Pendant, gold, decorated with translucent green enamel, and set with a central cabochon green turquoise, flanked by two natural pearls, an amethyst drop below, and triangular suspension loop, marked Carlo and Arthur Giuliano, 8.3 cm high. Designed by Charles de Sousy Ricketts, made by Carlo & Arthur Giuliano, 1899. *Bought with the Leverton Harris Fund from Henriette and Daniel Sturge Moore in 1972. M.5-1972*

50 *Blue Bird* brooch, gold, in the shape of a dove on berried foliage, enamelled in translucent green, and opaque turquoise and green, and set with a cabochon garnet eye, and seven

cabochon corals, a pin fastening across the back, 4.7 × 4.8 cm. Designed by Charles de Sousy Ricketts, made by Carlo & Arthur Giuliano, 1901. *Bequeathed by Miss Katherine H. Bradley, 1914. M/P.2-1914*

51 Hinged pendant, *Pegasus Drinking from the Fountain of Hippocrene* with miniature of Edith Emma Cooper (1862–1913), gold, enamelled in royal blue, green, red and white, set with four cut garnets, a cabochon garnet, three artificial pearls and one natural pearl, circular with protrusions round the edge, a baroque pearl drop at the bottom, and a Silenus mask at the top, to which is attached a gold bow and loop for suspension, the front decorated in low relief with Pegasus drinking from the fountain of Hippocrene against a blue background, the reverse with an enamelled motif composed of interlacing red, white and green circles and lozenges with a flower in the centre, with a hinge that opens to reveal a glazed watercolour miniature of Edith Emma Cooper in profile to right against a blue ground, the miniature signed lower left 'CR', 10.1 × 5.1 cm. Miniature painted and pendant designed by Charles de Sousy Ricketts, pendant made by Carlo & Arthur Giuliano, 1901. *Bequeathed by Miss Katherine H. Bradley, 1914. M/P.3 & A-1914*

52 Fan, *Psyche's Reception by the Gods*, paper leaf, painted and backed with parchment, mounted on mother-of-pearl sticks and guards, inscribed 'TO·M·FIELD', signed 'C.R.' to bottom left, 22.3 × 38.3 cm. Painted by Charles de Sousy Ricketts, c. 1901. *Bequeathed by Miss Katherine H. Bradley, 1914. M.14-1914*

53 *Sabbatai* ring, gold, the shoulders pierced by four tapering holes, the bezel in the form of a mosque with tower-like buttresses, four pierced doorways originally smeared with ambergris, each with a sloping roof and two arched windows above, the dome formed by a cabochon star sapphire, containing a

loose emerald, 3.8 × 2.5 cm. Designed and commissioned by Charles de Sousy Ricketts, probably made by Carlo & Arthur Giuliano, 1904. *Bequeathed by Miss Katherine H. Bradley, 1914. M/P.1-1914*

54 Pendant, *Psyche Descending into Hell*, gold, the front decorated in relief with the figure of Psyche against an enamelled opaque turquoise-blue ground with translucent green sections, set with sapphires, emeralds, chrysolites, a pink topaz, a clear gemstone and a garnet, with a pearl and an uncut emerald drop. Above is a grotesque mask and a gold loop for suspension. The reverse with a red, white, green and blue champlevé enamelled motif centred on a flower head, composed of interlacing circles, and a lozenge with looped points, with leaves in the spaces, surrounded by dots and hearts. Above are the initials 'TM' over 'MA'. Gold chain for suspension, 12.8 × 5.9 cm. Designed by Charles de Sousy Ricketts, made by Carlo & Arthur Giuliano, 1904. *Bought with the Leverton Harris Fund from Henriette and Daniel Sturge Moore in 1972. M.4 & A-1972*

55 Buckle, silver, hexagonal, cast and chased with pierced rose and foliate design, six solid radiating arms terminating in an oval cabochon labradorite, with a central oval of abalone shell with rope twist border, 10.5 × 8.4 cm. Made by John Paul Cooper and Lorenzo (Laurie) Colarossi, *c.* 1902. *Given by the Friends of the Fitzwilliam Museum. M.13-1975*

56 Casket, rectangular carcass with slightly convex hinged lid in walnut, covered in rough shagreen, the sides and lid divided into five panels by strips of silver with silver studs at regular intervals, the edges mounted in silver with rope edging, four bun feet and button clasp with square plate embossed with curling leaves and studs, interior with tiny cast silver plaque reading 'J Paul Cooper',

8.6 × 22.1 × 10.2 cm. The casket probably made by Lorenzo (Laurie) Colarossi, the clasp made by John Paul Cooper, *c.* 1932. *Exhibited at the memorial exhibition of Cooper's work held at the Rembrandt Gallery, Vigo Street, London, from which it was purchased by Ernest Marsh of the Contemporary Art Society, Arts and Crafts Fund. Marsh presented it to the Fitzwilliam Museum in 1944. M/P.2-1944*

57 Dish, *Draped Nymphs bowl*, silver-gilt, long oval dish in the style of fabric pulled taut, the bowl cast and engraved with wavy lines internally and externally, held at either end by means of looped handles by a cast figure of a girl, with draped dress, leaning backwards, ivory (not elephant or rhino) stands on the base of each foot, the bowl engraved 'OMAR RAMSDEN ME FECIT', hallmarked Omar Ramsden, lion passant, London, 1935–36, stamp commemorating the 25th anniversary of the accession of King George V and Queen Mary, 9.1 × 46.3 × 15.3 cm. Made by Omar Ramsden, 1935–36. *On loan from the Keatley Trust. KTL.5-1987*

58 Waist clasp, silver, cast and chased, set with an oval plaque enamelled in blue, turquoise, green and white with a lyre bird, the reverse engraved 'RAMSDEN & CARR MADE ME 1903', hallmarked Ramsden & Carr, lion passant, London, 1903–04, 5.7 × 5 cm, separate silver loop attachment. Made by Omar Ramsden and Alwyn Carr, 1903. *Given by Mrs Hull Grundy, 1983. M.2 & A-1983*

59 Chalice and paten, silver, Gothic-style chalice with spot-hammered surface, bowl with sloping sides and gilt interior on short stem with large knop embossed and chased with Celtic design of four stylised lillies, spreading circular foot with two applied bands flanking a border of embossed stylised flowers, above an embossed cross, circular paten with hammered surface, remains of

gilding on upper side, the underside of the foot engraved 'OMAR RAMSDEN ME FECIT' and 'H. THOMAS.D.D.AMICI ELIENSES A.S.MCMXXXV', hallmarked Omar Ramsden, lion passant, London, 1935–36, stamp commemorating the 25th anniversary of the accession of George V and Queen Mary, 16.8 × 12.2 cm. Made by Omar Ramsden, 1935–36. *Given by Mrs Hull Grundy, 1982. M.48 A-B-1982*

60 *PAX* dish, silver, quatrefoil-shaped with a spot-hammered surface and applied cast and chased ornament, a central applied medallion bearing the word 'PAX' in monogram and '1938' in relief, surrounded by a foliate wreath with round fruit, pears, grapes, sheaves of wheat and the number '4', plain foot ring, base engraved 'OMAR RAMSDEN ME FECIT', hallmarked Omar Ramsden, lion passant, London, 1938–39, 2.2 × 15.9 cm. Made by Omar Ramsden, 1938–39. *Given by Mrs Hull Grundy, 1984. M.17-1984*

61 Morse, silver, cast and engraved, a central cross with large cabochon amethyst at centre, each arm set with a cabochon garnet with silver-gilt border, the space between each arm with three silver roses, the head of each set with a smaller open-set cabochon amethyst, the background with reddish-brown translucent enamel, hallmarked Carl Krall, lion passant, London, 1898–99, Krall [in cartouche], 11.1 × 11 cm. In original red leather case with red velvet and white silk lining printed in gold 'BARKENTIN & KRALL/ Goldsmiths/291/REGENT ST. W'. Made by Carl Cristof Krall, 1898–99. *Lent by the Keatley Trust. AAL.2 &A-2004*

62 Hair ornament, tortoiseshell comb with hinged gold mount, attached to a silver spray of six ivy leaves, enamelled in translucent green, with four open-set garnet berries, marked with firm's logo of a sunflower flanked by two

Cs, 10.5 × 9.6 cm. Made by Child & Child, c. 1892–1910. *Given by Mrs Hull Grundy. M.77-1984*

63 Brooch, silver gilt, in the shape of a peacock, its tail openwork and enamelled in blue, turquoise, yellowy green, with three gold loops beneath, a pearl suspended from each loop, pin fastening across back, 3.8 × 4 cm. In original dark turquoise leather case lined with cream velvet and silk, printed in gold 'CHILD & CHILD/JEWELLERS/GOLD AND SILVERSMITHS/35 ALFRED PLACE WEST/ QUEEN'S GATE'. Made by Child & Child, c. 1892–96. *Given my Mrs Hull Grundy. M.35 & A-1984*

64 Cigarette box, silver, cast cylindrical body and cover with applied whorl decoration and cast silver and turned ivory knob, hallmarked lion passant, London, H.G. Murphy, 1938–39, studio falcon mark, 13.6 × 8.5 cm. Made by H.G. Murphy, 1938–39. *On loan from the Keatley Trust. KTL.1985*

65 Vase, silver, with fluted sides, three engraved wavy lines at rim and bottom of vase, reeded collar above flat foot with incised radiating lines, the base engraved 'Given by/The Goldsmiths' Company/To/R.E.A. MORRIS/ in gratitude for his services/1925 1958/ Goldsmiths' Hall/6th. July, 1958', hallmarked lion passant, London, H.G. Murphy, studio falcon mark, 1935–36, 25.7 × 13 cm. Designed by Richard Yorke Gleadowe, CVO, c. 1935 and made by H.G. Murphy, 1935–36. *On loan from the Keatley Trust. KTL.6-1987*

66 Brooch, silver, cast and chased openwork foliate mount, set with open-set cabochon carnelian, surrounded by silver rope-twist border, hallmarked 'SD', lion passant, London, 1928–29 and stamped 'S DUNLOP', 3.5 × 4.1 cm. In original blue leather case, with cream silk printed in black 'SIBYL DUNLOP Ltd./

Jewellers and Silversmiths,/69,/KENSINGTON CHURCH ST,/LONDON. W.8.' Made in the workshop of Sibyl Dunlop, perhaps by W. Nathanson, 1928–29. *Given by Mrs Hull Grundy. M.40 & A-1983*

67 Pendant cross, silver, cruciform, set with an oval opal in the centre surrounded by silver rope-twist border, with five faceted open-set amethysts, one at the extremity of each arm and two on the stem, and numerous cabochon amethysts, sapphires and chrome chalcedony interspersed with stylised plant motifs, the reverse with a hinged rectangular (with cut corners) compartment, completely champlevé enamelled in pale blue and purple, with green leaves and pink flowers, with silver suspension loop and attachment, 13.8 × 7.4 cm. In purple velvet case, the off-white silk inside printed in black 'SIBYL DVNLOP/Art Jewellers and Silversmiths/69 CHURCH ST. KENSINGTON/LONDON, W.' Made in the workshop of Sibyl Dunlop, perhaps by W. Nathanson, the enamelling by Henri De Koningh, *c.* 1930. *Given by the Friends of the Fitzwilliam Museum. M.5 & A-2004*

68 Bowl and cover, cast circular bowl of gunmetal with engraved line and teardrop-shaped decoration, rim with applied pierced and foliate white metal band of decoration, on five feet, the cover and knob with rope edge border and base of knob with engraved wavy line decoration, gilt interior, engraved on underside of cover 'F.J.B.H./21=VI=1930',

marked on underside of bowl 'EDWARD SPENCER' in a circle around 'DEL' with '66' below, 11.9 × 12.9 cm. Designed by Edward Spencer, made by the Artificers' Guild, *c.* 1930. *On loan from the Keatley Trust. AAL.7 & A-2008*

69 Standing cup/chalice, cast and chased, silver, cup with sloping cylindrical sides and a flared rim with an almost flat bottom, with applied reeded decoration between two borders of punched beads, and at the base of the cup an overlapping ovulo border with rope borders, on a spiral fluted trumpet-shaped foot on a circular base, with engraved and straight wavy lines, hallmarked Artificers' Guild, lion passant, London 1935–36, 14.9 × 10.2 cm. Probably designed by Edward Spencer, made by the Artificers' Guild, 1935–36. *Given by the Contemporary Art Society, Arts and Crafts Branch, 1941. M/P.4-1941*

70 Pair of salt cellars, silver, each of a cast low circular bowl with thread-edged border, engraved line and dot decoration, on a bulging fluted knop above a slightly domed circular foot with milled edge, the surface hammered, hallmarked Artificers' Guild, lion passant, London, 1934–35, with designer's mark on underside of base, a circular punch containing 'EDWARD SPENCER' around 'DEL', 5.1 × 6.8 cm. Designed by Edward Spencer and made by the Artificers' Guild, 1934–35. *Given by the Contemporary Art Society, Arts and Crafts Branch, 1941. M/P.2–1941 and M/P.3-1941*

GLOSSARY

BEZEL The visible part of a ring, worn on the upper side of the finger, often in the form of a wider flat surface, engraved with decoration, or with a mount containing a gemstone.

BRITANNIA SILVER An alloy of silver (around 96%) and copper, softer than sterling silver (92.5% silver) and hallmarked with the female figure of Britannia. Introduced in 1697.

CABOCHON A particular cut of hardstone or gemstone, cut completely smoothly, without any facets.

CAST A method of production whereby a molten material, i.e. metal, is poured into a mould.

CHAMPLEVÉ ENAMEL Although this comes from the French for 'raised field', the practice consists of carving into a metal surface in order to form pits into which vitreous enamel is fired.

CHASING A means of decorating a metal surface by working it from the front using various tools, to either depress or push the metal aside, without removing any of the metal.

CLOISONNÉ ENAMEL From the French for 'cell' or 'partition', thin metal wires are applied to a surface to form small cells, which are then filled with vitreous enamel.

ENGRAVING Cutting lines into a surface with a sharp V-shaped implement or burin, thereby removing some of the material.

FILIGREE Flat or round wire, tiny gold or silver beads or twisted thread, soldered together or onto a metal surface to form patterns.

GRANULATION A technique of covering a surface or making patterns with tiny granules of metal, usually gold, in the ancient world by fusing with heat and later by soldering.

HALLMARK A stamp applied to precious metal that attests to its purity, proving it has been tested by an official assay office, which also has its own stamp. In Britain, other hallmarks are also stamped, including year of assay (which is also usually the year of manufacture) and mark of the silversmith.

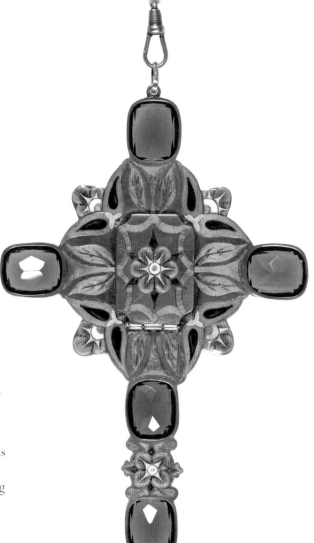

PEWTER A metal alloy, traditionally composed of between 85% and 99% tin, mixed with copper, antimony, bismuth and occasionally lead or silver.

PLIQUE-À-JOUR ENAMEL French term translated as 'letting in daylight', a type of vitreous enamel applied to metal cells (like cloisonné enamel) but *without* a backing plate, thereby letting light shine all the way through.

REPOUSSÉ Raised decoration formed by hammering and raising a sheet of metal from behind.

SHANK The 'hoop' or 'band' of a finger ring, which goes all the way around a finger.

SILVER GILT Silver that has been 'gilt', or gilded, coated with a very thin layer of gold, by mercury gilding or electrogilding.

SPOT-HAMMERING A process of lightly hammering a metal surface, creating a subtle, textured surface.

UNDER GALLERY The section beneath the bezel (*qv*) of a finger ring, often visible from the side or from certain angles.

NOTES

1. All quotations from Mrs Hull Grundy in this introduction come from an interview she gave to Vivienne Becker, published in *Art & Auction*, November 1982.
2. Written by Julia Poole for a web page on Mrs Hull Grundy, as part of the Fitzwilliam's 'Hidden Histories' project.
3. Burges 1863, p. 403.
4. Sala 1868, pp. 199–200.
5. Watherston & Son 1907, p. xvi.
6. Crane 1888, pp. 7–8.
7. Charles Ricketts, quoted by Michael Field, 9 December 1899, *Works and Days*, Notebook 13, p. 271.
8. The unification of Italy (*Risorgimento*) began in 1815 and was completed in 1871. See Gere and Rudoe 2010, pp. 398–417.
9. Castellani 1862, p. 1.
10. Ibid.
11. Ibid., p. 20.
12. G. Hunter, 'White, William (1825–1900)', *Oxford Dictionary of National Biography*, Oxford: Oxford University Press, 2004 (accessed online).
13. Hunter 2010, p. 132; also available online at historicengland.org.uk.
14. Hunter 2010, p. 134.
15. *Building News*, 18 January 1861, p. 50, quoted in Hunter 2010, pp. 136-7.
16. For a full discussion of Burges's jewels, see Gere 1972, pp. 50–52.
17. *The Builder* 34 (1876), p. 18, quoted in J. Mordaunt Crook, 'Burges, William (1827–1881)', *Oxford Dictionary of National Biography*, Oxford: Oxford University Press, 2004 (accessed online). I am indebted to Mordaunt Crook 2013, which informed this essay.
18. Burges's sketchbook, Victoria and Albert Museum no. 8823, p. 40, pressmark H/93/E/1.
19. Victoria and Albert Museum acc. no. 552-1907, a photograph of this casket and another, taken at the 1905 exhibition *Mostra d'Arte Antica Abruzzese*, at Chieti.
20. *The Ecclesiologist* XIX/NS XVI (1858), p. 226, quoted in Mordaunt Crook 2013, pp. 314-15.
21. Mordaunt Crook 2013, p. 314.
22. RIBA pressmark SD181, pp. 11-12.
23. The third decanter, now in the V&A (CIRC. 857-1956), was made for the lead merchant James Nicholson to accompany a drinking goblet he had ordered from Burges in 1863.
24. After having being inhabited by Pullan (for whom *see* p. 22), The Tower House was leased to Col. T.H. Minshall, who subsequently sold the lease to Col. and Mrs Graham in 1933, at which time some of the contents of the house were sold by Chesterton & Sons, on 16 October 1933. Other items remained in the house until John Betjeman took up the lease in 1962. He subsequently gave some pieces to the novelist Evelyn Waugh. Known items of furniture include the Golden Bed, now in the Victoria and Albert Museum (acc. no. W.5:1 to 10–1953), the Great Bookcase, now in the Ashmolean Museum (acc. no. WA1933.26), and the 'Sleeping Beauty' Bed (acc. no. F.70) and Zodiac Settle (acc. no. F.163), both now in The Higgins Bedford.
25. Haweis 1882, pp. 14, 22, quoted in Mordaunt Crook 2013, p. 310.

26. Haweis 1882, p.17, quoted in Mordaunt Crook 2013, pp.313–14.
27. Two goblets were made for his own use and a third was sold to the lead merchant James Nicholson, which is now in the Victoria and Albert Museum. See note 23.
28. Pullan c.1885, no.17.
29. Gere 2017, p.117 n44.
30. Email from Richard Dennis to the author, 9 January 2018.
31. Anthony Symondson, obituary of Charles Handley-Read, *Design Journal*, December 1971, p.75.
32. Haweis 1878, p.104.
33. Gere and Rudoe 2010, p.353.
34. Victoria and Albert Museum acc. no. E.112–2013.
35. Victoria and Albert Museum acc. no. M.5:1,2–2011.
36. Gere and Rudoe 2010, pp.418–19.
37. British Museum acc. no. 1978,1002.740, Hull Grundy Gift, 1978.
38. Victoria and Albert Museum acc. no. M.29–1970.
39. R. Hill, 'Dresser, Christopher (1834–1904)', *Oxford Dictionary of National Biography*, Oxford: Oxford University Press, 2004 (accessed online).
40. Whiteway 2004, p.152.
41. Rudoe 1994, p.41.
42. Ibid.
43. *Art Journal*, 1879, p.222, quoted in ibid.
44. Rudoe 1994, p.43.
45. Naturalisation Papers: Rinzi, Ernesto, from Italy. Certificate 5369 issued 25 February 1867. HO 1/138/5369, National Archives, Kew.
46. Royal Museums Greenwich acc. no. PLT0002. The accompanying design was later acquired by the National Maritime Museum, number ZBA1617.
47. Royal Collection Inventory Numbers 422305 and 422311
48. Ernest Rinzi, *Journal of Ernest Rinzi, 1898–1903*, bound manuscript journal, Post-1650 Manuscript Collection, Post-1650 MS 0668, Rare Book & Manuscript Library, University of Illinois at Urbana-Champaign.
49. Haweis 1878, p.104.
50. British Museum acc. no. 1978,1002.1027. Hull Grundy Gift, 1978.
51. Haweis 1878, pp.104–5.
52. Ibid., p.105.
53. Sala 1868, quoted in Becker and Munn 1983, p.52.
54. British Museum acc. no. 1913,0208. See Rudoe 1984.
55. Watt 1904, pp.25–6.
56. See South Kensington, *Indian Manufactures* 1872, no.2439, quoted in Gere and Rudoe 2010, p.297.
57. Many thanks to Judy Rudoe for this suggestion.
58. This comparison was pointed out in Gere and Rudoe 2010, p.404.
59. Culme 1987, p.470.
60. *The Illustrated Exhibitor*, 1851, p.470, quoted in ibid., p.469.
61. Victoria and Albert Museum acc. no. E.2:1494–1986.
62. I am very grateful to Charlotte Gere for sharing her research with me.
63. National Art Library, pressmark 209.G.Box II.
64. Watherston & Son 1907, p.I.
65. Sala 1868, pp.199–200.
66. Culme 1987, pp.245–6.
67. *The Trades and Manufactories of Great Britain* (1865), pp.31–3, quoted in Culme 1987, p.245.
68. *The Journal of Beatrix Potter*, translated from code by Leslie Linder, London: F. Warne, 1966, quoted in Culme 1977, pp.47, 48, 53.
69. Cumming 1993, pp.94–5.
70. 'Studio-Talk', *The Studio* 12 (1898), p.191.
71. Ibid., pp.189–90.
72. National Galleries Scotland acc. no. NG 1865 A–D.
73. Cumming 1993, p.40.
74. From a review of the exhibition *Arts and Crafts* at the New Art Gallery, *The Times*, 17 January 1903.
75. Cumming 1993, p.78.
76. M.S. Briggs, rev. W. Hitchmough, 'Voysey, Charles Francis Annesley (1857–1941)', *Oxford Dictionary of National Biography*, Oxford: Oxford University Press, 2004; online edn, October 2007.
77. *The International Studio* II (1897), p.2.
78. King's College Archive Centre, Cambridge, Papers of Charles Robert Ashbee, CRA/3/6, p.325. All following references to the papers of Charles Robert Ashbee refer to the King's College Archive Centre, Cambridge.
79. For the use of aluminium in jewellery, see Gere and Rudoe 2010, pp.203–6.
80. See Hamerton 2014, p.32.
81. Victoria and Albert Museum acc. no. W.5–1998.
82. Formerly in the collection of Voysey himself, acc. no. CIRC.519–1962.
83. Bernbaum 2016. I am grateful to Mr Bernbaum for allowing me to reproduce some of his research here.
84. *Esposizione d'Arte Decorativa Moderna, Regolamento Generale*, Turin, 1901, quoted in Fratini 1970, p.134.
85. *Deutsche Kunst und Dekoration* 11 (October 1902–March 1903), p.212, illus. p.235. Translation from German courtesy of Hayley Bartley.
86. *Dekorative Kunst* 10 (1902), p.417.
87. *House & Garden* 3 (1903), p.211.
88. *Der Moderne Stil* VI (1905), pl.59, fig.5.
89. RIBA pressmark VoC/2/2.
90. Bernbaum 2016, p.77.

91. Miller 1896, p. 348.
92. 'Gilbert Leigh Marks', *Mapping the Practice and Profession of Sculpture in Britain and Ireland 1851–1951,* University of Glasgow History of Art and HATII, online database 2011.
93. *The Studio* V (1895), pp. 219–20.
94. Ibid.
95. Ibid.
96. Spielmann 1905, p. 243.
97. Miller 1898, p. 134.
98. Ibid., p. 137.
99. Spielmann 1905, p. 243.
100. Miller 1898, p. 138.
101. Spielmann 1905, p. 243.
102. *Art Journal,* August 1897, p. 252.
103. Ibid.
104. Miller 1898, p. 138.
105. Culme 1987, pp. 312–13.
106. Miller 1898, p. 137.
107. Ibid., pp. 136–8.
108. Ibid., p. 137.
109. CRA/1/12, July–December 1902, 14 November 1902, p. 430.
110. Vallance 1902, p. 43.
111. CRA/1/10, November–December 1901, p. 536.
112. A further shop was opened around the corner at 67A New Bond Street, early in 1903, in order to hold exhibitions and display furniture.
113. *The Studio* VII, (1897), p. 32.
114. See Bury 1967 for more details.
115. CRA/1/3, 1887–92, p. 271.
116. 'The Arts and Crafts', *The Studio* IX (1897), pp. 126–7.
117. CRA/1/13, January–May 1903, pp. 43–4.
118. Ibid., pp. 46–7.
119. Ibid., p. 43.
120. CRA/1/6, March 1900, p. 69.
121. *The Studio* XXXV (1905) p. 236.
122. Lloyd 1984, pp. 2–3.
123. CRA/1/26, January–July 1914, p. 121.
124. Ibid., p. 126.
125. Crawford 2005, p. 328.
126. CRA/1/26, January–July 1914, p. 38.
127. Ibid., p. 42.
128. Thanks to Michael Krier for providing this biographical information.
129. CRA/1/21, 1909, p. 39, a letter from Alec Miller to Ashbee dated 11 January 1909 is on notepaper printed: 'MESSRS. MILLER AND HART/ARCHITECTURAL SCULPTORS AND CARVERS/CAMPDEN, GLOS./OF THE GUILD/OF HANDICRAFT/ALEC MILLER/FRED MILLER/WILLIAM T. HART'.
130. Conversation with the author, 23 March 2017.
131. An identical scene appears on a silver hand mirror with a back of carved walnut illustrated in Peel 2016, p. 67. Thank you to Alan Crawford for pointing this out.
132. Biographical information courtesy of Thomas Holman, Director, Wartski. I am very grateful to Thomas for sharing his currently unpublished research with me.
133. Wilson 1903, pp. xiv–xv.
134. Letter from Gordon Craig to Henry Wilson, August 1915, RCA Archive, quoted in Manton 2009, p. 101.
135. CRA/1/5, 1898–8, 9 May 1899, p. 9/45.
136. CRA/1/12, July–December 1902, September 1902, p. 380.
137. H. Wilson, *Address to the Goldsmiths', Silversmiths', Jewellers' and Allied Trades' Art Council at the presentation of prizes to workmen and apprentices for essays upon the applied arts at the Franco-British Exhibition at Goldsmith's Hall,* 8 December 1908, printed in *The Watchmaker, Jeweller, Silversmith and Optician,* January 1909, quoted in Manton 2009, p. 87.
138. For example, one tiara is now in the collection of the Victoria and Albert Museum, acc. no. CIRC.362–1958, whilst another belongs to the Worshipful Company of Goldsmiths.
139. Wilson 1903, pp. 28–9.
140. Victoria and Albert Museum acc. no. E.669:170–1955.
141. Victoria and Albert Museum acc. no. E.669:425–1955.
142. The drawing: Victoria and Albert Museum acc. no. E.669:296–1955; the necklace: The Higgins Bedford, acc. no. 1983.199, given to the Museum by Mrs Hull Grundy.
143. Anscombe and Gere 1978, p. 155, fig. 201.
144. Victoria and Albert Museum acc. no. E.669:410–1955.
145. Victoria and Albert Museum acc. no. E.669:293–1955. This finished hair comb is in the collection of Glasgow Museums, acc. no. E.1976.1.739.
146. For a detailed argument of Knox's early involvement with the *Cymric* range, see Bernbaum 2014. Biographical information from D.M. Wilson, 'Knox, Archibald (1864–1933)', *Oxford Dictionary of National Biography,* Oxford: Oxford University Press, 2004 (accessed online).
147. Culme 1987, p. 296.
148. A volume of scraps of pattern designs survives in the collection of the Victoria and Albert Museum, C/M/8/A.
149. CRA/1/26, January–July 1914, 11 May 1914, p. 125.
150. Ibid., p. 124.
151. The true identity of Ricketts's mother has only recently been discovered; see Delaney and Verney 2016.
152. CRA/1/6, January–September 1900, p. 72.

153. Delaney 1979, p.5.
154. British Museum acc. no. 1962,0809.2.
155. Scarisbrick 1982, p.163.
156. British Library, Add Mss. 46789, fol. 138 recto, quoted in ibid., p.164.
157. Quoted in Gere 1972, p.138.
158. Munn 1984, p.68.
159. Ashmolean Museum acc. no. WA1952.53.
160. Victoria and Albert Museum acc. no. M.35-1939.
161. British Library, Add Mss. 46789, fol. 129 recto, quoted in Scarisbrick 1982, p.164.
162. Quoted in Donoghue 2014, p.71.
163. From the full diary of Michael Field, *Works and Days*, Notebook 7, pp.92 and 96. This and all other Michael Field diary quotations were accessed digitally via the Michael Field Diary Archive, *Victorian Lives and Letters Consortium*, Center for Digital Humanities, University of South Carolina.
164. *Works and Days*, Notebook 7, pp.95-6.
165. Donoghue 2014, pp.91-3.
166. *Works and Days*, Notebook 13, p.258.
167. It has been stated previously that the pendant was given to Bradley just three days later on 8 December, but it is not mentioned around this date in *Works and Days*.
168. British Museum acc. nos 1962.0809.2.7-10
169. Gere and Munn 1996, p.155.
170. *Works and Days*, Notebook 14, p.17.
171. *Works and Days*, Notebook 24, p.148.
172. *Works and Days*, Notebook 15, pp.137-8.
173. Delaney 1979, p.20.
174. Ricketts's diary of 24 September 1901, quoted in Munn 1984, p.68.
175. *Works and Days*, Notebook 15, p.311.
176. Gere and Munn 1996, p.152.
177. Seyffert 1895, p.465.
178. *Works and Days*, Notebook 15, p.347.
179. Scarisbrick 1980, p.6.
180. *Works and Days*, Notebook 18, p.59.
181. *Works and Days*, Notebook 18, p.17.
182. *Works and Days*, Notebook 18, p.55.
183. *Works and Days*, Notebook 18, p.61. The Samothrace corset was longer in the body than previous corsets, providing a smoother outline for the new, straighter style of gown, but was cut very low at the bust and therefore did not provide as much support.
184. *Works and Days*, Notebook 17, p.191.
185. Letter from Sturge Moore to Ricketts, quoted in Legge 1980, p.228.
186. Letter from Ricketts to Sturge Moore, quoted in Legge 1980, p.229.
187. Information from Henriette Sturge Moore, quoted in Scarisbrick 1982, p.168.
188. Letter from Riette Sturge Moore to Museum Director David Piper, 20 April 1972, Fitzwilliam Museum Archive.
189. Quoted in Gere 1972, p.138.
190. Scarisbrick 1982, p.167.
191. Munn 1984, p.70.
192. Royal Academy cat. no. 412 E.
193. V&A cat. no. W 80.
194. Cat. nos 412 H and W 81 respectively.
195. Cat. nos 412 I and W 82 respectively.
196. Cat. nos 412 A and 412 O.
197. Goldsmiths' Hall cat. nos 666-669.
198. Wilson 1899, pp.213-14, quoted in Kusmanović 1999, p.21. I am indebted to N.N. Kusmanović's previous research and book, from which this shortened biography has been created.
199. Kusmanović 1999, p.34.
200. Royal Collection Inventory Numbers 102599 and 39965 respectively. One further piece by Cooper exists in the collection, but was a gift to Queen Mary and therefore not purchased by her (RCIN 1002599).
201. All sketch and costing books remain in the Cooper Family Archive.
202. For a detailed analysis of Cooper's use of shagreen, see Kusmanović 1999, pp.69-92.
203. Birmingham 1973, Introduction (n.pag.).
204. A. Shannon and M. Wilson, 'Ramsden, Omar (1873-1939)', *Oxford Dictionary of National Biography*, Oxford: Oxford University Press, 2004 (accessed online).
205. Ibid.
206. Purchase tax was a tax of 33.33 per cent applied to luxury goods between 1940 and 1973, in order to reduce the deemed wastage of raw materials.
207. Ramsden archive, Goldsmiths' Hall, Work book F, p.137, design no. 864.
208. Ibid., p.1 of illustrated photo album, Portfolio C.
209. Ibid., Work book M, p.134, design no. 2021.
210. See *BBC Antiques Roadshow*, filmed at Hampton Court (no. 2), series 33, episode 27, aired 29 May 2011, 0:17:46-0:20:01.
211. National Trust acc. no. 10582.
212. 'Carl Cristof Krall', *Mapping the Practice and Profession of Sculpture in Britain and Ireland 1851-1951*, University of Glasgow History of Art and HATII, online database 2011.
213. 'Fine Church Metal-Work', *Art Journal*, February 1908, p.38.
214. Acc. no. 1981,0603.1.
215. Acc. nos NMW A 50497 and NMW A 51690.
216. Various accession numbers, acquired by the Circulation Department in 1964.
217. 'THE ART METAL EXHIBITION', *Art Journal*, August 1898, p.254.
218. S. Huxtable, 'Re-reading the Green Dining Room', in Edwards and Hart 2010, p.37.

219. The Falcon Studio moved premises in 1935, setting up at 22 Marylebone High Street.

220. Biographical details taken from Atterbury and Benjamin 2005.

221. Quoted (not referenced) in Atterbury and Benjamin 2005, pp. 94–5.

222. Ibid., p. 93.

223. The original version from 1931 is in the collection of the Goldsmiths' Company. Another example, dated 1938–39, is in the collection of the Victoria and Albert Museum, purchased by the Museum the year it was made from the Goldsmiths' Hall exhibition of *Modern Silverwork*, acc. no. CIRC.228&a-1938.

224. *Royal Academy Exhibition of British Art in Industry, January–March 1935*, 3rd edn, London: William Clowes and Son, 1935, p. xii.

225. Jenkins 2000, p. 78.

226. Goldsmiths' Company Archive. Many thanks to Eleni Bide and Stephanie Souroujon for this information.

227. Hinks 1983, p. 84.

228. Postcard from Mrs Hull Grundy to Julia Poole, 10 December 1982, Applied Arts Department, Fitzwilliam Museum.

229. De Koningh 1927, p. vi.

230. Ibid., pp. v–vi.

231. 'Art Handiwork and Manufacture', *Art Journal*, November 1905, p. 348.

232. Ibid.

233. 'Art Handiwork', *Art Journal*, February 1906, p. 55.

BIBLIOGRAPHY

Anscombe, I., and C. Gere (1978) *Arts & Crafts in Britain and America*. London: Academy Editions.

Atterbury, P., and J. Benjamin (2005) *Arts and Crafts to Art Deco: The Jewellery and Silver of H.G. Murphy*. Woodbridge: Antique Collectors' Club.

Becker, V., and G. Munn (1983) 'Robert Phillips Underestimated Victorian Jeweller'. *Antique Collector*, October, pp. 50–55.

Bernbaum, A. (2014) 'Origins of the Liberty Cymric Silver Range'. *Journal of the Archibald Knox Society* 3, pp. 26–43.

Bernbaum, A. (2016) 'Voysey's Aluminium Clocks'. *The Orchard* V, pp. 68–77.

Birmingham City Museum and Art Gallery (1973) *Omar Ramsden 1873–1939: Centenary Exhibition of Silver*. Birmingham: Birmingham City Museum and Art Gallery.

Burges, W. (1863) 'Antique Jewellery and Its Revival'. *The Gentleman's Magazine* 214, pt I, pp. 403–11.

Bury, S. (1967) 'An Arts and Crafts Experiment: The Silverwork of C.R. Ashbee'. Victoria and Albert Museum Bulletin Reprints, reprinted from *Bulletin*, III/ 1, January, pp. 18–25.

Castellani, A. (1862) *Antique Jewellery and its Revival*. London: printed for private circulation.

Crane, W. (1888) *Arts & Crafts Exhibition Society Catalogue of the First Exhibition MDCCCLXXXVIII*. London.

Crawford, A. (2005), *C.R. Ashbee Architect, Designer & Romantic Socialist*, 2nd edn. New Haven CT and London: Yale University Press.

Culme, J. (1977) *Nineteenth Century Silver*. London: Country Life.

Culme, J. (1987) *The Directory of Gold & Silversmiths, Jewellers & Allied Traders 1838–1914*. Woodbridge: Antiques Collectors' Club.

Cumming, E. (1993) *Phoebe Anna Traquair 1852–1936*. Edinburgh: National Galleries of Scotland.

De Koningh, H. (1927) *The Preparation of Precious and Other Metal Work for Enamelling with a Brief Historical Survey*. London: C. Lockwood & Son.

Delaney, J.G.P. (1979) *Some Letters from Charles Ricketts and Charles Shannon to 'Michael Field' (1894–1902)*. Edinburgh: The Tragara Press.

Delaney, J.G.P., and C. Verney (2016) *Charles Ricketts's Mysterious Mother*. The Hague: At the Paulton.

Donoghue, E. (2014) *We Are Michael Field*. London: Pan Macmillan.

Edwards, J., and I. Hart (2010) *Rethinking the Interior, c.1867–1896, Aestheticism and Arts and Crafts*. Farnham and Burlington VT: Ashgate.

Fratini, E.R. (ed.) (1970) *Torino 1902, polemiche in Italia sull'Arte Nuova*. Turin: Martano.

Gere, C. (1972) *Victorian Jewellery Design*. London: William Kimber.

Gere, C. (2017) 'Charles Handley-Read as a Collector in His Own Words'. *Journal of the Decorative Arts Society* 41, pp. 102–17.

Gere, C., and G.C. Munn (1996) *Artists' Jewellery: Pre-Raphaelite to Arts and Crafts Jewellery*. Woodbridge: Antique Collectors' Club.

Gere, C., and J. Rudoe (2010) *Jewellery in the Age of Queen Victoria: A Mirror to the World*. London: British Museum Press.

Hamerton, I. (2014) 'The Evolution of Voysey's Architectural Clocks and Timepieces'. *The Orchard* III, pp. 25–36.

Haweis, M.E. (1878) *The Art Of Beauty*. London: Chatto & Windus.

Haweis, M.E. (1882) *Beautiful Houses: Being a Description*

of Certain Well-known Artistic Houses, London: Low, Marston, Searle & Rivington.

Hinks, P. (1983) *Twentieth Century Jewellery, 1900–1980*. London: Faber & Faber.

Hunter, G. (2010) *William White: Pioneer Victorian Architect*. Reading: Spire Books.

Jenkins, P. (2000) *Unravelling the Mystery: The Story of the Goldsmiths' Company in the Twentieth Century*. London: The Goldsmith's Company and Third Millennium Publishing.

Kusmanović, N.N. (1999) *John Paul Cooper: Designer and Craftsman of the Arts and Crafts Movement*. Stroud: Sutton Publishing.

Legge, S. (1980) *Affectionate Cousins: T. Sturge Moore and Marie Appia*. Oxford: Oxford University Press.

Lloyd, S. (1984) *H. Balfour Gardiner*. Cambridge: Cambridge University Press.

Manton, C. (2009) *Henry Wilson: Practical Idealist*. Cambridge: Lutterworth Press.

Michael Field (*c.*1888–1914) *Works and Days* (full transcripts). Accessed via the Michael Field Diary Archive, *Victorian Lives and Letters Consortium*, Center for Digital Humanities, University of South Carolina, http://tundra.csd.sc.edu/vllc/field.

Miller, F. (1896) 'Some Gold, Silver, and Coppersmiths'. *The Art Journal*, November, pp. 345–9.

Miller, F. (1898) 'The Craft of the Silversmith'. *The Artist*, July, pp. 133–8.

Mordaunt Crook, J. (2013) *William Burges and the High Victorian Dream*, 2nd edn. London: Frances Lincoln.

Munn, G.C. (1984) *Castellani and Giuliano, Revivalist Jewellers of the Nineteenth Century*. London: Trefoil Books.

Peel, G. (2016) *Alec Miller: Carver, Guildsman, Sculptor*. Tenbury Wells: Graham Peel.

Pullan, R.P. (*c.*1885) *The Designs of William Burges, A.R.A.* London.

Rudoe, J. (1984) 'The Layards, Cortelazzo and Castellani: New Information from the Diaries of Lady Layard', *Jewellery Studies* 1, pp. 59–82.

Rudoe, J. (1994) *Decorative Arts 1850–1950: A Catalogue of the British Museum Collection*, 2nd edn. London: British Museum Press.

Sala, G.A. (1868) *Notes and Sketches of the Paris Exhibition*. London: Tinsley Brothers.

Scarisbrick, D. (1980) 'British Rings at the Fitzwilliam Museum'. *The Society of Jewellery Historians Newsletter* 10, pp. 4–6.

Scarisbrick, D. (1982) 'Charles Ricketts and His Designs for Jewellery'. *Apollo* CXVI, September, pp. 163–9.

Seyffert, O.A. (1895) *A Dictionary of Classical Antiquities, Mythology, Religion, Literature & Art*, 2nd edn. London: Swan Sonnenschein.

Spielmann, M.H. (1905) 'Gilbert Marks: Silversmith'. *The Burlington Magazine* VII/27, June, pp. 242–3.

Vallance, A. (1902) 'Modern British Jewellery and Fans'. In C. Holme (ed.), *Modern Design in Jewellery and Fans: by the Artist Craftsmen of Paris, London, Vienna, Berlin, Brussels, etc.*; reprinted as G. Mourey et al., *Art Nouveau Jewellery & Fans*. New York: Dover, 1973.

Watherston & Son (1907) *The Place of Jewellery in Art*. London: Printed for private circulation.

Watt, G. (1904) *Indian Art at Delhi, 1903: Being the Official Catalogue of the Delhi Exhibition, 1902–1903*. London: John Murray.

Whiteway, M. (ed.) (2004) *Christopher Dresser – A Design Revolution*. London: V&A Publications in association with Cooper-Hewitt National Design Museum, Smithsonian Institution, Washington DC.

Wilson, H. (1899) 'The Arts and Crafts Society: With Especial Reference to Certain Exhibits'. *The Architectural Review* 6, June–December.

Wilson, H. (1903) *Silverwork and Jewellery*. London: John Hogg.

FIGURE REFERENCES

FIG. 2 Cartoon from Punch, 16 July 1859. Courtesy of The John P. Robarts Research Library, University of Toronto

FIG. 3 Ivory Achaemenid fitting, carved in the shape of a horned lion's head, 4th–6th centuries BC. London, British Museum. Acc. no. 1864,1217.1

FIG. 8 Christ from *Diptych: Christ and the Virgin*, workshop of Quinten Massys, *c.*1510–25. London, National Gallery. Acc. no. NG295.1

FIG. 15 Photograph of the members of the Guild of Handicraft, early 1892. Cambridge, King's College Library. Papers of Charles Robert Ashbee, CRA/1/4, reverse of p. 116

FIG. 22 Edmund Dulac (1882–1953), *Charles Ricketts and Charles Shannon as Medieval Saints* (1920), tempera on fine linen over board. Cambridge, Fitzwilliam Museum. Acc. no. PD.51-1966

FIG. 36 London transport poster for Exhibition of Modern Silverwork, held at Goldsmiths' Hall in 1938. Designed by Edward McKnight Kauffer (1890-1954). © E McKnight Kauffer/Victoria and Albert Museum, London. Acc. no. E.3224-1980

INDEX